GREEN MOUNTAIN
OPIUM EATERS

· A History of Early Addiction in Vermont ·

GARY G. SHATTUCK

THE
History
PRESS

Published by The History Press
Charleston, SC
www.historypress.net

Copyright © 2017 by Gary G. Shattuck
All rights reserved

First published 2017

Manufactured in the United States

ISBN 9781467136945

Library of Congress Control Number: 2017931797

To the woefully few nineteenth-century Vermont doctors and Woman's Christian Temperance Union sounding the first alarms

CONTENTS

1

EARLY ABUSES

Mountains, remote and difficult to access, separated by equally challenging valleys, hillsides and intersecting rivers and streams—these made up the obstacles foremost in nineteenth-century Vermonters' minds when they considered their physical relationship to the outside world, ones causing politicians to half-jokingly declare them a superior race in their seclusion. Their hardiness did not go unnoticed, and in 1840, army recruiters made it a point to select such Vermont men for service, believing that those "from mountain regions are firm, compact, hardy, have activity and enterprise, with the boldness of mind and valor, that constitute them natural soldiers."[1]

Regaling officers in Montpelier at the close of the Civil War in 1869, General William Grout reminded them how an earlier intrepid generation "from hillside and valley, and mountain fastness" quickly descended from Vermont's high places in the Revolutionary War's opening days. They could not help but do so, he said, because their legacy, evidenced by their forefathers' many travails in contests over these rugged lands, was built on "the military prowess of her people."[2] Vermont was, he proudly said, "the legitimate child of war." The following year, thousands gathered at Rutland's centennial celebration of its settlement in the shadow of the nearby "trinity of goodly mountains, Killington, Pico and Shrewsbury" to hear similar sentiments from religious, civil and military leaders reassuring them that they lived in a place "where families may grow up untempted, and uncontaminated by vices."[3]

While Vermonters viewed themselves as a hardy breed accustomed to extraordinary frontier hardships responding admirably in times of crisis, the reality of the purported idyll they lived in was simply a fiction. In fact, an insidious affliction had slowly made itself known in the Green Mountains that none of these speakers acknowledged. Mountainous seclusion did indeed have its benefits, as doctors noted it made the transmission of disease and society's ills from far-off urban cities more difficult. But the times began to erode their isolation in midcentury with the arrival of the railroad, and that particular advantage began to quickly fade. As the century progressed, a demon of huge proportion made itself known, but authorities turned their heads instead and doggedly pursued a myopic policy prohibiting the manufacture and sale of alcohol begun in 1852.

Rather, had a true accounting of the times been offered to those audiences by the responsible physicians among them, they would have been forced to acknowledge what many wanted to keep secret. As Dartmouth Medical College's esteemed professor Dr. Carleton Pennington Frost made clear in 1870, many Vermonters were then suffering, having fallen into the habit of consuming the strongest narcotic known to man.[4] Opium and its derivative morphine, both highly addictive and readily available, were fast becoming the simulants of choice for Vermonters by midcentury, growing so prevalent by 1890 that another physician of that time declared their irresponsible administration by doctors as criminal and constituting "a crying evil of the day."[5]

Despite clear evidence of the problem, officials continued to refuse either to acknowledge or take any action to otherwise alleviate it. Starkly demonstrating that fact are the laws in effect in 1894, in which concerns over alcohol occupy an expansive 111 sections of the statute book—spread out over twenty-two pages—while those concerning drugs amounted to a mere 4 sections contained on less than a single page.[6] Officials' inaction continued, and in 1900, prominent Burlington physician Ashbel Parmelee Grinnell provided definitive proof that Vermont was then in the throes of a devastating opium epidemic, lamenting, "Sooner or later the reformers of the world have got to divert some of their feverish antipathy to alcoholic stimulants and consider calmly and intelligently the drug evil."[7] Unfortunately, more than another decade had to pass before that occurred.

The story of Vermont's experiences with opium abuse, which responsible members of its medical community identified at the close of the century, presented perhaps the largest societal challenge facing it in its history. Early on, until the railroad delivered some prospect of modernity, remote

mountainous communities had been left to themselves to evolve and resolve whatever stimulant-related issues that arose among themselves as best they could. Concurrently, stumbling and inept medical and pharmaceutical practitioners fraught with infighting and unable to convince the population of their trustworthiness or effectiveness could only watch as many turned instead to alternative treatments and medicines in their efforts to self-diagnose and medicate. Abetted by a hands-off state legislature—unwilling to interfere in their struggles as it focused solely on alcohol's prohibition—a vibrant patent medicine trade arose, frequently utilizing highly addictive opium and increasing the presence of addiction. With the invention of the hypodermic syringe and needle in the mid-nineteenth century and return of soldiers from the Civil War already exposed to the effects of the drug, a body of ill-trained, irresponsible and complicit physicians operating in unrestricted fashion then administered it widely, watching as both patients and themselves fell under its influence.

By the mid-1890s, addiction peaked on the national level and began a steady decline in the next decades. However, for Vermonters, the horror continued on until reforms in 1915 finally brought some semblance of order to an out-of-control situation. Unfortunately, scientific advances in refining opium even further in the form of highly addictive heroin provided yet additional opportunities for abuse, resulting in a second wave of addiction in the Green Mountains by century's end. While there is little in this tragic story that is consistent with the idyllic mythology surrounding the state's formative years, it remains of sufficient interest in order to understand the particularly difficult course its inhabitants negotiated in their relationship with highly addictive drugs.

❧❦

Substance abuse in Vermont began early on, with large numbers of settlers from Connecticut and Massachusetts flooding into the so-called New Hampshire Grants at the close of the French and Indian War in 1763. Taking up lands along the west side of the Connecticut River in an area claimed by New York, the inhabitants indulged so heavily in all manner of alcohol that it quickly became of public concern. Following petitions to authorities in New York City for assistance, the counties of Cumberland (1768) and Gloucester (1770), bounded by the river and the Green Mountains to the west, were created. This included the establishment of

various courts authorized to license inns, taverns and retail establishments and their sales of spirits, an appetite so large that on a single day in June 1772, the Cumberland court alone issued a notable forty-one licenses for a population of only 3,947 individuals.[8]

Evidence of further abuse continued. Only three years later, Ethan Allen and Benedict Arnold led militia troops through the gates of Fort Ticonderoga in the opening moments of the Revolutionary War, and immediately afterward, Allen's men came across the British commander's store of ninety gallons of rum, consuming it and then going on a rampage throughout the fort. When Arnold attempted to stop their depredations, they pointed their weapons and threatened to kill him, with one actually snapping an unprimed gun in his direction. As Allen explained in justification afterward, the rum was "greatly wanted for the refreshment of the fatigued Soldiery," calling its taking "appropriate for the use of the Garrison."[9] From Arnold's perspective, he summarily dismissed Allen as "a proper man to head his own wild people."[10]

Vermont's unruly revolutionary militia continued marching to the tune that rum sounded. Throughout the war years and immediately after, when summoned to quell demonstrations within the rambunctious Grants, extant records reveal alcohol's pervasive presence on literally hundreds of occasions. Claims seeking reimbursement for expenses incurred in obtaining it were as varied as the particular circumstances, noting in cryptic fashion entries such as: "5 gallons of Old Rum...to drive the Yorkers"; "one hundred and eleven gallons of Rum...for the use of this Steats [sic] troops"; "five barrels of rum...for the use of the militia of this state"; "taken from Joseph Parkhurst for the benefit of Militia in the Alarm at Royalton...six quarts & pint rum"; "one barrel of rum for the use of the State's troops stationed at Bethel"; "six gallons of rum for the garrison at Castleton"; "liquor for the guard after the battle"; "one quart of old rum for the officers"; and "twelve gallons of rum delivered to Capt. Jos. Safford and company when on their march from Bennington to Brattleborough to guard the ammunition." Alcohol also accompanied scouting excursions, was provided to prisoners and their guards, given to teamsters transporting goods and supported attending doctors.[11]

In January 1778, Vermont's Council of Safety was forced to take action to address the burgeoning alcohol problem threatening public safety. The cause for their immediate concern was because "divers persons...have brought, and sold to the inhabitants, in small quantities, and at exorbitant prices, (and continue so to do) certain spirituous liquors, whereby drunkenness,

idleness, quarrels, &c &c is promoted among us."[12] Because the operations of the law courts allowing for licensing had been suspended by the war, the council chose instead to allow town officials to assume that responsibility. Notwithstanding, alcohol continued to fuel increasing unrest among the troops, and only two years later, regulations were imposed authorizing the court-martial of any militiaman committing depredations on the civilian population by threatening, compelling or forcing citizens "to loan, give, or sell any...liquors" against their will.[13] Unwilling to stop indulging the troops' drinking, when civil unrest broke out in the southern part of the state in 1783, authorities made certain to requisition not only ammunition but also "spirituous liquor" for their consumption.[14]

Early legislators gathering together to fashion their various laws also consumed large amounts of alcohol. A single volume titled *Wine Account for the General Assembly of 1787* details the incredible thirst of Governor Thomas Chittenden (himself a tavern keeper) and accompanying judges, lawyers, doctors, militia officers and surveyors as they ran up large bills for brandy, rum, gin, bowls of punch, bitters, grog, sling, wine, flip and sherry.[15] By early 1794, their raucous gatherings had become so disruptive that "A Friend to Virtue" felt obliged to reveal their antics to the public. "Some of the foremost members of the House, some of the Judges of our Judicial Courts, and at least one Member of the Council, and (shocking to relate!) professor of Godliness, were guilty of the most savage like drunkenness," he wrote, participating in "bacchanal revels" while actually in session. Of what effect, he reasonably asked, could any of their laws have against immorality when "the makers are the first and most egregious transgressors?"[16]

Loud drunken legislators hardly constituted the only example of deficient professionalism of the times; the hypocrisy was amply demonstrated by the medical profession itself. Still in its infancy, with practitioners possessing vastly different levels of intelligence, education and competency, Vermonters were forced to witness long, tumultuous decades unfold before physicians evolved to the point at which they could be trusted to administer to their health. Those earlier individuals calling themselves "doctors" tended to sick and injured animals just as readily as they did people, and their abilities in both types of cases were closely scrutinized by the public. As Vermont's first historian, Dr. Samuel Williams, noted in 1794, "The customary methods of education for the professions of divinity, law, or physic, are extremely deficient; and do not promise either eminence or improvement. The body of the people seem to be more sensible of this defect, than professional men themselves."[17]

Several doctors from Bennington and Rutland Counties already understood the low regard that many held for them, and in 1784, they formed the First Medical Society—followed by other counties in ensuing years—and then the Vermont Medical Society (VMS), authorized by the legislature in 1813. As a result, these individual societies assumed the responsibility for evaluating the fitness of applicants and their licensing, together with imposing sanctions against those deemed ignorant, immoral or not in compliance with their regulations. Doctors also met periodically to conduct society business and listen to presentations on various topics, including an early "dissertation on the application, operation and effects of opium" provided by Dr. Samuel Shaw in Rutland in November 1795 during a First Medical Society's meeting.[18]

Despite these well-intended efforts at self-improvement, people continued to suffer at the hands of the incompetents to such an extent that in 1803 the legislature took up the problem with "An act to prevent the fraudulent impositions of pretended Physicians, Surgeons, and Quacks upon the good citizens of this State."[19] The act sought to prohibit unlicensed practitioners from obtaining court judgments against patients refusing to pay their onerous bills. It was a fact made distressingly clear in the bill's preamble, which stated, in part:

> *Whereas many persons wholly unacquainted with the science of Physic and Surgery and ignorant of the nature, effects and operation of Medicine have palmed themselves upon the good citizens of this State as regularly educated Physicians and Surgeons whereby life and limbs are often put in jeopardy and property wrongfully taken from the honest & industrious Which evils to prevent.*

Unfortunately, the effort was summarily dismissed from further consideration.

It was not the first time that lawmakers had avoided becoming involved in protecting the state's health. A few years earlier, in 1798, Brattleboro's Dr. Samuel Stearns understood the medical community's dire need for a treatise covering treatment of the sick and approached the legislature seeking authority to conduct a statewide lottery to facilitate publication of a first-of-its-kind medical compendium, "A Regular System of Pharmacy, Physic, and Surgery." Believing that such an effort might substantially improve the quality of care available, Stearns explained it would prove of great interest and use to physicians, surgeons and apothecaries "in all the difficult and dangerous Cases, Operations, and Processes they May have to

Encounter."[20] Many other esteemed physicians throughout New England recognized its importance and enthusiastically endorsed it by providing testimonials. One Rhode Island doctor, emphatic that it should be allowed, stated, "It is much better to have the Minds of Physicians illuminated, than to keep them groping in the dark for want of Information, wandering about with the Engines of Destruction, and Ignorantly Committing Slaughter and Depredation amongst their Patients."[21] The legislature dismissed the noble effort outright, without explanation.

In the absence of official oversight, Vermonters remained exposed to the whims of imaginative individuals seeking to extract whatever money they could from their unsuspecting victims. In one heart-wrenching 1804 account, only a year after the legislature turned aside its anti-quackery bill, a newspaper reported the death of eighteen-year-old Hannah Evarts so that "it may instruct the credulous, and form a lesson for those who are too often employing such vile imposters of physic, who are continually ransacking the country, 'seeking whom they may devour.'"[22] The story concerned a John Johnson passing himself off as a purported "cancer doctor" who had performed "miraculous cures" based on knowledge gained from having "read a great many German authors and…[receiving] much information from the native Indians."

Despite their skepticism at his claims, the girl's desperate parents—weary of witnessing Hannah's sufferings from an undisclosed condition—allowed Johnson to treat her with the understanding that he not employ opium. He assured them he would not, but a witness observed him using it to prepare a concoction powerful "enough to kill three persons." Johnson then forced this, together with a quart of rum, down the girl's throat, resulting in her predictable death. Tried for murder, a jury found Johnson guilty only of manslaughter, for which he received a sentence of "thirty-nine stripes, to stand in the pillory one hour, to pay costs." However, the sentencing judge made certain that he actually served time, ordering him to prison for seven years following his third conviction for counterfeiting.

Disease constituted a serious problem between the war and early years of the nineteenth century, and several epidemics swept through the region. Smallpox accompanied the retreat of the Patriot army from Canada in 1776, and the following year officials in Bennington established pest

houses in order to isolate those undergoing inoculation in an attempt to control it. Should anyone choose to depart before their treatment was finished, or if anyone suffering from the disease was found wandering the roads, they were subject to a twenty-pound fine.[23] In 1784, the problem persisted, with officials assessing a sizeable fifty-pound fine on anyone failing to report the presence of the disease within a community.[24]

Of additional concern were the yearly outbreaks of measles, typhus, dysentery, cholera, pleurisy, influenza, pneumonia, spotted fever, scarlatina (scarlet fever), whooping cough, canker rash, "ground itch" and hydrophobia ("canine madness").

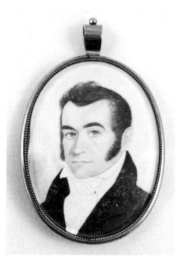

Dr. Joseph Gallup. *Woodstock History Center, Woodstock, Vermont.*

Scores of individuals died, some within only a matter of hours after symptoms first appeared. In 1803, there was a huge increase in instances of typhus and dysentery, and in 1810, spotted fever struck with a vengeance. However, all of this paled in comparison to what one prominent doctor, Woodstock's Joseph A. Gallup, described in his groundbreaking 419-page work, *Sketches of Epidemic Diseases in the State of Vermont,* as "the most severe epidemic disease that has ever afflicted the inhabitants of Vermont, the epidemic peripneumony, or disease of the lungs [later identified as cerebro-spinal meningitis]," taking place between 1812 and 1813.[25] Attributed to the arrival of troops stationed in the region because of the current war, upward of 6,400 individuals, including 750 soldiers, died within a five-month period. Castleton's Dr. Selah Gridley contracted the disease himself while tending to many ill patients, recalling, "So numerous were the sick that it became impossible to attend them in any proportion to their danger."

Treating these outbreaks posed a considerable challenge to the medical profession. Practitioners struggled to understand the dizzying number of symptoms that patients presented and then prescribe an appropriate remedy, the effects of which were not fully understood. Treatments were as rudimentary as bloodletting by lancing a convenient vein (an arm in an adult or carotid artery in a child) and then draining off copious amounts of blood. Alternatively, the practice of competent pharmacology was largely restricted to the metropolitan areas, allowing for much creative discretion

to take place in the more remote areas. Frequently, in treating fevers, these doctors resorted to the "celebrity" that opium and brandy taken individually and in combination had attained in past epidemics. As Burlington doctor John Pomeroy's files note in one case, "a plentiful use of spirit, brandy, wine, op[ium]…[and] arsenic] for several days" worked well.[26] In another case involving suspected dysentery failing to respond to sedatives, Dartmouth's medical college founder Dr. Nathan Smith—who happened to be passing by at the moment in the accompaniment of some students—was asked to intervene. As a witness recalled, he "asked but one or two questions, and administered a compound opiate, in a dose causing his pupils to fear the patient would be relieved from all pain and enter the spirit land within the coming hour." Soon after, the sick woman fell asleep, and when asked if he thought she would recover, Smith replied that she would. And she did.[27]

Efficacy aside, the frequent use of opium by doctors offered an easy way to address a patient's symptoms by simply rendering him or her unconscious while also giving a sense to observers that the physician knew what he was doing. However, it was a false impression, one that Gallup noted at the time frequently allowing for both the disease and the "treacherous remedy" that opium represented to play out in the end.[28] It was a dangerous game they played—but one they willingly engaged in simply because of the astounding effects that this miraculous substance could produce in such a short period of time.

2

OPIUM ARRIVES

The word *opium* comes from the Greek *opos*, meaning "juice," the form in which it is harvested from the poppy flower (*Papaver somniferum*), prevalent in the Mediterranean region. Early Minoan, Greek and Egyptian societies all traded in the substance, and Homer referred to it in *The Odyssey* as "nepenthes." Ancient physicians recognized its importance and had made such frequent use of it that by the end of the Roman Empire, a reckless public was consuming it without abandon. While the addictive, or habitual, qualities of opium were recognized at the time, it was a phenomenon largely escaping Western practitioners' attention until the early seventeenth century.[29]

Opium renders its amazing effects in two ways: to the brain and to the muscles and organs. Brain receptors rapidly accept one particular set of its alkaloids, thereby suppressing the sensation of pain, while another affects the body physically, ushering it into a state of deep relaxation. A state of euphoria also accompanies opium's effects and will last for several hours. In the process, respiration is lowered, blood pressure reduced, digestive functions are decreased, body temperature falls and perspiration is inhibited. Ingesting the drug took several forms over the course of time, including eating; mixing it in powdered form with alcohol, camphor and tea; consuming pills; and, later in the nineteenth century, by hypodermic syringe and needle. While the Chinese custom of smoking opium (called *da yen*, or the "big smoke") became the method of choice for many in East Asia and in large North American cities, there is no evidence of such use in Vermont.

In its raw state, the drug is less effective than its important derivatives, morphine and heroin. The former, named after the Greek god of dreams, Morpheus, was first extracted in 1803 and found to constitute between 3 and 24 percent of the raw substance. As one medical student recorded during a lecture on the use of the two substances in 1841, "5 drops of [morphine in solution] is equal to 25 drops of tincture opium."[30] In 1874, an Englishman first refined morphine into highly addictive heroin, and it was successfully marketed in 1898 by the German drug manufacturer Bayer as a nonaddictive cough suppressant and cure for the morphine addiction.

Virtually all of the opium used in America for much of the nineteenth century originated in Asia Minor and later the subcontinent. Other locales produced it in lesser quantities, including Egypt, Persia and France. Known commonly as Turkey, Smyrna or Constantinople (reddish brown in color) and East India opium (almost black), compressed cakes of the malodorous, nauseating, bitter-tasting poppy juice covered with leaves and petals entered into the nation's stream of commerce and eventually arrived in remote Vermont. Notwithstanding the several Latin names the medical community attached to it (*Opium purificatum*, *Extractum opii*, *Pilulæ oppi*, *Tinctura opii*, *Confectio opii*), the public came to know it simply as "laudanum [opium mixed in wine], the black drop [no alcohol], or acetate of opium; the Dover's Powder, and Paregoric Elixir [camphorated opium]," made available in the form of pills, tinctures, confections, electuaries (medicinal paste) and anodynes.[31]

During the Revolutionary War, opium was used to treat sick and injured soldiers, and while not specifically identified, it most certainly constituted a portion of the large shipment that Vermont doctor Reuben Jones arranged in June 1780, receiving £1,314 for his troubles in "getting drugs for the state's troops" from Charlestown, New Hampshire. It would also have been included in the several instances when "medicine" was obtained to tend to the mortally wounded militiaman Sylvanus Fisk at the time of the Guilford riots in 1784.[32]

Following the war, Vermonters took active notice of opium's effects. In 1788, the *Vermont Gazette* published a comprehensive three-column front-page explanation describing how to grow and process poppies into opium.[33] Two years earlier, surveyor of many of the state's towns and roadways and self-professed doctor Eben Judd recorded instances of administering opium to himself and others and of visiting a doctor in Guildhall who "told me a method of making Opium by Cuting of the tops of Popies [*sic*] and drying them and then boiling them away."[34] One hundred miles away, in Dutchess County, New York, entrepreneurs pursued the patriotic

call to develop the country's agriculture and manufacturing capabilities and closely studied the production of opium domestically. Similar efforts continued, and in 1808, a Middlebury paper reported, under the heading "American Opium," the recent meeting of a local New York medical society offering a twenty-five-dollar bounty to anyone able to "produce the largest quantity of good pure opium, not less than sixteen ounces of his or her own cultivation."[35] In 1822, even the Vermont legislature received indirect advice on the subject when minister John Lindsey admonished it during his opening sermon to exploit the state's yet undiscovered "vegetables and minerals" lying "undistinguishable in the forest or buried in the earth" on the behalf of medical science.[36]

Meanwhile, at Dartmouth's medical college, just across the Connecticut River in Hanover, Dr. Reuben Mussey lectured on the theory and practice of physic in 1814. As one student recorded in his notes, Mussey described the attributes of the "Sleeping Poppy" yielding a substance "called opium—very good, made from what grows in our garden."[37] Others took note, and that same year, the Society of Shakers in Niskayuna and Lebanon, New York, grew and refined sufficient opium to supply all of Albany's needs.[38] In 1813, and again in 1817, the respected *American Dispensatory*—which many medical professionals consulted for information concerning various drugs—clamored for increased domestic production. This was necessary, it opined, in order to remove the "frequently adulterated foreign productions" coming from overseas:

> *Such is the intrinsic value of opium, and such the high price which it commands, that every method, promising to increase the quantity in the market, should be encouraged as of great importance to the community.*
>
> *The citizens of the United States have not in general been apprized, that this exotic may be cultivated on our own soil to an extent adequate to every exigency, and with a profit exceeding that of many other productions of husbandry.*[39]

In Putney, Dr. Jonathan Moore aggressively cultivated great quantities of opium from his own gardens, becoming so successful that the drug constituted the primary ingredient in his widely acclaimed Dr. Moore's Essence of Life. Available throughout the state in general stores, bookstores and even the local newspaper office, Moore's Essence received numerous endorsements from important people, including one of the state's founders, U.S. senator Stephen R. Bradley. He stated unequivocally that

"the citizens of America would receive great benefit in a more general use" of the product.[40] Others called for increased production, and one writer enthusiastically recommended that the free labor of children be used to harvest opium from Vermont's rich soil, resulting in a "profitable employment" to the grower.[41]

While Moore vigorously touted his cure as a remedy for virtually all forms of illness and disease, even he implicitly acknowledged its dangerous side effects. In advertising, he cautioned consumers "to begin with small doses and increase as the patient may require," recommending forty drops for an adult, repeated every two hours, twenty drops for an eight-year-old child and ten for an infant.[42] Woodstock's Joseph Gallup vigorously disagreed and attacked the medical profession's blinded devotion to using opium, condemning Moore's Essence specifically as an ineffectual nostrum, or quack medicine. Rather, he argued that bloodletting provided more reliable results, telling the population that opium could be "dangerous and fatal."[43] Revealing the unsettled state of the profession at the time, other physicians countered that such heavy reliance on draining off blood resulted in more harm than any opium could cause.

The medicinal attributes of opium and its contested usage aside, many in Vermont already consumed it for another reason. In a particularly revealing moment in 1816, esteemed physician, professor and a co-founder of the Castleton Medical Academy (1818) Dr. Selah Gridley spoke before the VMS immediately after his election as president. His topic, "The Importance and Associability of the Human Stomach," provided him with an opportunity to describe yet another aspect of opium's benefits.[44] "Does anyone ask," he inquired of his audience, "what constitutes the pleasure of existence?" In answering, he said:

> *It consists of a pleasant and easy action of the stomach, and other organs immediately associated with it. Do any doubt the truth of the position? I reply, when the stomach is duly excited by food, by wine, by opium and by tea, the highest degree of corporeal, moral and mental happiness is enjoyed. It is in this state only, that the person feels social pleasure, or exercises, in perfection, the faculties of taste, judgment and reason. In this state only, man delights in action and business or reclines himself into rest and sleep.*

In acknowledging that opium held equal sway with food, wine and tea, affording an individual "social pleasure," Gridley's admission explains just how much the population had come to rely on the drug for its extra-

medicinal effects. In fact, his observations were deemed so significant that the cash-strapped society immediately "voted that the Treasurer be directed to procure 500 copies…to be printed as soon as may be."[45]

The possibility of developing an unhealthy attitude toward the consumption of opium was never far off. Responsible physicians understood the hazards of administering the drug, and some assessed a patient's condition and then applied measured amounts in response to particular symptoms. As Gallup recognized, opium was dangerous because of its "leaving a permanent excitement in the system for several days."[46] Fear of fostering the creation of a devastating habit clearly sat foremost in his mind, and he predicted a price would be paid in the future for its indiscriminate use, writing that opium and brandy "have not yet atoned for the injury they have done." One of the so-called "galaxy" of stimulants, together with tobacco, wine and spirits, people were further cautioned in their use of opium because it became an acquired taste gained over a period of time.[47]

Medical students also began to receive warnings to monitor the drug's application because of untoward results ("convulsions and death") and to understand the potential for abuse by its victims, themselves easily identified because of their "debility…[and] wrinkled limbs" from overuse.[48] One Pennsylvania medical student described opium's effects in 1792 as permitting the user to "feel as though they were in heaven," allowing them to acquire habits affording "pleasure by suspending [life's] many little uneasinesses."[49]

Mothers also received warnings to be careful in their choice of nurses; unscrupulous caretakers were known to administer gin, opium and opium-based Godfrey's Cordial to quiet children so they could do their work in peace.[50] For decades, children suffered because of their actions, exacerbated by being forced to take yet additional drugs in order to counter the ill effects. In a telling condemnation of the practice, Addison County's widely respected Dr. Jonathan Allen described children in 1829 refusing to drink their daily allotment of alcohol and being coaxed to do so through "the inviting influence of sugar."[51] Then, he explained "[t]he same requisites are essential to induce children to take opium, tobacco, or most other medicines," with the result that these substances became "desirable as articles of living and even seem to constitute one of the necessaries of life." Fellow physician William Sweetser agreed that children were receiving harmful treatment from their parents and nurses and that "all the injurious consequences of the spirit and opium must result from its abuse."[52]

Evidence of addiction in adults was also clearly present, as Allen described in 1815. A female patient "fond excessively of opium" chose to

take it rather than other drugs he offered her.[53] In Middlebury, same-sex partners Charity Bryant and Sylvia Drake wrote unabashedly over the course of several years of their liberal use of opium and laudanum for health-related complaints. As Charity described, she used them in order to obtain deep relief following a long day's work ("I bathed myself freely in… camphor and opium") and to ward off the discomfort brought on because of long carriage rides.[54] Just over the border in nearby Troy, New York, a physician freely supplied large amounts of opium to a man obtaining it for his wife because she "was in the habit of taking it, and wished to have some with her on her journey."[55] Unfortunately, she died shortly thereafter, and her husband was convicted of murdering her by poison.

The public also continued to hear a drumbeat of opium's allure from foreign sources. In 1822, Englishman Thomas De Quincey's explicit *Confessions of an English Opium-Eater* describing his various pleasant debaucheries under its influence (mainly laudanum) was released in London.[56] By then, the drug had become so entrenched in the city's environs that local druggists supplying De Quincey told him the number of "amateur" opium eaters (compared to his voracious appetite) was "immense." It was so large that "on a Saturday afternoon the counters of the druggists were strewed with pills of one, two, or three grains, in preparation for the known demand of the evening" when factory workers appeared at the end of their work day.

Vermonters' openness in consuming opium did not gain an equivalent level of notoriety until late in the century, but in the meantime, they certainly did what they could to quietly gain access to it. Although early accounts of taking the drug for the purpose of intentionally ending one's life are infrequent, they did begin to appear and increased over the next decades. Never done in a consistent manner, newspapers adopted various ways to convey the sad message to the public, ranging from an attention-getting "Suicide" banner over a decedent's name or inserting some innocuous attribution to a benign reason such as "heart ailment." These oblique references fooled no one. In 1797, Haverhill, New Hampshire's Major Joshua Young found himself explicitly identified in a Vermont newspaper as a suicide, with bold letters emblazoned above his name relating that he had "put an end to his existence by taking a dose of opium."[57] To add further insult to his unfortunate situation, an official inquiry into the surrounding circumstances simply concluded that his actions constituted "willful murder."

Accounts continued throughout the century, becoming routine as they cryptically described the connection between suicide and the presence of opium. In 1836, a paper matter-of-factly noted "Suicide, Elisha B. Pratt…killed

himself by taking opium"; in 1838, "Another suicide," involving Nathan Barber "by taking opium; he died almost immediately after"; in 1847, the "suicide" of William Hollenbeck "by taking opium. The cause is said to be intemperance"; in 1864 the "supposed suicide" of George Taylor who, after dinner, "lay down on the bed, saying: 'I am going to sleep,' and eating a quantity of opium, he expired"; in 1868 an "attempted suicide" using opium by Mrs. George Farnham, despondent over her husband's excessive drinking; and in 1887, seventy-five-year-old Mrs. Bronson tried to cut her own throat because "she was crazed by opium eating."[58]

For Rebecca Peake—sitting in a Chelsea jail in 1836 after a jury convicted her of murdering her son-in-law by feeding him poison (in addition to dosing two other surviving family members)—a hangman's noose was avoided when she reportedly overdosed on opium she managed to accumulate from smaller quantities provided to her by a visiting doctor.[59] However, not all suicides involved raw opium, and the news began to increasingly report many deaths attributed to its potent derivative morphine.

Access to opium in Vermont for medicinal or personal use (and for treating animals) was totally devoid of any kind of official regulation until the early twentieth century. As early as 1785, the Bennington community became aware of opium's easy availability when Aaron Hastings placed an advertisement offering it for sale to "the Gentlemen of the Medical Faculty in particular; and…the Public in general."[60] Two years later, his competitors Meyers and Towner also offered opium and assorted other drugs at prices "much lower than they have ever been sold in this town."[61] They offered the drug in its raw form, as well a patent, or nostrum, medicine—one supposedly prepared pursuant to a legitimate British patent bearing the names of English manufacturers Bateman's Drops, Godfrey's Cordial and Hill's Balsam of Honey, but none of the labels disclosed opium's presence.

This was a very loose time in the preparation of drugs in America, and it invited vast amounts of fraud involving adulterated substances offered in recycled vials, both as nostrums and as supposedly legitimate drugs distributed by unscrupulous physicians. As one individual admitted of the times, "Many, very many days were spent in compounding these imitations, cleaning the vials, fitting, corking, labelling, stamping with facsimiles of the English Government stamp, and in wrapping them with little regard to the originator's rights."[62] Opium served as the active ingredient in many of these preparations, so frequently relied on that it became known as the "quack's sheet anchor."[63] Because these bogus concoctions required that they deliver some kind of noticeable effect in order to assure a return customer, opium

was used in the most outlandish ways. In 1807, Vermonters learned of one elixir, John Crous's cure for hydrophobia, that included "the jaw bone of a dog, burned and pulverized" and huge amounts of opium and laudanum.[64]

Period newspapers are replete with examples of these substances offered for sale in Vermont. In Middlebury, Pomeroy & Williams advertised repeatedly that it had "just received…an extensive assortment of Drugs & Medicines," including various patent medicines (Hooper's Pills, Anderson's Pills, Lee's Bilious Pills, Bateman's Drops, together with "Opium Turkey," all available for sale both "night and day").[65] In Peacham, Elisha Phelps sold crockery, dyes, paints and a vast number of drugs, including opium,[66] while in Brattleboro, Arms, Clark & Company offered another huge selection, including opium, together with groceries, paints and dyes. The company's advertisements called the attention of "physicians and heads of families in particular" to the fact it took particular care in providing drugs of "superior quality."[67] Unsurprisingly, doctors themselves took advantage of these lucrative opportunities and opened up apothecary shops offering patent medicines of their own creation, such as Rutland's Isaac Green and Thomas Hooker and Peacham's William Scott.[68]

<center>❧❧</center>

Vermont's developing addiction to opium cannot be understood without considering the incredibly divisive role that alcohol played, as people turned to the drug following statewide prohibition in 1852 (becoming effective the following year). The consumption of intoxicating beverages began immediately with the arrival of the state's first settlers. Wresting a livelihood from the frontier forests constituted the majority of their activities during the state's first twenty-five years. Before the soils became depleted and the state witnessed significant migration outward following the War of 1812, residents produced a prodigious amount of grain crops. Wheat alone grew so abundantly that farmers obtained between twenty and thirty bushels per acre, enabling them to export thirty thousand surplus bushels in 1792.[69] In an economy lacking currency, wheat served in that role to such an extent that one historian opined the ensuing divide between the state's wealthy ("aristocrats") and poor ("plebeians") was demonstrated by one's ability to procure either wheat bread or having to rely on skillet-prepared johnnycake.[70]

As the country forged its way, freedom from dependence on Europe for spirits or having to rely on molasses from the Caribbean to produce rum

was of great concern, and attention immediately centered on these efforts of American farmers. With so much grain available domestically, great efforts then went into developing a distilling infrastructure to produce spirits. Vermont's Samuel Williams noted in 1794 that while distilleries at the time "have met with good success in their attempts to make gin," the future held out even greater promise, predicting they would provide a "very considerable advantage to the state."[71] Nationally, that was indeed the case; the country's production doubled from some ten million gallons in 1801 to over twenty million by 1810, a result certainly influenced by the issuance of some one hundred patents (5 percent of all issued) for various distilling processes in the years leading up to 1815.[72]

Other endeavors pursued by early Vermonters included expanding the availability of inns and taverns for those crossing over the notoriously bad roads. One British traveler headed to Lake Champlain in the early 1790s passed through Burlington (approximately three hundred residents). He noted that "it consists of a few wooden houses, neat in their construction" where "[i]ts inhabitants seem to derive their support from what they call 'keeping tavern,' paltry shopkeeping, or working as carpenters."[73] Their example was repeated in the more heavily populated southern counties, and by 1801, extant, although incomplete, records reveal the presence of a staggering 489 licensed inns and taverns statewide (population 154,465). In Rutland alone, their numbers exploded the following year, going from 46 to 122.[74] Of note, none of these figures take into account the presence of the many unlicensed establishments also offering similar services.

Chittenden County (population 12,778) had 34 licensed inns and taverns in 1801, many clustered around Burlington, and each required spirits—whether they be in the form of the various concoctions the legislature imbibed in 1787 or as cider brandy, potato or grain whiskey or New England or maple rum—for their thirsty customers. Further inland, where fewer taverns existed for local inhabitants to gather, distilleries immediately sprang into existence. Of the reported 125 registered operations in Vermont in 1810 (10 in Poultney, 4 in Shelburne and 30 in Chittenden County), "some turn[ed] out 50 gallons of liquor a day or 600 barrels a year."[75] One such operation was that of Oliver Cromwell Rood in Waterbury.

Around this time, Rood decided to build a potato whiskey distillery and either fashioned his own equipment or purchased one of the many patented methods then hawked by various merchants around the state. Distilling was not an easy business, and Rood seems to have avoided the occupational hazards of burning his place down, as Joseph Bowman did in Montpelier

in 1803 and Jabez Rogers in 1805 in Middlebury (for the second time), or fatally falling into a vat of boiling liquid, as Joseph Jones managed to do in St. Albans in 1807.[76] Their hardships notwithstanding, the state's legislators, otherwise uninterested in advancing medical knowledge, certainly appreciated their work. As one patriotic legislative committee considering Rogers's petition for relief from creditors following his mishaps described his efforts, they were "really serviceable to his country."[77]

One of Rood's early journals covers the period between 1809 and 1815, and over the course of some two hundred pages, he meticulously recorded the sale of huge amounts of gin and the periodic bottle of high wine (an intense alcoholic concoction) to hundreds of individuals. Demonstrating the voracious thirst of his neighbors not otherwise purchasing gallons of New England and West Indies rum at the local general store, the first four days of his records include the names of thirty-nine individuals, each of them purchasing gin in quart and gallon quantities. He then meticulously entered their names in the following years as they returned seeking their spirits. Interestingly, Rood's journal also mentions the sale of numerous hogs fattened on the waste products from the distillation process.[78] Clearly a popular man, Rood certainly profited handsomely in supplying the community with stimulants.

Taverns served as the secular gathering place for consumers of Rood's efforts, both those living in the vicinity and those pausing in their travels, teamsters pursuing trade in Boston or Troy or others arriving by stagecoach. Crowding in next to a roaring fire on a cold day, they conducted business, learned the latest political news, read postings of court proceedings, treated friends to drinks paid for with bounties from killing wolves or tried to sleep on a feather bed of questionable cleanliness before heading out early the next day. Outside in the fields where they hayed in the hot sun, laborers expected strong, ardent spirits for their efforts ("a pint of rum to a pound of pork"), and farmers found themselves obligated to increase their allotments of "liquid fire" from a pint to a quart to keep them happy, only to see them wither and fade as a result.[79]

Why Vermonters consumed so much alcohol is a matter of conjecture. Theories include the availability of rum rationed to soldiers during the Revolution who then refused to give it up with the arrival of peace, a general loosening of societal restraints freed up by the nation's independence and the economic realities surrounding agriculture and distilling activities.[80] This last point appears most relevant for those living in the Green Mountains because of the abundant amount of grain available that could be converted

into spirits at so little cost versus the added expense of transporting it to the large cities. Vermont also shared many of the same characteristics of other countries with high consumption rates, such as Scotland and Sweden: agriculturally based, rural, lightly populated and geographically isolated from foreign markets.[81]

However, explanations for the phenomenon were not of particular concern at that moment, and lamenting the presence of so many distilleries simply became a fact of life for those trying to avoid their pernicious effects. It was, after all, a time "when men were men and hard liquor was soft drink."[82] Unfortunately, even children suffered as a result. Eight-year-old John Wheelock was laid to rest in Rutland on July 4, 1799, the victim of "spirituous liquors, violently given him by a stranger" at his father's tavern.[83]

In the meantime, people could expect little help from a legislature that approved and promoted the presence of so many of these establishments and distilleries in the first place, leaving their oversight to the very locals who allowed the problems to fester. There was no solace to be had from the governor, either. In 1803, Governor Isaac Tichenor expressed the view that "the happiness and safety of society does not depend on the multiplicity of its laws" and believed that they "should be few in number, explicit, and duly enforced."[84] Both a hands-off policy that avoided involvement in curbing alcohol consumption and a continuing reluctance to enforce what laws that did exist created an atmosphere that then allowed additional abuses to develop, including the use of opium.

❧❧

Sometime around 1817, John Woodcock, a student at Dartmouth's medical college, submitted "A Dissertation on Delirium Tremens" in partial fulfillment of his degree requirements.[85] In the treatise, he described some of the new challenges facing the medical profession caused by increasing consumption of intoxicating spirits and the use of opium in treating the debilities that ensued. While confusion, irritability, spasms, hallucinations, delirium tremens (DTs) and unconsciousness resulted from consuming too much alcohol, they were actually relatively rare when drinking less potent fermented beverages, such as wine and beer. Notwithstanding, it was not unheard of for opium to be infused into those substandard beer-making processes requiring a stimulating effect that might otherwise have been absent. Now, with the recently arrived distillation processes flooding the

countryside concentrating alcohol into a smaller volume of liquid, those adverse results became more commonplace. As a result, the appearance of drunkards, whether induced by potent spirits or opium-infused drinks, became familiar sights in taverns and inns and along the sides of roads. For those in positions of authority committing their drunken indiscretions out in the open, their behavior became known as "high scrapes." While many viewed their collective actions with disgust, there was no ready alternative for this tolerated evil attributed to the so-called "new cultural conditions."[86]

As Vermont's early physicians Gallup, Gridley, Allen and others continued to cautiously employ opium in their treatment of the frequent frontier fevers, Woodcock described its use in instances involving the DTs, also called brain fever, drunkenness and febris. Whereas opium was used to quiet the heat generated by a fever, for those in the throes of irrational delirium, it was administered in large amounts in order to overtake consciousness and bring on a deep sleep—allowing them to avoid harming themselves and others. In his carefully crafted paper, Woodcock describes three cases he treated, one of whom was actually a physician ("a devotee of Bacchus in every sense of the word"), all receiving bleedings of between sixteen and twenty ounces of blood, shaving their heads (to release heat) and blistering. When none of these efforts worked, he then administered large doses of opium, reporting that in each case the patient awoke refreshed. Unfortunately, the unnamed doctor relapsed, suffering once again from severe hallucinations, and received so much opium that he died. In similar fashion, on another occasion, the experienced Jonathan Allen reported treating a man suffering from seizures caused by tetanus incurred because of a hand injury and administering so much opium that his patient was "removed…to the world of spirits."[87]

Despite the possibility of such outcomes, Woodcock still recommended using opium in treating DTs, including assisting the inebriate to withdraw from the drinking habit by using diminishing amounts of wine and calomel. In Bennington in January 1823, poor Saxton Picket never had a chance to experience the relieving effects of opium to counter his most recent bout of the DTs. With his doctor in attendance listening to his ranting complaints and threats to commit crimes allowing him to be sent to prison so the state could care for him, the two waited for Picket's wife to return from the local apothecary with "a little opium." However, before she arrived, Picket gained access to a straight razor and, despite the doctor's best efforts to restrain him by holding back his arms, succeeded in lowering his head "onto the razor until he cut his neck off clear to the bone."[88]

Opium also became important in treating those suffering from severe mental disabilities deemed too violent for others to manage. In 1806, young Brattleboro attorney and former secretary to the governor and his council Richard Whitney experienced such uncontrollable behavior that attending physicians' first resorted to controlled drowning in order to render him insensible. However, when that failed to show positive results, when Whitney regained consciousness, they then administered opium. The dosage was too high, and he died. Upset at the results, the wife of one of those doctors, Anna Marsh, subsequently bequeathed $10,000 allowing for the creation of the Vermont Asylum for the Insane in Brattleboro in 1834.[89] Despite Whitney's unfortunate ending, opium continued to be used at the new facility as both a favored method to corral those unable to comport themselves and as a soothing agent to permit their participation in further treatment.[90]

However, not all were quite so willing to employ opium to treat the DTs as Woodcock counseled, and in 1833, Dartmouth medical student Calvin Pratt made the observation that it was actually the drug itself "that frequently produces this disease."[91] Pratt described the suffering of one individual:

> He talks to himself, imagines himself to be surrounded with dangers or that he is in a strange place confined with wild beasts. He fancies whatever & he may be frequently miserable a good deal....If he is a merchant he thinks everybody is trying to cheat him or that his affairs are all going wrong, his creditors are all calling for money and he can't get a cent to pay them. If he is a mechanic he is forever laboring upon a piece of machinery without finishing it or is continually cutting or wounding himself with his own instruments & groans aloud with the pain of the imaginary wound. He sees strange sights and is tortured with a multitude of rats and mice, fleas, worms or some other vermin which he vainly endeavors to get rid of.

While divergent views existed among the medical men on the effects and uses of opium in their practices, one common complaint concerned their own ingestion and abuse of substances.

In 1819, medical student Cyrus Hamilton wrote in his dissertation, "On Ebriety," that physicians habitually took "spirits before entering the sick chamber to counteract the effects of contagion, and to shield the olfactories from offensive odours."[92] Their actions, he said, had a "very pernicious effect" because they "frequently end[ed] in habitual drunkenness." For others witnessing their actions, he wrote that "the example may do much mischief, either by causing intemperance in

nurses, which might prove fatal to the patient, or on occasional attendants & visitors, who may think its use necessary to prevent their contracting the disease." It could also create a very unpleasant experience for the patient. Hamilton described "a drunken physician attempted to amputate the fingers of a man" injured by an exploding gun. "After hacking and mangling him most unmercifully for more than thirty minutes & putting him to the most excruciating torture," he reported that another doctor stepped in and humanely completed the operation.

Describing these problems in further detail, Dr. John P. Batchelder, newly elected vice-president of the recently formed Western District of the New Hampshire Medical Society, delivered a notable oration in Charlestown on May 27, 1818. Titled "On the Causes which Degrade the Profession of Physic," he listed numerous examples bringing the medical men into disrepute in the public's eyes: irreligion (Sabbath breaking); conducting abortions (describing one physician "who has been in the constant habit" of practicing it on his wife and causing her death); quackery; disagreements among physicians; want of humanity ("neglecting the poor"); indecency of behavior; want of firmness and decision of character; and dissipation. The answer to their problems, he told them, rested with the physician returning to his home after work, "the strongest citadel against most vices," decrying the practitioner who instead "flies from the sickroom to the barroom."[93]

Concerning this last complaint, Batchelder expounded on the intemperance problem doctors faced because of their frequent use of alcohol. In fact, the literature names several of them, including Jacob Roebeck of Grand Isle, described as "somewhat addicted to strong drink" and who many thought could have been governor "if it were not for his excessive drinking," and Rutland's Yale-educated Daniel Reed. Known for overindulgence, Reed ended up dying destitute.[94] Noting that physicians "have been accused of being more addicted to this vice than gentlemen of other professions," Batchelder listed its reasons: "irregularity in eating, drinking, and sleeping, exposure to storms and inclement weather, the frequent witnessing of scenes, which make his heart to sink within him, and a dreadful anxiety, which is his constant companion," all inducing him "to resort to the bottle." However, Batchelder did not find this particularly surprising, since attending doctors were constantly asked to indulge by those they visited to minister to their illnesses. "A desire to make him comfortable produces the bottle," he wrote, "the usual token of a hearty welcome, and it is, 'Doctor, will you drink this or that.' Fatigued…he partakes. The exhilarating effect is remembered; it becomes desired; at length habitual; and lastly almost necessary."

As patients and their families and friends pushed spirits on visiting doctors, they became the unwitting recipients of their own fare turning on them with a vengeance. With their various drugs frequently administered in powdered form, doctors recommended they be mixed and dissolved in alcoholic drinks and then consumed at various times of the day. Thus, it became routine to take medicine morning, noon and night—and often in between—each occasion necessitating a glass of some kind of potent spirit in a ritual called dram drinking. (A dram is actually an apothecary measure.) In one of the rare admissions that doctors

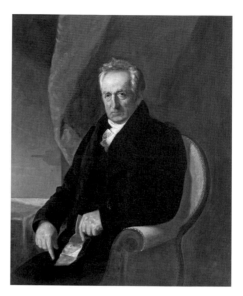

Dr. Nathan Smith, founder, Dartmouth Medical College. *Yale University/John Hay Whitney Medical Library*.

were responsible for fostering the public's habits of periodic drinking in this manner, Dartmouth's Dr. Nathan Smith made specific reference to the phenomenon in an 1811 lecture. Describing the administration of Peruvian bark (a muscle relaxant used for malaria), he told his students that he never prescribed it to be taken in spirits because "it always increases the affection," telling them it was "better to [use] simple water."[95] He then confirmed the doctors' complicity in fostering such habits by admitting that "dram drinking [is] often a consequence of taking medicine in spirits." In fact, doctors' role in increasing the consumption of alcohol was a factor leading to the creation of the Vermont Temperance Society in 1828.[96]

Many followed their doctors' orders willingly and precisely, taking their medicine as prescribed, thereby introducing an insidious habit into their daily routines. While many drank the less alcoholic beverages of hard cider, fermented beer and wine, ardent spirits began to take over in many other ways. Drinking it indoors at home and in taverns continued, but it was also commonplace to see it present at barn raisings, militia musters, weddings, funerals, in churches—both minister and parishioner partook between services—and in the courtroom, where lawyers openly passed the bottle around.[97] The local general store made it a practice to have spirits available by the bottle and from a nearby tapped barrel ("potations free to all"), while

teasing customers' thirst by offering them free salted codfish. In Rutland, country folk arriving in town with their goods to trade made certain to travel from store to store tasting their individual liquors and only then agreeing to sell to the one deemed the best.[98]

Throughout the first half of the nineteenth century, election time meant the presence of spirits in one form or another. Politicians treating their constituents to liquid fire became a time-honored tradition and one not easily denied. In 1806, the legislature took up the issue of whether to prohibit the practice on Election Day, and "after some time spent in debate" and taking a roll call vote, it turned the measure aside. However, in Cabot that same year, it had become so bad that voters chose to lock all their liquor in a closet for thirty minutes while they decided issues—to avoid imbibing freemen from "becoming totally confused about which way they were voting."[99] Both alcohol and drugs remained important articles for the public's consumption, as exemplified by the front page of the *Rutland Herald* in 1810. Two local merchants advertised the recent arrival of fresh stocks of drugs and medicines for sale and printed a long article advocating a robust production of ardent spirits as a part of the nation's military preparedness. This was necessary, the author wrote, in order to avoid repeating the "enormous expenses…and deepest sufferings" incurred by the Patriot army during the Revolutionary War because of "the frequent destitution of wine, good distilled spirits, and porter."[100]

Stimulants in the form of alcohol and opium had certainly found an inviting home in Vermont in these years, and they came to play an important role in the following decades. The emphasis on distilling ardent spirits only accelerated and intruded onto the familiar ground that less harmful fermented concoctions occupied. Cost was hardly an obstacle, as a man could easily purchase a gallon of whiskey or even an ounce of opium for a mere fifty cents. More people began to experience delirium tremens and received opium treatments to quell their hallucinations. Widespread bouts of disease struck in vicious manner, leading a stumbling medical profession—many of whom suffered from their own alcohol addictions—to resort to the drug's strong effects to quiet their fevers. Certainly a two-edged sword, opium was a tiger demanding great respect that eventually turned on the medical men themselves. Upward of 16 percent of medical practitioners nationally—a disproportionate number working arduously in the countryside—became addicted to it by century's end.[101] Until that time, opium was as acceptable as alcohol, recognized for its ability to make its user more "sociable," and people saw little reason to limit its use for just medical reasons.

3

THE PITFALLS OF IGNORANCE

The challenges that Vermonters faced in the early nineteenth century in the delivery of medical services and the manner in which alcohol and opium addiction developed certainly exceeded those experienced in any other New England state simply because it was so widely unsettled. Until an effective school system could be introduced, ignorance and the inhabitants' need to rely on neighbors close by for support inhibited their acceptance of outside information intended to better their lives. Their attitudes toward the consumption of those readily available stimulants and the difficulties that a nascent medical profession faced in convincing them of its ability to guard their health joined together to create a permissive atmosphere that allowed addiction to take hold and grow.

In 1810, there were 218,000 inhabitants living in 243 towns, many of them remote and primitive in physical, intellectual and moral capacities. Of that number of towns, 97, or 40 percent, with an estimated 50,000 people residing therein, were deemed "destitute" of access to a competent minister.[102] Various reasons for that lack of spiritual guidance existed, principally significant opposition by church elders unwilling to permit the imposition of religion foisted on them from outside. Seeking to remedy the problem, the Vermont Bible Society was created in 1813 in order to widely distribute Bibles to the many far-off families without one. Following up in 1818, the Vermont Juvenile Missionary Society was formed "to supply the destitute towns in this state…with a preached gospel, by the labors of missionaries."[103]

The work before them was formidable, as the Bible Society received numerous requests from towns, particularly in the northeastern part of the state, pleading that it send someone to minister to them. One early missionary venturing out into the wilderness reported back:

> *In a number of towns…infidelity has assumed its boldest appearance. The Holy Scriptures are rejected as the work of human invention, and the Sabbath treated with avowed and public contempt. There are instances of parents* commanding *their children to labor upon the Sabbath, declaring that if they were employed upon no other day, they should be on this.*
>
> *Profanation of the name of God is another* prevailing *vice. Children are taught, from their cradles, to speak with contempt of the Saviour. In one instance I recollect a child was* requested *by its parent to speak profanely. The child hesitated for a while, and then burst into tears, and exclaimed, "Papa, I dare not say that wicked word."*
>
> *The* ignorance, *which exists upon the subjects of the soul, is to be deeply lamented. Many families have lived ten or fifteen years without the scriptures in their houses; others are unable to read, if a bible were presented. An aged lady informed me, that she lived fourteen years without hearing a sermon or a prayer.*[104]

Another observer sought to explain what was occurring in these remote areas, noting that "the vices of Sabbath-breaking, of profane swearing and intemperance extensively exist."[105] These disturbances occurred, he wrote, because newly arrived settlers had "been required to fell the forests around them; to change the wilderness into cultivated fields; to provide comfortable habitations and subsistence for their families; to construct roads and bridges; and to give to their children the rudiments of an education."

Education, or the lack of it, was indeed a factor in much of the discord. Evidence of similar conduct in more populated communities was identified by Middlebury College's Reverend Henry Davis in his 1815 sermon to the legislature. Lamenting the ongoing problem with profane swearing, he called it "sinful in the extreme…and dangerous to the dearest interests of the community."[106] For those refusing to observe the Sabbath, he condemned their places of refuge on that sacred day: "The tavern, formerly the quiet and peaceful retreat of the traveler, has become a scene of noise, of riot, and of wrangling." He further admonished his audience:

Listen to the curses and the impious oaths of children, as your walk the streets. See neighbors quarrelling, and harassing each other with law suits; their fences broken down; their fields overrun with weeds and briars; their habitations decaying; their foundations tumbling from beneath them; their windows filled with tattered garments; and everything around them, like the language and person of their wretched occupants, exhibiting the marks of idleness, of indigence, and of degeneracy.

It was of no use expecting Vermont's uneducated parents to enlighten their children and teach them to conduct themselves appropriately, he said. The reason was simple:

Parents who are ignorant, it must be remembered, are too apt to be satisfied that their children should remain so. Not knowing by experience the blessings of education, they are, in general, willing that they should grow up in the same want of information, in which they have grown up, and inherit the same vices and wretchedness, which they themselves have been heirs to.

Should the lawmakers in his audience fail to step in and pass measures to correct these deficiencies, he predicted yet more "indolence and vice, and poverty, and crime of the most destructive tendency."

At the same time, Davis recognized the delicate path the lawmakers were treading with their wavering constituencies, pragmatically observing that since "the physical strength resides with the people," they could expect them to throw off their laws if they were "incompatible with their interests." Notwithstanding, benevolent organizations, such as the Middlebury Female Bible Society, persisted in their optimism. In 1820, a speaker painted the society a picture of hope:

View the comfortless hut of poverty. The chill blasts of winter pierce through its casements. Its inhabitants are reduced to a state of the most extreme wretchedness. He, on whom they depend for support, wastes the reward of his labours for the intoxicating draught. His partner, wane and emaciated, overcome with the burden of her afflictions, in the bitterness of anguish, resigns herself to gloomy despondency. The Bible enters. The drunkard dashes the cup of intemperance from his lips, and the seat of discord and sorrow becomes the abode of harmony and peace.[107]

In various accounts, writers describe a hardworking, economically depressed, dispersed population in dire need of education to correct their swearing, Sabbath-breaking, intemperate ways. Whether this waywardness could be corrected by missionaries providing Bibles or a legislature establishing an effective educational system remained to be seen. However, in the meantime, Vermonters continued to maintain a tightfisted grip on all things relating to their physical and moral well-being, and it had a strong effect on the development of the medical profession itself. This intransigence then contributed to their ensuing addiction to strong narcotic drugs.

<div align="center">⤳⤲</div>

The difficult winters that these Vermonters experienced led many to imbibe strong alcoholic drinks in the privacy of their cold and drafty homes. Farmers had ready access to significant amounts of pressed cider, frequently filling up their cellars with twenty or more barrels to see them through the dark months. For those seeking stronger drink, they brought their cider to the local distiller, who then turned it into apple brandy, or apple-jack, while others took their perry (pear juice), wheat, corn, barley and oats to be similarly converted into potent concoctions. For the destitute among them, it was a convenient way to quiet noisy children, feeding it to them (causing them "to sleep like kittens by the fire")—the cheapest diet they could afford.[108] For those of means, the local general store also made available a higher class of alcohol that included New England, Jamaica, St. Croix and cherry rum by the gallon or barrel; French and Spanish brandy; and port, Lisbon, sherry and Malaga wine.

During those dreary months, their homes were sealed up tight to ward off the cold. A visiting physician traveling through Burlington in 1842 described the situation, observing residents' peculiar habit of "shutting up in the winter," made all the worse by "almost a total want of exercise, to complete the picture."[109] It was such an extreme practice, he concluded—after having visited over 150 European and American cities—he had "never [seen] so much consumption [tuberculosis] anywhere as in Burlington, in proportion to its population, in the same classes of people," noting further that "the disease was principally with the best classes." Another doctor from New Hampshire confirmed his observations and described the effects Vermonters experienced on their transitioning from using large, open fireplaces to small, or close, stoves.

One stove often answers for the whole family, during the cold season. The warming, cooking, and washing are all done in one room. The exhalations from the cooking-vessels, and from the lungs and person of the whole family, are all mixed together, and breathed over and over, to sustain the movements of life. Is it to be wondered at that consumption is…far more common among the Green Mountains of Vermont than it was…before the close stove.[110]

Harriet Beecher Stowe also recalled her upbringing in the northern climes, where families would "confine themselves to one room, of which every window-crack has been carefully caulked," suffering through temperatures of "between 80 and 90, and the inmates sitting there with all their winter clothes on, become enervated by the heat and by the poisoned air."[111] It was not unusual, she wrote, that the cold they then "caught about the first week in December has by the first of March become a fixed consumption," leading her to explain that it was "no wonder we hear of spring fever and spring biliousness, and have thousands of nostrums for clearing the blood in the spring." Between Vermonters' self-enforced inactivity for several months, living in unhealthy, confined spaces and developing serious illnesses, and with many consuming large amounts of alcohol, it is hardly surprising to see that they then turned to yet additional substances in order to alleviate their symptoms.

The "thousands of nostrums" Stowe described further reveal the tenacious hold that Vermonters maintained in administering to their personal health without the interference of doctors. Self-diagnosis and medicating were commonly practiced, and they remained very much a part of society for many decades, causing considerable consternation within the medical community. The public did have access to a number of well-intentioned treatises concerning health matters. In 1830, a Bellows Falls paper described the recent arrival of one of the more comprehensive authorities of the times, *The Book of Health: A Compendium of Domestic Medicine*, a London publication "with directions how to act when medical aid is not at hand." Various revisions were made by Boston physicians to adapt it to North American needs, thereby allowing anyone, whether in an urban or rural setting, to ponder its 179 pages, and which contained more than fifty references to opium.[112]

Also stepping in to aid the medicine-imbibing community were the unregulated pharmacists themselves, frequently doing so in an open and aggressive manner far outstripping the efforts of physicians. In 1839,

Portsmouth, New Hampshire druggist and apothecary William R. Preston authored *Medicine Chests for Ships and Families*, which provides additional insights into the nature and quality of medical advice available to the public.[113] According to Preston, the well-equipped home should possess no less than forty-five different drug preparations, including the ever-present opium-based Dover's Powders ("particularly recommended in rheumatism, dropsy, and other complaints where a free and copious perspiration is required") and laudanum ("be very careful in its use, as too large a dose might be attended with fatal consequences").

In their self-diagnosing and medicating, or "dosing," even in the absence of ailments, Vermonters began to witness the beginning signs of addiction. As one Bennington paper reported in 1827:

> *One way in which the people become sick, is by doctoring themselves when well. Medicines were never designed for persons in health; and to them nothing on earth is more useless than a physician, or more detrimental than an apothecary's shop. And yet some will be continually dosing themselves with drugs and specifics, for fancied ailments, which a little more exercise and attention to diet would soon make them forget.*[114]

At the same time, in order to combat the dire effects ardent spirits had on them, residents in central Vermont took it on themselves to consume a concoction called Dr. Chambers' Medicine for Intemperance. While some attested to its effectiveness, several individuals actually died outright, suffering violent spasms similar to the DTs. In the loose way that medical advice was provided at the time, a local paper simply suggested an alternative to the public, advising that "opium would be one of the most important" countermeasures a person could use to offset alcohol's effects.[115] Dartmouth professor Dr. Reuben Mussey also recalled these days of so-called "pill-drugging" and described a young Vermont man consulting him for an ailment: "He said that he had taken *six hundred of Brandeth's pills* [a purgative] *within a few weeks*. I asked him if he thought he had derived benefit from them. He replied that he thought not, on the whole, but suspected he had been injured, as he had lost much strength." When asked why he continued to take them, the man answered, "Because my way is to give everything a fair trial."[116]

Resorting to nostrums and alternative substances continued unabated and remained such a pervasive part of society that it became a subject of another medical student's dissertation decades later. As Albion Cobb

wisely noted with caution in 1878 in his "The Right Use of Medicines," they should be avoided at all costs for the simple reason that "ready-made medicines, like ready-made clothes, are almost certain to fit no one exactly, and to fit the majority very badly indeed."[117]

This persistent inclination to resort to drugs of questionable effect by an uneducated public refusing to acknowledge the harm they inflicted in turn caused a profound effect on how the medical profession viewed itself. Faced with a public professing a higher ability to diagnose and prescribe remedies for themselves than anyone with formal training could provide, doctors found themselves forced into the background. When a visiting New York physician attempted to administer a conservative course of treatment to a diseased individual between 1810 and 1816, he met with strong opposition from local residents convinced of the effectiveness of stimulants. As the doctor explained, "On inquiry what was to be done, the reply was, give opium, brandy, ardent spirits, wine, sweating....These opinions generally prevailed among the people and the [local] physicians. It was considered malpractice to neglect these remedies, or to use bleeding or other [methods]."[118] Even in those instances in which doctors believed bleeding an appropriate alternative, but the family disagreed, they simply walked away without argument, one noting, "I was not required to, nor permitted."[119]

The power of uninformed public opinion, not science, dictated the course of Vermont's early medicine. As Dartmouth's Dr. Albert Smith described midcentury in his "Defects in the Modern Practice of Medicine," this willful ignorance forced doctors to do things they might not otherwise agree with:

It is not to be supposed that it is always right, that all its demands and requirements must be implicitly obeyed—that the Vox Populi *is the* Vox Dei. *We know that it is often terribly perverted, so as to serve almost an infernal influence. It takes its cue sometimes from misguided or unprincipled physicians; at others, from shrewd and ingenious quacks—but when once adopted, it is overbearing and despotic, and woe betide the poor disciple of Aesculapius that would alone dare to withstand its stern mandate. Can it be a matter of wonder that our profession should be influenced by the force of numbers and the power of the multitude...into the visionary and unsound notions of the people? Now the best of physicians are greatly influenced by the power of public opinion in various degrees, both as to the manner of prescription and the kind and variety of medicine used. This is a force always over us and which we are constantly resisting as the offspring of ignorance and presumption.*[120]

Subservience by trained doctors to an ignorant public and an unconcerned legislature created an environment that allowed stimulants to take an even firmer hold than ever before.

The difficulties that Vermont doctors faced in gaining the public's trust are largely attributed to themselves, as they evolved from a roughshod, uneducated state to a profession capable of garnering a modest degree of respect by the beginning of the following century. Two schools of thought concerning the treatment of patients were at the base of their disagreements, each in direct conflict with the other and causing long-lasting resentment between them. One was composed of those who received a formal education, called "rationalists," and who sought official recognition and approval through the imposition of official licensing requirements assuring their competency.

Conversely, a second set of practitioners arose in opposition, resentful of the monopolistic, presumptuous and self-centered ways that the educated seemed to lord over them and the public. Headed most notably by Samuel Thomson, originally from Alstead, New Hampshire, the movement adopted a pragmatic, empirical approach viewing patients simplistically, looking only at the outward aspects of their ailments without considering underlying causes. These constituted methods that an uneducated public could readily see for themselves and understand, thereby empowering them in their own choices of how to proceed with their own healthcare decisions. Whereas the rationalists recognized the value of substances such as opium in their practices, the empiricists (also called "botanical doctors") rejected them as too harsh and used instead naturally produced substances (emetics) that induced vomiting to rid the patient of illness, later employing even more benign forms of treatments using water.[121]

Opium constituted a poison to one's system the Thomsonians believed, a position the founder adopted early on at the time of his mother's death in 1790. Attended by several doctors to treat her "galloping consumption," Thomson thought the name they gave her condition appropriate, "for they are the riders and their whip is mercury, opium and vitriol, and they galloped her out of the world in about nine weeks."[122] His views became further entrenched upon observing Woodstock doctors administering mercury and opium between 1801 and 1803 during an outbreak of typhoid fever, viewing them as unnecessary, extreme measures. As his alternative botanical system

Empiricist-botanical doctor Samuel Thomson.
Special Collections, University of Vermont.

grew in popularity, inevitably, problems arose when some patients did not get well. Their families then summoned trained physicians to provide aid, and this caused great resentment among them, fearful of their own reputations being put at risk should they fail to correct a problem not of their making. As a result, derisive terms fell into common use, and the Thomsonians were classed with all the other pretenders to medical knowledge. As one trained physician explained, they were called "quacks," a term derived "from the cry of the duck or goose, and the definition of the verb is to boast, to talk ostentatiously, as pretenders to medical skill quack of their cures. Thus it comes to mean an ignorant practitioner."[123]

On the other hand, the rationalists did all they could to counter these uninformed practices. Instead, they viewed a patient's symptoms as representative of an unseen condition that required considering causes not apparent on the surface. They refused to countenance anything having to do with the untrained pretender, and as early as 1814, the VMS made it an affirmative duty of its membership to report any other member suspected of "intrigue, deception, or quackery" for expulsion proceedings.[124] Even some members of the public acknowledged the harm that the quacks caused, with one individual writing that allowing these "dabblers in medicine who hardly know the difference between opium and opodeldoc [soap], emetic tartar and white arsenic" to continue was "worse than putting edge-tools, or fire-arms into the hands of madmen."[125] In New Hampshire, one writer pleaded for help to "deliver us from the imposition of such men, as enter our houses, leading silly women captive, who are laden with credulity, and by smooth words and fair speeches, deceive the hearts of the simple. These men are great pests to society. They not only rob us of our money, but rob us of our health and perhaps of our lives!!"[126] However, the sentiment was not necessarily shared by all, and one Brattleboro publisher went out of his

way to take a proponent for change to task, arguing that no matter how strong public opinion was against these "doctor-cheats," it was for the people themselves to decide who treated them—and without official intervention. To do otherwise and allow the imposition of laws was, he wrote, "a little too much like Connecticut intolerance."[127]

Even so, allegations of outright fraud committed by trusted doctors did little to instill public confidence in the profession. In 1816, an Orwell parishioner had an opportunity to examine the books of Dr. Nathaniel Sherrill and found he had altered the accounts for many of his patients, inflating the amount of money owed to him for services. Members of the church confronted Sherrill with the evidence, and he admitted he had done so and intended to alter others. When faced with additional damaging entries, he confessed all his misdeeds, leading one parishioner to write to her son that "this strange event, like a flash of lightening, soon spread over the town."[128] It was devastating for residents to learn of the betrayal committed by one they trusted and thought above suspicion. "Some were loth [sic] to believe it," she recorded, while "others were blaspheming the holy religion on the account of its professors." Sherrill later signed a confession but then recanted, throwing the congregation into turmoil. As the writer sought to glean some lesson from the event, she wrote to her son: "My dear Child, how evident it is, that the love of money is the root of all evil. May we be kept, by the Grace of God, from coveting our neighbors' wealth, or outward estate."

Despite these various challenges, the educated doctors decided it was time to act, and on October 7, 1818, the VMS wrote to the legislature, "soliciting their aid in promoting the interests of our Society and the good of society" in passing laws "for the encouragement of Medical Science & the Suppression of [quackery]."[129] Two years later, the society continued in its efforts by appointing a committee to meet with the legislature to better their precarious financial condition, charging the members to "use their discretion…of petitioning for some donation for the benefit of this Society." Their many calls for some kind of intervention finally found a sympathetic ear, and on November 14, 1820, the lawmakers did what they refused to do in 1803, making it illegal for anyone to seek fees for medical services unless they were a member of a state medical society and had obtained an appropriate degree. They also removed the responsibility for licensing doctors from the local societies and placed it into the hands of the Supreme Court.[130] Despite those good intentions, in 1825, the VMS was forced to admit that the problem of untrained physicians remained, as the "scanty

requirements" placed on applicants "tend[ed] to depreciate the reputation of the profession and to injure the community."[131]

For those seeking to become legitimate doctors, the earliest method required their associating with an established practitioner, called a "preceptor," for a three-year period before obtaining a certificate of competency and then applying to a local society for a license. As area medical societies and colleges developed (Dartmouth founded in 1798, Castleton in 1818, University of Vermont in 1822 and Woodstock in 1835), additional requirements provided that the individual be at least twenty-one years of age, attend a chartered medical college, present a dissertation and pass an examination. The applicant then presented himself to the local society and, if determined competent by its censors, was allowed a license to practice.

The early subjects they studied evolved—gradually becoming more sophisticated—and included anatomy, chemistry, physiology, *materia medica*, theory and practice, obstetrics, surgery, botany, clinical practice, medical jurisprudence, physics ("natural philosophy"), mineralogy, pharmacy, zoology, magnetism and electricity. The course in *materia medica* required the close study of plants and their various parts and learning how to extract medicaments from them. Because of the absence of pharmacies in the countryside, students were also expected to know how to prepare and compound their medicines, usually in powder form, which they then carefully wrapped in folded colored pieces of paper. Their ability to flawlessly perform each of these acts in the presence of the patients when called on was also of particular importance, as it demonstrated their overall competency as a doctor.[132] Accordingly, physicians then became their own traveling drugstores, routinely carrying supplies in saddlebags and chests until as late as the 1870s, as Oliver Wendell Holmes recalled:

> *His stock in trade,*
> *A mighty arsenal to subdue disease,*
> *Of various names, whereof I mention these:*
> *Lancets and bougies, great and little squirt,*
> *Rhubarb and Senna, Snakeroot, Thoroughwort,*
> *Ant. Tart., Vin. Colch., Pil Cochiæ and black drop,*
> *Tinctures of Opium, Gentian, Henbane, Hop.*[133]

Notwithstanding such a list, when called on, only a few were actually used, and "Calomel, Opium, Tartar Emetic, and the Lancet formed the four corner-pillars" of medical practice.[134]

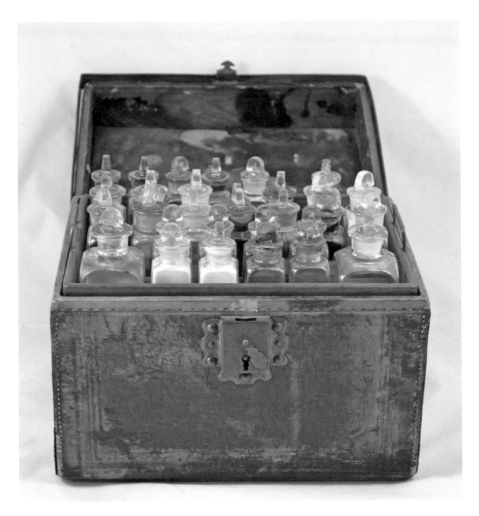

Medicine chest owned by Dr. Edward Williams, circa 1844. *Woodstock History Center, Woodstock, Vermont.*

Doctors unable to adequately convey to a patient they knew what they were doing resorted to outlandish behavior to overcome their prospective charges' hesitancy and gain trust. This was the age of so-called heroic medicine, when aggressive and often harmful treatments (bleeding, purging and blistering), including the heavy use of opium, were frequently employed. As Dr. Albert Smith recounted of those times:

> *I well remember the rough demeanor, the harsh and overbearing manners, the hard coarse and often unfeeling expressions of these men. And to the*

sick they were hardly less gentle—the patient experienced rough handling, ferocious probing and all the hardest usage of a blind practice or of an unfeeling surgery. It was the etiquette of the day for these men to be harsh… [or] *they would have inspired no confidence by any other course.*[135]

Seeking approval from their patients, Smith related that doctors put on airs and talked "in a way peculiar," utilizing "high sounding phrases and medico-[Latinized] technical terms that were <u>Greek</u> to the hearers and probably nearly as unintelligible to the speaker." Similar conduct was repeated outside the sickroom. A Rutland judge was overheard using base, unlearned language in a political harangue to members of the public at a local inn around 1808. When later confronted over the way he conducted himself, the judge apologized to the listener, protesting that "you must not so much blame me, as the damned country in which I live. I have a wife and children dependent on my salary, and this is the way I must earn it."[136]

But it was the physicians' excessive use of harmful drugs in the accompaniment of their ridiculous behavior that was most concerning. As Smith described the situation:

I am aware that many physicians get to be very reckless in the administration of medicine. They prefer this reputation of bold heroic kill or cure doctor to the tame character of being safe, careful doctors.…. They know that everyone to whom they have administered to in doses recognized by no dispensatory, have lived through their heroic practice, and in many instances have come out of it all the better, and they do not know that theirs have killed anyone.[137]

Additionally, their ensuing negligence in using opium and morphine resulting in death was not at all uncommon. As he revealed further:

You have all heard the old stale joke that no one was qualified for a Physician till he had contributed to the peopling of the churchyard; and, no doubt, have seen many intelligent persons who think that instead of always curing, or administering medicine so as to accomplish this object, we do now and then <u>kill</u>. It is sad to think that it might ever be so—yet with such agents as opium, morphia…is it improbable? It is not improbable that these messengers of health should…sometimes inadvertently or maybe inconsiderably or still worse recklessly…increase their dose as to overpower the remnants of life and to end the life and disease together.

Rough handling, eccentric behavior, verbose public performances and irresponsible administration of life-threatening substances by these frontier professionals seeking legitimacy in the eyes of their respective constituencies had now become the accepted norm.

Yet an additional complication attending the life of a traveling Vermont doctor concerned his ongoing difficulty in obtaining payment for his services. It remained a lingering cause of resentment among members of the profession for many decades that they gave so much of themselves in the name of medicine and received so little in return. Rising in the middle of the night to aid a sick patient and traveling long distances by horseback or carriage over rough roads in difficult terrain—in good and bad weather made worse by deep winter snows—constituted the daily demands placed on them. When unexpectedly accosted in their travels by those seeking relief, the drugs they dispensed frequently constituted an out-of-pocket expense. Smith opined:

> *Your various prescriptions on the street, on the road, at the places of your patients, the friends of your patients and neighbors; and, indeed, the constant demand made on you wherever you are, for which you are entitled to fees but get none, for everybody else prescribe in the same manner, without any responsibility however.*

Despite their hardships, physician bills for home visits throughout the nineteenth century remained modest, ranging from twenty-five cents in 1800 to eighty-eight cents in 1900.[138] However, it was the markup on their medicines that allowed them to make their profits. As one Connecticut man described it in 1830, "The Doctor not infrequently furnish[es] his own medicines and charge[s] four hundred percent profit and what is still worse keep[s] the Patient and his friends in ignorance of what he is taking by writing his receipts in language which the community does not generally understand."[139]

While some doctors might be fortunate enough to receive actual money for their services from well-off patients living in villages and towns, for their rural constituency, it was an entirely different matter. As physicians' journals of these times reveal, they received innumerable payments in the form of crops, wood, livestock, handiwork or items resulting from their patients' labors on the land. But of them all, few could match the payment that Smith himself received from a Castleton family while providing services to the community on the behalf of an absent doctor.

As Smith described it, the doctor he assisted had tended to one individual in particular "for more than 20 years, and this woman all that time had been an invalid, and he had never received as much as a single quarter for his services."[140] When Smith stepped in expecting payment for a visit, he fared little better: "Except at one time, I received 2 or 3 dozen of phials all smeared with patent nostrums as the vile contents left them." Old, filthy, discarded medicine bottles had become unique items of barter for the destitute to pay for their medical services. As Smith related, "This is a fair specimen of many families that fall to the share of every physician," while also lamenting that "his are the worst accounts in the world."

At the same time, Smith wondered why people spent their scarce money on patent medicines when they could, instead, use it to pay for the services of doctors? Was there a reason that might explain the presence of so many thousands of patent medicine bottles in the homes of both destitute and well-off Vermonters? Was the fact that addictive opium and morphine were becoming more prevalent a factor explaining this phenomenon?

4

INTERNECINE SQUABBLES

L arge numbers of second- and third-generation medical students from throughout New England traveled to Vermont in the first half of the nineteenth century to pursue their educations. By the time the Vermont Academy of Medicine in Castleton ceased operation in 1862, some three thousand students had received instruction and over 1,400 medical degrees were awarded—more than any other medical school in the Northeast during this period, notably exceeding the 300 degrees allowed to Harvard students.[141]

When not otherwise attending to their schooling, the wild ways of the visiting young men living in Castleton's local homes and boardinghouses had an effect on the locals. Perhaps the most notorious event occurred in 1830 when several of them participated in the infamous "Hubbardton Raid," during which Mrs. Penfield Churchill's remains were disinterred from a nearby cemetery and brought back to the school. A great howl of disapproval ensued as the body, minus its head, was recovered by an angry mob. Two students, called "resurrectionists," seeking a subject for dissection, were charged for their participation. The local paper noted that such behavior was "by no means rare," and it continued for the next several decades.[142] In fact, as late as 1896, Dartmouth's Dr. Carleton Pennington Frost—one of those first warning of the state's rising addiction to opium two decades earlier—agreed to become a bondsman for two of his Vermont students (one also employed by a local drugstore) charged with robbing a suicide's grave in Norwich.[143]

Grave robbing, Dartmouth Medical College, 1870s. *Dartmouth College Library.*

Some of the lawlessness within the student ranks can be attributable to the loose manner in which they were allowed admission in the first place. Because many were so desperate for the opportunities a medical degree offered, it was not unusual for some to conceal their actual ages or the true extent of their qualifications. For those fortunate enough to gain admission, they then went about attending classes but only after purchasing tickets from lecturing professors, which they displayed whenever entering a classroom. Several of the courses allowed for actual hands-on experience, and it was during the *materia medica* portion of their curriculum that many of these young men first became exposed to the strong drugs they expected to use in their

Dr. Theodore Woodward's lecture admission card and Dr. Jonathan Allen's certification of attendance, 1824. *Castleton University.*

practice. Unfortunately, it also allowed them unsupervised opportunities for experimenting—certainly a factor portending the development of their own addictions later in life.

The journal of Castleton student Asa Fitch, who attended the school between 1827 and 1829, provides an important perspective into the promiscuous use of stimulants by students at the time.[144] Only nineteen years old when admitted, Fitch first experienced the effects of "nitrous oxyd" when he and a friend, with whom he experimented in mutually inflicted bleedings, took a supply of it out into a field and breathed it in, leaving them "laughing most heartily." From there, he went on to inhaling ether, finding its effects "if not identical, the next best thing to the gas," allowing him to report that "I flew about as though on eagle's wings vanquishing whoever happened in my way."

Only a few days later, Fitch took a more serious turn and decided to try opium to see if a professor's statement that seventy-five grains of it (a common aspirin tablet is five grains) could be ingested without detriment in twenty-four hours. Then, over the course of nine hours, he took a dose of the drug every twenty minutes, ultimately consuming between thirty-five and forty grains. As he later reported, it caused a severe effect: "turns of nausea, retching, and eructation [belching] of air were common through the night," making him "glad to see the morning." However, it was apparently not bad enough of an experience for, after sustaining a serious leg injury incurred while stumbling about under the effects of another ether experiment, he was back at it again, "stimulating with opium."

Fitch's roommate witnessed his actions, and presumably those of other students, and decided to partake in an effort to learn firsthand the symptoms opium caused in order to write his required thesis describing its effects on one's health. As Fitch described the scene, his friend took the drug "in large doses, and the room is in a pretty pickle. He has vomited upon the floor and lies here, half dead, taking one grain every half hour, and I am sitting up to take down the symptoms." Interestingly—and whether it was because of the two young men's actions is not recorded—that year the professor instructing the students in *materia medica* and pharmacy was dismissed for incompetence.[145] The use of one's own body for the purpose of experimentation was not, however, limited only to students. In 1840, the esteemed president of the Medical School of Woodstock, Dr. David Palmer, met his demise by inhaling sulphuric acid while conducting a demonstration before an audience, passing on after an agonizing period.[146]

Over at the Dartmouth medical school, student members of the so-called Temperance Society of the N.H. Medical Institution began to express a growing apprehension over their own and the public's use of alcohol, tobacco and opium. Beginning in 1833, they merely counseled that people not consume those substances when in good health, only to demonstrate an increased concern two years later when they signed pledges promising that they themselves would not do so unless under the direction of a doctor. In a particularly revealing moment, their pledge disclosed that it was they who were partly responsible for the distribution of these substances to others, and they swore to put a stop to it:

> *We, the undersigned, pledge ourselves to abstain from the use of all intoxicating drinks, together with tobacco and opium, except when prescribed as medicines by a physician, and we further promise not to offer them to others unless in similar cases, and to use our endeavors to influence those around us to act likewise.*[147]

Similar pledges also found acceptance among members of the general student body. In 1830, just across the Massachusetts border at Amherst College, scholars formed a new association called the Antivenenean Society, or "the society against poisons."[148] As the Dartmouth students had, they too promised themselves it was best to "dispense with Ardent Spirit, Wine, Opium and Tobacco as articles of luxury or diet," but only "while connected with this Institution."

As students recognized the harm that stimulants caused, several disruptions took place in Vermont society in the 1830s, particularly the anti-Masonry and religious movements, made worse because of the 1837 market dislocations and Canadian rebellion. Within the medical profession they hoped to enter, despite the best efforts of the learned physicians to convince the public of their own particular worth, the empiricist quacks had gained such success that in 1833, an organized movement sought to revoke the 1820 law requiring that physicians be licensed. This law had kept them from obtaining recourse in the courts from nonpaying customers for their unique forms of treatment.

Equating the law with "a Cancer in the natural body," one vehement petition to the legislature in opposition signed by many clamored that unless revoked, it would allow for dire consequences and "extend itself to the very vitals of this Commonwealth and overset the fairest frame of Republican Government that human wisdom ever invented."[149] The law operated

"as a monopoly," they charged, acting in favor of those fortunate enough to obtain a medical diploma and allowing "a privileged few…to convert to their own private profit and emolument the maladies incident to our natures." To a large number like-minded individuals in Bennington, the law was "repugnant to the spirit of the constitution of our country."[150]

At issue for each group was the perceived interference the law posed with the public's right to choose their own doctors and methods of treatment unhindered by governmental oversight. "The free and independent right to select our family physician is one of the dearest privileges man can enjoy," they claimed. Deeply resentful at the law's restrictions, empiricists argued that:

> We have in the choice of our physician endeavored not to interfere with the known rights of any man or set of men. Yet our rights on the other hand…have been grossly invaded by the passage of a law which gives to the regular doctor (so called) the supreme advantage over all other orders of men in administering medicine to the sick thereby placing at his control our lives and our property without any consent.…Is such law worthy of this boasted land of liberty? Are not the constituents as competent to select their physicians as their legislators? It is one of the privileges of an independent people to pay their money to whom they please and for what they please without the direct or indirect inference of anyone.

While the quacks' legal efforts were unsuccessful, the fierce independence that Vermonters displayed in these years over the control of their healthcare continued, as they refused to stop patronizing them and using their questionable alternative methods in addition to persisting with their own harmful self-diagnosing—and medicating. Sensing its irrelevance on so many fronts, the VMS conducted no meetings between 1830 and 1841.

The problems presented by the two extremes of the educated versus the empiricists continued, and at the opening lecture of Castleton's 1836 commencement, one of its founders, Dr. Theodore Woodward, spoke for many of the rationalists. Decrying the uninformed state of the citizenry ("almost destitute of the first rudiments of the science of medicine"), Woodward belittled the presence of the quacks among them ("in almost every part of our enlightened land") exploiting their patients' ignorance and calling them "beings in the shape of human creatures" and "prowling ostentatious braggadocios."[151]

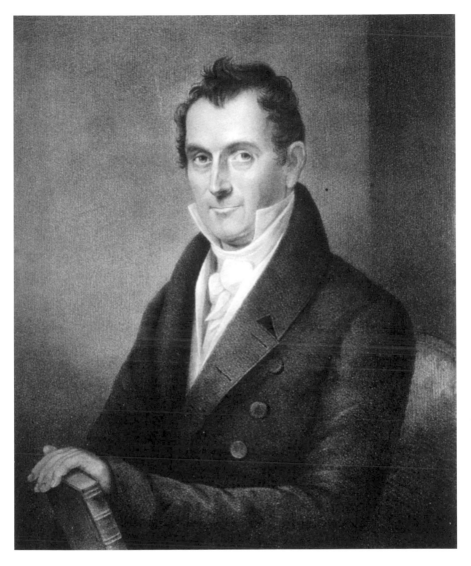

Dr. Theodore Woodward, Castleton Medical Academy. *U.S. National Library of Medicine.*

Only a few weeks earlier, several members of the educated class conducted a controversial autopsy on the body of twenty-two-year-old Philenda Benton, who died while under the care of a botanical doctor in Barre. Other deaths had also been attributed to such alternative forms of treatment, and they believed it their duty to make an inquiry into the circumstances of her passing. The public had also become intensely interested in witnessing autopsies firsthand, which doctors in Woodstock took advantage of in 1834

when they opened up the cadaver of an inebriant during a heavily attended event to point out the extent of his diseased organs as a lesson about the pitfalls of drinking. Autopsies often took bizarre turns, particularly one that took place in 1843. On that occasion, doctors attending the victim of a suspected arsenic poisoning case removed his stomach and intestines and threw them onto "a shovel of ignited coals" to see if they could detect the release of the telltale smell of garlic—their suspicions were confirmed.[152]

In young Philenda's case, the results revealed she had received lobelia (a powerful herbal remedy used for respiratory problems). However, her demise was attributed to suffocation; her windpipe was "filled with 'Composition' (a powder of cayenne pepper, valerian and bayberry bark)."[153] Their findings did not go unchallenged, as the deceased's family and friends vigorously came to the defense of her empiricist botanical doctor, arguing that if she and they were willing to take the drugs he recommended, why did the trained medical men not respect those choices? Indignant at being challenged, the established physicians identified what they believed caused the disputes between the two schools of thought: money. The lead physician conducting the autopsy admitted afterward in a conversation with a botanical doctor in attendance, "Whenever I oppose you and your practice, it is only from selfish motives, as your practice interferes with my emoluments of office."[154]

Fear of having their livelihoods challenged by those practicing alternative forms of medicine was certainly of concern. Only a year earlier, the Vermont Botanic Infirmary (later adding "and Insane Hospital" to its name) opened in Montpelier to great fanfare. Offering the "Thomsonian system of Medical Practice," Dr. J. Wright, "Botanical Physician," promised the public what constituted a direct attack on Castleton's Theodore Woodward and his educated brethren. He ridiculed their methods of treatment, including their use of the dreaded opium. People suffering virtually any malady, Wright said, could have their health restored at his facility because they received "vegetable medicines" and would not "have their constitutions *ruined*, and the remainder of their lives made *miserable* by the use of vegetable and mineral *Poisons*."[155]

The Botanic Infirmary opened up in Burlington under the auspices of a Dr. Whicher, who announced the many cures he made using the Thomsonian system, including a woman "taking Opium 6 years…cured in twenty days."[156] Reinforcing their opposition to the use of poisons utilized by the rationalists, the botanical doctors in Bennington County gathered in Peru in January 1838 to form the Thomsonian Medical Society of the Southern District of Vermont. Their belief in the use of unthreatening

vegetable preparations in their work was made quite clear when, in Article 7, they made it an offense punishable by expulsion and having the offender's name published in newspapers should a member ever provide—among other substances—opium to a patient.[157]

The meeting constituted an important organizing effort aimed at gaining credibility in the public eye. In fact, it was so successful that in East Bennington alone, four out of the five educated physicians practicing in the community simply left. In their place, the people stepped in and sought to administer to their ill neighbors, heartened by the instruction of local botanical doctor Silas Wilcox telling them to "Be your own physician! No one can supply your place. It will not only save your lives, but your money."[158] For those interested in further instruction, infirmary operators Wright and Whicher made certain to describe in their advertising their training at various Thomsonian infirmaries in New England, while Wright offered opportunities to train local men at his business. Meanwhile, a Peacham pastor proudly told his congregation that twelve of the community's young men, indicating their empiricist training, "have been educated as Physicians, without having pursued a college course."[159]

The public at large may have been as unlearned in medicine as Woodward described, but that did not stop them from continuing in their efforts to rescind the unpopular 1820 law protecting the educated physicians' "monopoly." They also sought the right to continue to administer to themselves whatever medicines they wished. Over the course of the next few years, the legislature received a flood of petitions signed by hundreds of Vermonters seeking to address a multitude of concerns: enhancing temperance efforts, changing licensing laws (arguing that retailers selling alcohol also constituted a monopoly), addressing pauperism caused by intemperate behavior, halting the public posting of drunkards' names, ending slavery in the District of Columbia, prohibiting the admission of Texas into the Union and abolishing war and capital punishment.

While the legislators ended up refusing to act on alcohol-related complaints because they believed there was insufficient proof a majority of the population wanted reform, they did note in 1837 a rising problem with addiction. The lawmakers were concerned particularly with the young, who, they described, were "bent on pleasure, and reckless of consequences" and willing to "indulge themselves in drinking, until they have fastened upon themselves the bonds of an inexorable and a fatal habit."[160] Similarly, missionaries spending time in the Vermont countryside noted the behavior and decried the ineffectiveness the temperance movement seemed to be

having, predicting "that a number of the present generation will either themselves fill a drunkard's grave, or rush into the grave with their hands stained with the drunkard's blood."[161]

An additional factor concerning the consumption of stimulants involved differences encountered because of gender. As one 1837 Rutland temperance petition explained the situation, women were in a class of their own when it came to alcohol. "The females of this country," it stated, "are, comparatively, free from intemperance, and it is owing to the obvious fact that the tyranny of custom has not compelled them to drink. To all practical purposes liquor has been prohibited to them."[162] However, that did not mean women were not otherwise seeking out stimulants for, as students at the University of Vermont heard from one lecturer in 1841, the prevailing fashion of the day saw men consuming wine while ladies used opium.[163]

As the botanical rage ran its course, women assumed vigorous roles within their families, forcing their drugging and dosing with unneeded and harmful substances. As Dr. Albert Smith recalled, he frequently responded to calls to correct the ill effects of the many nostrums inflicted on family members. He described the women of those households as

> *chief priestesses in this mode of medication, the prime director and manager. All the kindness, gentleness and forbearance of the female character was swallowed up in their mania, so that not unfrequently we witnessed the grossest exhibitions of coarseness of manner, and vulgarity of speech. It was not enough to encounter one of these virago's, and I shunned them as I would a wild animal.*[164]

The effect these women had on their families was devastating:

> *The inordinate and constant dosing of this system was perhaps one of its worst features. Its medicine seemed to be taken when sick to get well, and when well, so as not to be sick. It was a constant dosing, an entire reliance upon medicine to the entire disregard of all the rules of Hygiene. They scouted all the rules of diet and pretended that with their medications they needed no restrictions, and dearly did many of them pay the penalty of their folly. It was common to witness whole families suffering under this gross delirium, the sensibilities of the whole system destroyed, their health and strength undermined almost past recovery. Many of these broken down patients' families came into our hands—they came to us literally burnt up.*

Notwithstanding, women continued to represent the strongest bond between the sexes when it came to their relationships with doctors themselves. "The attachment of a woman to her physician," one described, "is one of the strongest she knows," simply because "it is with her we have most frequent dealing in the sickroom."[165]

Lawmakers finally rescinded the physician licensing law in 1838, with one noting with disgust the ever-present discord within the medical profession and its inability to uniformly and properly diagnose and treat the sick. With regard to the use of drugs, he stated that the infighting was no surprise, since many practitioners "are at variance in regard to the origin and nature of diseases and their modes of treatment. Nor is there any certainty in their prescriptions or predictions."[166] Agreeing that the population needed release from doctors' tyranny, another legislator expressed the widespread belief that the people themselves knew what was best and repeal would result in "leaving true knowledge to flourish, as it always best did, without restraints."[167]

With the law removed, the medical landscape changed dramatically. It was four long, tortuous decades until November 1876, when the legislature finally returned to the subject. It was only then that it passed a law requiring that doctors be licensed, making their failure to do so a misdemeanor crime punishable by a fine of fifty dollars.[168] Notwithstanding the vigorous, constant attention paid to all things relating to alcohol into the next century, aside from provisions passed in 1839 making it an offense to adulterate "any drug or medicine, in such manner as to render the same injurious to health" or to "mingle any poison with any…medicine with intent to kill injure" another, no other laws were passed dealing with the harm that drugs were causing.[169]

Even following the creation of the largely advisory state board of health in 1886—to address public sanitation needs because of widespread water contamination by unregulated discharge practices—implementation of health-related laws remained lax. The underlying cause concerned the state's failure to address enforcement because it persistently lacked any kind of central authority responsible for seeing the laws were carried out. With towns spread out, the people had only their local state's attorney to look to for enforcement, but he possessed his own independent power to choose when, or not, to bring charges against offenders. As Dr. Ashbel Grinnell recalled in 1897, just on the eve of exposing the state's opium epidemic in 1900, "Such laws as did exist were either not attempted to be enforced or were only enforced when the strongest public opinion demanded that something be done."[170]

The public now experienced the unrestrained administration of all manner and form of medical treatments—ranging from the benign to the harmful. While Thomson's botanical movement began to see a decline in followers in the next decade when the fallacy of much of what he advocated became apparent, other forms of quackery blossomed. Alternative treatments appeared in form of water cures taken at spas in Brattleboro and Middletown Springs. These also drew the disapproval of the educated doctors, who considered it further exploitation of an unlearned public. "You may as well undertake to reason with your horse," one of them said of the quacks, "as to address arguments to those who are totally ignorant of science, whose empirical rules as like the baseless fabric of a vision, growing out of the eccentricities of a dreamer, and owing their encouragement to the love of novelty and the credulity of the ignorant."[171]

As Woodstock's Joseph Gallup lamented to the VMS in 1845, the discord these alternative methods caused was profound, pleading that "harmony of sentiment is…more needed in this profession than even in religion or politics."[172] Further splintering took place within both the rationalist and empirical ranks, as some educated doctors branched off into homeopathic methods of treatment and Thomsonians became hydropaths. Their infighting had huge ramifications, Gallup said, for public "opinion is fickle," susceptible to being misled and forming erroneous conclusions. While acknowledging the "mystery" surrounding the doctor's efforts (working "behind the curtains"), he astutely noted that because of their internal disagreements (a "rottenness in Denmark" he called it), the citizenry was becoming increasingly confused. In such an atmosphere, he reasonably asked, "Who shall decide when doctors disagree?" His answer? "It is notorious that the most ignorant gossip will undertake to decide for them."

The possibility that uneducated medical advice could be dispensed without official oversight scared Gallup and his fellow rationalists. Their concern for the public's easy exploitation was certainly valid, for, as he noted further, the promiscuous times also allowed for the "general use of patent medicines so liberally bestowed or supplyed [sic] by selfish and interested individuals."

5

"MEDICINOMANIA"

Vermonters' fascination with self-diagnosis and medication and unrestricted consumption of patent medicines had become an uncomfortable fact of life by midcentury. In 1851, one Brattleboro wag sought to identify what he was witnessing, calling it alternatively "Dosimania, or a madness for dosing oneself," "Fussimania—a madness for making oneself and everybody else unhappy," "Nervimania" and "Hepaticomania."[173] But in the end, he settled on "Medicinomania," an all-inclusive term he believed defined the "terrible disease" many suffered under with their obsessive use of drugs. The condition existed regardless of whatever kind of doctor might have been consulted, whether it be "Drs. Mesmeric, Homeopathic, Hydropathic, Cancer, Consumption, Botanic, Root, Eclectic, Analytic, Seventh son of a Seventh son, Magnetic, [or] Regulars." The affliction's progression was simple enough, he wrote, beginning with the sufferer simply not feeling well, then becoming sure of it, leading him to believe he was actually sick and then requiring him to go "to doctoring" himself with whatever kinds of medications he could get his hands on. Causes for the condition were several, the writer said, but predominately it involved those who habitually smoked, chewed or snuffed tobacco; drank spirits; or took opium.

The mid-nineteenth century also marked an important transition point in the way that drugs were introduced into the Vermont marketplace, which affected their overall availability. Up until this point, access to and consumption of opium and morphine was relatively unremarkable and

constituted a largely unthreatening activity conducted in private, known only to family members and doctors sharing their confidences. At a time when the national addiction rate was calculated at no more than 0.72 individuals per 1,000, the state's population of 291,948 in 1840 meant the presence of some 210 addicts.[174]

However, these numbers were set to increase at alarming rates in the next decades, coinciding closely with developments within the important pharmaceutical trade as it evolved in the way it conducted its internal operations and in its relationships with the public and medical profession. While in its "infancy" in the state's earlier years, with the arrival of the railroad in 1848, things began to change dramatically, allowing it to then enter into the time of its "youth."[175] Advancing from the simple offerings of opium in its raw state and prepared nostrums that entrepreneurs such as Aaron Hastings made to the Bennington community in 1785, apothecary druggists became increasingly sophisticated in the following decades. As with the medical men, no training was required of those pursuing this business early on, as they sought to obtain knowledge informally by working alongside others with purportedly more experience. Compounding their various concoctions based on recipes obtained from outside the state or simply handed to them by members of the local farming community, a robust business developed that came to include dyes, paints and varnishes, in addition to medicinal treatments for their ailing animals.

If a Vermonter chose to make a purchase of drugs personally rather than from a doctor, he went to his local general store's "drug department" for the transaction, where he spoke with a clerk. It was located in a wholly unique area, described by one witness as

> *a curiosity; it was the* dirtiest *part of the whole establishment; its smell overpowered that of the tobacco, codfish and bad whiskey. It was a heterogeneous array of paper bundles, densely covered with dirt, mingled with bottles of all forms and sizes, well coated with a mixture of the contents and dirt, having labels with mis-spelled English and worse Latin, and no labels at all. From these were dispensed picra, oil of spike, laudanum, paregoric, and sundry other villainous compounds.*
>
> *The tinctures were never filtered, and never of any definite strength. A coating from half an inch to an inch thick ornamented the counter on which every drug in the establishment was represented. Mortars, graduates, and other implements, if there were any, were rarely, if ever, washed, and a general air of filth and slovenliness pervaded the whole concern....*

The compounds dealt out to their patients were prepared in the most crude manner, and often so nauseous and disgusting that the remedy was indeed "worse than the disease." Crude drugs were taken in substance, or infusion, or decoction, and the stomach compelled to do the work that should have been done in the labratory [sic]. I have seen a pill mass dispensed on an old bit of a written sheet of paper, which had served a child as a writing book at school, and the patient directed to pill *it out for himself.*

The education of the clerk selling his wares from behind the counter to the public and doctors stocking up was often lacking, and they had little appreciation for the harm their products could inflict if used incorrectly. Unfortunately, in their confusion, it was not uncommon for mistakes to occur, including dispensing opium and laudanum because of their similarity in appearance to other substances. Overall, as one individual described the woeful state of knowledge within the drug trade at the time, "In country villages, East as well as West, the principal dealers in drugs and medicines were country storekeepers who knew as much about bark, rhubarb and opium as they did about algebra and conic sections."[176]

Of continuing concern was the cost of the drugs themselves, which drew an abiding public suspicion of those selling them. As one druggist bemoaned the situation:

Any dry goods or grocery clerk, or any tyro in the business may handle the most deadly *poisons. The people look with jealousy and suspicion upon the business. There is a* mystery *about it that excites their curiosity; they take it for granted that the drug business is a perfect El Dorado, and the prevalent notion that drugs and medicines are* all *profit, is so deeply rooted, that if you sell morphine at five cents advance on a bottle…your customer thinks it pays two or three hundred instead of five percent. Our business has suffered much, and quite unjustly, from this deeply settled prejudice.*[177]

In attempting to remove the suspicion of profit-seeking motivations, druggists sought to change the way they presented themselves to the public. In the years immediately following the railroad's appearance, many new drugstores began appearing, and older stores engaged in the business were forced to clean up their practices. One druggist observed:

The dingy shops of a few years ago with their ill-assorted bottles and jars, and dirty counters and floors have well nigh disappeared. In their place will

be found Stores kept scrupulously clean, often with handsome marble floors, and marble-topped counters, fitted with the requisite assortment of bottles, jars, and drawers all labeled with the modern glass labels, and presenting the handsomest appearance of any kind of stores. The improved looks of Drug stores, of the present day, is perhaps due more to the invention of glass labels, than to any other cause.[178]

In their own drive toward professionalism, drugstores became favored gathering places for both laymen and physicians. As one observer described the situation:

It is not enough that [the pharmacist] *have a showy store resplendent with gilt and plate glass, with an immense Mansard soda fountain, a cigar case, two hundred varieties of sugar coated pills, and one hundred elixirs; over whose door hangs an enormous sign on which is conspicuously painted "Pharmacist."…These centers of inebriation have no place in the well-regulated drug store of today, any more than the professional loafers who are accustomed in some places to loiter. The drug store is not the proper place for a news room; it is no place for unemployed physicians to congregate and discuss the political affairs of the day.*[179]

However, for the doctors actually working, the cost of the drugs they purchased remained an issue, and in 1871 the newly created Vermont Pharmaceutical Association bemoaned the fact that "too many of our physicians to this day" bought the cheapest drugs possible.[180] Unfortunately, fearing the loss of their business, druggists accommodated their wishes and sold them whatever "cheap, worthless or adulterated goods" they had on hand.

The sale of inferior drugs certainly included opium, and as one investigator determined in 1846, "There is no article in which frauds have been more extensively practiced than in opium [including] Turkey opium, the best kind in the market."[181] He explained that "one-fourth part generally consists of impurities" made up of "extracts of the poppy, lettuce, and liquorice, gum Arabic, gum tragacanth, aloes, the seeds of different plants, sand, ashes, small stones and pieces of lead." Three decades later, the problem still persisted, with one Dartmouth medical student noting in 1877 that due to opium's high price, it "has induced dishonest speculators to adulterate it largely using gum licorice and other substances; even adding… bits of lead to the interior of the mass to increase its weight."[182]

Charles Chapman Drugs & Medicines, advertising "Winslow's Soothing Syrup Children" (*right side window*), Woodstock, Vermont, late 1800s. *Woodstock History Center, Woodstock, Vermont.*

Even though Vermont passed a law in 1839 punishing the adulteration of any drug or medicine, it appears to have had virtually no effect. While other states had already taken similar action, they also recognized the increased dangers that poisons presented and placed restrictions on their sale. However, Vermont persisted in its inaction and failed to follow their example, eventually drawing the attention of the American Pharmaceutical

in community, whose avarice and cupidity overcomes his duty, and whose selfishness knows no brotherhood in his profession or in suffering mankind." So much money was being made by doctors and charlatans of all ranks through these bogus treatments that the committee recited the examples of T.W. Conway, who "from the lowest obscurity, became worth millions from the sale of his nostrums, and rode in triumph through the streets of Boston in his coach and six" and "a stable boy in New York" who became "enrolled amongst the wealthiest in Philadelphia by the sale of a panacea which contains mercury and arsenic." So much fraud was occurring that the committee concluded "innumerable instances similar could be adduced" as well.

The contents and effects of Powell's nostrum and the extent of his personal wealth aside, he represented one of the more unique situations of the times. A respected, educated physician, president of the Third Medical Society of Vermont (1825) and lecturing professor at the University of Vermont medical school, he was also an admirer of empiricist Samuel Thomson and his botanical teachings. As Joseph Gallup noted, there was a rupture occurring within the educated ranks, and Powell demonstrated as much when he described his dissatisfaction in 1837 with the excessive number of medicines used by doctors (specifically condemning the overuse of calomel) and praised Thomson for his alternative efforts.[189] From his perspective, there were simply too many medicines on the market, and if Thomson offered a reason to decrease their number, then so much the better.

These years also marked the dogged determination of the state's temperance societies in curbing alcohol consumption. Total prohibition had not yet been achieved, but their combined efforts had resulted in a noticeable reduction in the amount of personal harm and injuries that imbibers inflicted on themselves; in fact, the number of distilleries in 1850 had been reduced to only one, employing two men. At the same time, the educated members of the medical profession took account of their loss of business because of those efforts, as well as acknowledging their own involvement in the popular nostrum drug trade. When the Addison County Medical Society met in Middlebury in 1846, one of its members spoke and "animadverted very seriously upon the profession's countenancing or in any way promoting the use of nostrums, patent medicines, &c. which are calculated to deceive the people and often prove of most serious injury."[190] While others joined him in condemning the practice, some surely paused to consider otherwise. Another recognized a tantalizing opportunity presented to them because of the public's wide

use of nostrums. It was ironic, the account of their meeting relates, but "the true meaning of [his statement] was too plain to be misunderstood":

> *He remarked that he had been much gratified with the evening's discussion, that he believed that all of us had made a mistake on this subject. That only a short time since intoxicating drinks were sold promiscuously to every body in every village, public house and nook. Then, diseases were manufactured in abundance and we had business in plenty. That the temperance reform had nearly destroyed our business. He plainly saw, that by the use of nostrums, &c. we could again restore our business to its former abundance. All that we had to do was to encourage their use today and tomorrow the Doctor would be needed to remove the disease produced by the nostrum.*

While it seems unlikely that a group of learned physicians would advocate the use of harmful nostrums, the "true meaning" of precisely that, an inference "too plain to be misunderstood," indicates they knew some would indeed take advantage of the opportunity.

Certainly not all doctors were so inclined to misbehavior, and in 1849, Brownington physician J.F. Skinner provided a succinct overview of the problem posed by incompetent practitioners selling their suspicious concoctions:

> *The facts are, that the influence of the press, and the influence and interest of the men of trade, are all enlisted in favor of quackery. Now the question is, shall the physicians of the country stand silently by, and see the game of deception played off, and quietly surrender the whole field to the occupancy of quackery; or shall they themselves engage in that most difficult and laborious part of professional labor, and prepare and furnish to the public good and efficient medicines, honestly and faithfully recommended, with plain directions for their proper use?*[191]

Skinner's honorable cry for the responsible prescribing of medicines by doctors is one that continued to be of concern in the following decades but was largely ignored by many seeking to separate a complacent public from its money.

One of those heavily engaged in such activity was Middlebury's educated Dr. William P. Russel, representing perhaps the starkest example of the times as he exploited the laissez faire manner in which alcohol and drugs, especially

Dr. William P. Russel, Middlebury, Vermont. *Henry Sheldon Museum, Middlebury, Vermont.*

opium, were handled. His conduct and effect on the community spanned many years and reveal an important transition taking place within Vermont society as it dealt with the implications that alcohol reform efforts brought about—allowing for the increased use of drugs.

Included in this change was the shift in the physical location where the permissible sale of alcohol could take place, removing it from the general store selling all forms of intoxicants over to a separate apothecary where, in its pure state, it was used in a much restricted manner in the preparation of compounds. Advocates argued for such close supervision, demanding that the only appropriate place for it was in "the laboratory & apothecary's shop."[192] This was necessary because, as one temperance petition reported, "the free use of liquor has led to the establishment in villages of numerous groceries. They are the hot beds of intemperance, producing a noxious growth, destructive of everything that is useful, and the sooner they are extirpated the better."[193] Middlebury doctor Jonathan Allen agreed; his poor community was witnessing such dire effects through "family sufferings, street riots, broils and quarrels [occurring] every few days…in our village."[194] However, creative individuals like Russel were able to defeat such proposals by simply combining the sales of both alcohol and drugs under one roof in a section of their stores labeled "apothecary" while they also sold general store goods.

Initially studying medicine under Allen and subsequently graduating from the Berkshire Medical Institution in Pittsfield, Massachusetts, Russel practiced medicine in Middlebury from 1831 until his death in 1873. Not only did he provide medical services, but he also maintained what one called at the time "a large establishment of drugs, medicines and groceries."[195] Included in his voluminous inventories were the many patent medicines freely available and being consumed throughout New England. A tenacious entrepreneur, he took further advantage of the drug rage and concocted a substance to treat animals called "Russel's Horse and Cattle Cure," selling it at his store or during his rounds in two- and four-dollar quantities. He was

described as "a man of unusual social popularity," and it is certainly not surprising he should receive such acclaim when one considers his extensive role in supplying his neighbors and friends with all manner of stimulants.[196]

However, not everyone appreciated his contributions, as they sometimes crossed the lines of acceptability. In 1867, he was identified in an adverse manner concerning his sales of alcohol during the prohibition years. "I have a student [from Canada]," complained a Middlebury College professor, "whose father put him here to keep him away from drinking associates. Dr. Russel lets him have all the liquor he wants. Sells it to him by the [quart]."[197] It is also clear that Russel ran afoul of his local church when he sought "a letter of dismission & recommendation" in an effort to leave it and join another congregation. Refusing to accommodate his request, the church went further and suspended him from any future fellowship among them. In explanation, one member wrote with particular emphasis, "That the only reason for [this] action, which we deem necessary to state, is that he has lived for years in neglect of the ordnances of the church, & justifies himself in so doing."[198]

The duplicitous conduct that Russel engaged in that angered some within the community can be understood through the many records he maintained in his roles as both a doctor and purveyor of alcohol and drugs. As Waterbury distiller Oliver Rood carefully recorded the many purchases of intoxicating spirits by his customers, Russel did the same thing, identifying them with particularity. While the law in the years immediately prior to the state's imposition of prohibition in 1852 and thereafter allowed sales of alcohol by licensed individuals, it could only be done for medicinal, chemical and mechanical purposes. The most often abused portion of the law concerned its dispensing for purportedly medical reasons, when, in fact, the evidence reveals it was being used for personal consumption. However, punishment for offenders such as he did not exist because enforcement of the toothless prohibitory laws was sporadic and not uniformly applied in either urban or rural locations. Even members of the legislature laughed while in session at their own winking violations of prohibition ("these misdemeanors of ours") in their receipt of alcohol from others.[199] However, for those actually seeking to comply with the law, the pressure on them was immense to find responsible licensees in an atmosphere that the Vermont State Temperance Society noted in 1850 included "the opinion, so universally [held], but unfortunately, entertained, that spirituous liquors are necessary for medical purposes."[200] As a result of this voracious desire for alcohol, the society noted with resignation that most licenses issued authorizing the sale of alcohol

were "usually granted to persons who wish to make money by the traffic, and their thirst for gain induces an abuse of their license."

Such abuse is readily apparent in one representative month, October 1845, of Russel's papers when he recorded the sale of alcohol in his "License Report" journal to no fewer than seventy-nine individuals, demonstrating either the presence of widespread illness or simply an ongoing effort to avoid compliance with license requirements.[201] Evidence of its evasive nature are shown through cryptic entries for the sale of so much brandy, gin, whiskey and rum in pint, quart and gallon quantities. While in September Russel recorded the reason for several sales such as "sick" and "sick wife," the next month he abandoned that practice and recorded infrequently that they took place because of "baby," "for horse," "sick folks" and, tellingly, "man in distress." When he received bulk shipments of spirits, it came in numerous barrels delivered to his store and out of which he filled the many empty bottles that also arrived. It is interesting to note that he also sold many of those same empty bottles to customers, indicating their own efforts to preserve creations they made at home.

More telling are Russel's accounts for the 1840s when he sold opium in various forms (raw, morphine, laudanum, paregoric, Dover's Powder and dysentery drops) to more than four dozen people, several of them on numerous occasions and only days apart.[202] Clearly an addict, Amos Nichols purchased raw opium no less than an eye-popping one hundred times, while Hector McLean did the same, including laudanum. Also notable was a "Mrs. Brewster," who bought tea and brandy to accompany her opium elixir (paying nineteen cents for a half ounce and thirty-four cents for an ounce) and paregoric. Similarly, in nearby Weybridge, storekeeper Julia Thomson's 1846 account book reveals that she also had at least one customer particularly interested in stimulants, as she recorded numerous sales of brandy, wine and opium to Samuel Balon.[203]

Whether she purchased her drugs from Russel or not is unknown, but beginning during this time, local resident Sophronia Croix entered into a two-decade period in which she consumed a staggering four pounds of morphine annually, spending an estimated twenty-two dollars each year for its purchase.[204] Interestingly, William Slade, past vice-president of the Vermont Temperance Society and congressman (and member of the Congressional Temperance Society), is also listed as one of Russel's opium customers. Between 1845—while serving as governor—and 1847, Slade purchased the drug on several occasions in its raw state and also in the form of pills, black drops and Dover's Powder, in addition to gin and bitters.

Doctors' records of accounts confirm the heavy use of opium in their practices, such as Dover's Dr. Jedidiah Estabrooke, who took full advantage of the drug's ready ability to turn a writhing, anguished patient into a docile, sleeping creature. Over the course of 219 pages of his journal kept between 1827 and 1853, Estabrooke reveals his normal routine as he entered, on literally hundreds of occasions, the names of patients, dates of attendance and the type of drug(s) administered for their particular problems. Estabrooke made repeated references in one way or another to opium itself or some opiate-laced creation such as Dover's Powder, pills or cough drops. Other remedies included paregorics, calomel or mercury and morphine.

Similarly, Castleton's Theodore Woodward also kept a journal between 1832 and 1835, revealing, once again, that opium and morphine were freely distributed to patients. As Estabrooke had done, Woodward's entries show that he closely engaged with his patients, attended them on many successive days and routinely delivered the same drug (most prominently opium on dozens of occasions) during the course of their particular ailment or, perhaps, developing addiction. Many times he provided the drug to patients' family members when they came calling, presumably reporting they were doing so on their behalf.

Unrestrained, the public's consumption of strong drugs presented a new phenomenon when doctors began to notice that they had to take increasingly larger amounts in order to obtain a desired effect than they did initially. As Albert Smith described during this time, "Many persons bring themselves to swallow opium in large quantities, without feeling its narcotic affects. Instances are related in which two drachmas, or five fluid ounces of Laudanum, have been taken in 24 hours, yet before the habit was induced these persons could not have taken as many grains without danger." Unabashedly, patients made increased demands on their doctors, he said, insisting "on being freely medicated." They were usually indulged. But if on the rare occasion they were not, then the local druggist could always supply the need without asking embarrassing questions of them.

Meanwhile, another phenomenon appeared, as Vermont's Lucy Ainsworth, also known as "Sleeping Lucy," rose to prominence posing yet an additional challenge to the medical profession. Working in Reading in 1846, followed by a period in Montpelier and then Boston, with neither an educated nor empiricist background, Lucy styled herself as "the *best* and *most reliable* Mesmeric Physician and surgeon of the age" with a following of "over Two Hundred Thousand People" consulting her.[205] Snubbing the "professionals," as she called them, "Doctor Lucy" belittled and found

Lucy Ainsworth from "Sleeping Lucy" by McDonald Newkirk. *Vermont Historical Society.*

endless fault with their efforts as she demonstrated her amazing ability to mend broken bones and dislocated joints by laying her hands on patients while in a trancelike state.

Lucy reportedly gained such an ability at an early age while suffering from an illness deemed beyond healing by attending physicians. However,

she reported to family members that she envisioned a cure (learned while in a deep sleep). They prepared a concoction made from herbs and roots that proved successful. Following additional instances of reported clairvoyance allowing her to find lost items, she was consulted by the local sheriff to help solve crimes, and one doctor paid her fifty cents for each patient diagnosis she provided to him.

Recognizing the potential for additional income, Lucy also became notable for the huge amount of drugs she sold during this time. While there is no evidence of her employing educated chemists to prepare compounds on her behalf, she apparently either made them herself, used those provided by the Shakers in their herbal offerings or purchased them from established pharmaceutical establishments. These would have included alcohol and opium. Using nondescript names for her large list of drugs such as "Green" and "Black" salve, "Indigestion Medicine" and "Blood Syrup," as well as "special prescriptions for particular cases," Lucy sent her products throughout the United States and Canada.

Vermonters' attention to the potential for harm that opium presented in the 1850s can best be described as unremarkable—consistent with the rest of the nation. This can be understood in the context of the overall availability of the drug in the period after 1840, when customs officials first noticed 24,000 pounds of it suddenly appearing in a New England port. However, that number increased rapidly three and one-half times by decade's end to 87,000 pounds, then to 105,000 pounds in 1860 and 146,000 in 1867.[206] By 1898, those numbers paled in comparison to the 565,317 pounds arriving in the preceding twelve months.[207] In the last half of the century, opium imports increased three times faster than the growth in the nation's population, accelerating from 1,425,196 pounds in 1860s to 6,435,623 pounds arriving between 1900 and 1909.[208]

Conversely, those imbibing their strong, intoxicating, ardent spirits and causing public disorder, family hardship and personal harm constituted the greatest perceived danger, not drugs, and certainly not the opium used to quiet those suffering from delirium and for the many taking it as an aid to obtain sleep. Accordingly, the Vermont Temperance Society (created in 1828) initially focused its reform efforts on the harm that distilled concoctions such as rum and whiskey caused. Eventually, fermented beer and wine received similar attention as the society moved to ban their production and sale as well, finally succeeding in 1852. As a result, with one form of stimulant now outlawed, the imbibing population simply turned to those remaining legal for consumption. While the state's population stagnated that decade,

increasing less than 1,000 individuals from 314,120 in 1850 to 315,098 in 1860, the drug trade blossomed, and unsurprisingly, a corresponding rate of addiction followed the increased importation of opium.

Additionally, the number of druggists also increased substantially, rising from 19 individuals in 1850 (physicians numbered 663) to 112 in 1875 (569 physicians). In the two years between 1873 and 1875, the number of drugstores doubled to 107.[209] Even with this explosive growth—and increasing evidence of addiction becoming obvious—it was not until 1915 that Vermont passed its first drug law. Accordingly, opium, morphine and later heroin (after 1898), remained virtually untouched commodities by the temperance movement, regulated only in the way that the public might chose to limit their use or through the efforts of concerned physicians and druggists.

"MOST TAKE IT IN THE FORM OF MORPHINE"

Relationships mattered, and in telling fashion, theses of Dartmouth medical students from the 1850s and thereafter reveal important regional concerns occurring within the medical field. Whereas topics addressed up to this time concentrated on particular illnesses and substances used to treat them, such as the alcohol, tobacco, opium, inebriety and delirium tremens, later in the century, other issues presented themselves. Now, some chose to closely study the competency of those engaged in providing medical services and their interplay with the public. Accordingly, they wrote many diverse and lengthy papers, such as "The Reciprocal Duties of Physician and Patient" (1851); "Reciprocal Duties of Physician and Community" (1852); "The Relations and Responsibilities of the Physician" (1856); "Duties of Medical Men" (1859); "The True M.D." (1860); "Duties of the Medical Practitioner" (1869); "The Student's Idea of a Model Physician" (1870); "The Duties and Education of Physicians" (1871); "Medical Honor and Principle" (1872); "Duties of the Physician" (1875); and "Relations Existing between Physician and Apothecary" (1880). Consistent within each are not just admonishments relating to obtaining appropriate training for their respective practices but also repeated references directed toward gaining patients' trust.

Doctors recognized that latter need early on and that confidentiality between them and their patients was a necessity. As William Sweetser sheepishly admitted to the Chittenden County Temperance Society in 1830 in explaining his refusal to betray patients' struggles with alcohol, "Turn over

the records of our hospitals and see how many of their inhabitants they owe to intemperance!...Shall I withdraw the veil concealing from the public view the secret victims to this vice? Shall I tell how many deaths are continually occurring from intemperance, which are never referred to their true cause?"[210] Refusing to go further, he explained that these secrets remained forever hidden, telling his audience, "The physician is a mournful witness of too many such cases, but they must lie deep buried in his own bosom."

Decades later, doctors continued to hear more than they wished from their patients as they sat and listened to all matter of complaint. As the sick became more comfortable with their caregivers, it was not unusual for them to admit in confidence, as one doctor described to Vermont Medical College graduates in 1856, "the perplexities of business, the consciousness of crime, or even any of the lesser troubles which need not be enumerated."[211] However, he cautioned, these secrets were ones that had to remain solely between them and not be used by the physician in order to enhance his reputation in the eyes of others. As he warned further, "It is a miserable, a contemptible way of getting notoriety. It may be very agreeable to excite the wonder and admiration of a crowd of idlers in the town lounging-places, at the relation of your successes in medical treatment—but it is a taste that had better not be cultivated." Even quack Sleeping Lucy appreciated the need for patients' confidence, advertising they need not worry that she talked with others about them because "she is utterly unconscious of what she says" as she treated them in her "Mesmeric Sleep."[212] Reinforcing that fact at the close of their sessions, Lucy took time to reassure her patients "all that has passed between them is a 'sealed book.'"

However, concern over the betrayal of patient confidences remained, and in 1880, one medical student described what was occurring within the pharmacy trade when couriers arrived at the druggist's door. "Idle conversations are occasionally indulged in between the druggist and the messenger who calls for the medicine," he wrote, "the subjects being the patient, the disease, and the doctor."[213] Finding the situation intolerable, he recommended that "the slightest intimation of suspicion that one knows for what disease a particular remedy is prescribed entitles the seller of drugs to be kicked out of his own door."

At the same time, concerns over the obligations of the public itself, a body well experienced in all manner of self-diagnosis and medicating, toward their medical men arose as many looked for reasons to justify their hypochondria and consumption of drugs, particularly opium and calomel. As one student related in 1859, the doctor had to be cautious of their complaints as

there are always quantities sufficient of old women who are always wonderfully fond of the marvelous. And there are any quantity of such people who are always ready & willing to be sick, provided they can have the doctor & it is only necessary for them to be told they are sick for them to have a long run up fever or anything the doctor in wisdom may choose to term it.[214]

In sum, he concluded, "Patients often think themselves sicker than they really are & they watch all the looks, motions & actions of the physicians" searching for affirmation of that fact. In turn, it placed the physician in a delicate role as he tried to maintain a neutral demeanor and tone that did not mislead in some way, while also seeking to avoid giving the impression that monetary compensation lay at the heart of his efforts.

However, as in the past, doctors were not immune toward drawing attention to themselves in the process, driving teams of horses at high rates of speed between calls or sometimes employing a personal driver as they attempted to sleep because of overwork and in order to convey the appearance of a man on the run and in high demand. But it came at a cost. One doctor admitted to their self-serving ways in 1871:

Is it a very uncommon occurrence for the physician to alight at the door, very likely of some aristocratic mansion, feel the pulse, it may be, of his fair patient, examine the tongue, prescribe with all due gravity and formality, receive his fee, and drive away grandly, knowing perfectly well that his patient needs nothing but pure air and a well-regulated diet? He takes good care, however, to leave in the mind of his patient the impression that the doctor's services are very essential; that the case may become very critical, requiring careful watching and medication; while there is resting upon his own mind the sneaking conviction that he is himself but little better than a humbug. The only solace for his accusing conscience is that if he did not humbug his patient, somebody else would, and that would not pay him so well, all which is probably true.[215]

Such behavior aside, and while a difficult goal to achieve, many doctors actually did try to honor their confidential obligations to patients and minimize the embarrassment they might suffer if their secrets were revealed. Calling an affliction "disease of the heart" provided a convenient escape in this regard, and Vermonters were told that many opium eaters avoided having their names tarnished through this subterfuge.[216]

Concealment of the reasons for patients' deaths, which could have further identified the extent of the opium problem, remained an obstacle for years as doctors refused to comply with registration laws instituted in 1857 requiring them to provide such information to local authorities. Many were simply "indifferent" to the law, while others refused to participate, "claiming that it is neither just nor constitutional to demand of a medical man professional services without remuneration."[217] Authorities were at a loss to force their participation and had to face the stark reality that "in a rural region like Vermont, rigid...laws are not readily borne or easily enforced." Even had the doctors complied, those statistics that were actually gathered failed to distinguish drug usage (considered a "poison") from other causes of death and would have simply been classified as "accidental," unless specifically determined a suicide. Unfortunately, throughout the remainder of the nineteenth century, obtaining accurate death-related statistics in the state remained difficult, with officials lamenting in 1888 their "very incomplete and imperfect" nature.[218]

Without question, the unregulated patent medicine trade, with its opium and morphine infusions, continued to contribute to Vermonters' developing addiction rate. Unfortunately, relevant guidance provided at the time by the American Pharmaceutical Association (founded in 1851) during an 1853 Boston convention attempting to grapple with that very problem failed to have any effect in the Green Mountain State. While avoiding for the time being any pronouncement interfering with the otherwise widespread, unrestricted sale of opium, the gathering mustered sufficient courage to resolve that "the use of secret or quack medicines is wrong in principle and in practice attended with injurious effects to both the profession and the public at large."[219] Importantly, they described several far-sighted measures ripe for implementation and recommended that their brethren

discourage...the use of these nostrums; to refrain from recommending them to their customers, not to use any means of bringing them into public notice; not to manufacture or to have manufactured any medicine the composition of which is not made public; and to use every opportunity of exposing their use and the false means which are employed to induce their consumption.

However, any effort to comply with such common-sense measures in Vermont (where officials focused instead on implementing prohibition's recently instituted restrictions) relied solely on the willingness and ability of druggists—meaning that any chance of doing so remained many years off.

In the meantime, while official statistics relating to the suffering that drugs caused are absent, accounts of doctors and druggists provide ample evidence of their devastating effect. The problem developing under their very eyes that they directly facilitated raised little concern from a majority within either profession and was allowed to expand, in part, because of the often crooked relationships existing between themselves. In turn, the robust and lucrative trade they fostered, together with the public's unceasing hunger for drugs, became so attractive that others stepped forward, and large-scale manufacturers sprang into existence to satisfy demand.

Even before this turn toward specialization in drug manufacturing took place, the outward appearance of common Vermonters because of their consumption of medicines had become so noticeable by 1866 that it drew the attention of those visiting the state. As one individual said to VMS vice-president Dr. Henry Jackson, while pointing to a huge advertisement for vinegar bitters painted on a rock, "Do you know I cannot help associating the leanness of the average Vermonter with too intimate acquaintance with patent medicines."[220] Agreeing with that assessment, Jackson observed that Vermonters "pay more annually for their doses than it would cost to maintain a State Board of Health, with an office in every town." Others noted the phenomenon taking place elsewhere, with another writer describing that "opium is continually resorted to by many of both sexes, but particularly by females, and these of the higher circles, as a substitute for the stimulus ordinarily afforded by gin or brandy."[221] Though illegal to sell, men continued in their otherwise socially acceptable role in consuming liquor, excluding women as they had in the past. But they were not going to be denied their own stimulants and turned to readily available opium, resulting in their very countenances changing. The writer further noted their "emaciation, and… dyspeptic symptoms, and gastric derangement."

Increasing instances of drug advertising for bogus treatments appeared in many locations in the Vermont countryside, and in 1873, a member of the VMS described the situation:

> A glance at any of the advertising columns of our newspapers, secular and religious, in city or country; the placards which meet the eye upon every highway and corner of the street; the shelves of our drug stores; nay, the

cupboards of families where we are called professionally testify to what an
enormous magnitude the trade in Patent Medicines has grown.[222]

Two of those widely used substances he complained of included White's
Elixir and Mrs. Winslow's Soothing Syrup, which contained, respectively,
opium and morphine. Winslow's was also called "the mother's solace,"
described by a New York scrub woman caring for children as requiring "just
one teaspoon…and they lay like dead till morning." As Jackson described its
ill effects, it "has often proved the mother's sorrow, for it has been altogether
too soothing to many crying children, and their cry is hushed forever."[223]
However, inflicting harm on the addict and innocent child was not the
only result from using these substances. Families suffered also, and Jackson
provided the example of one consuming over a twenty-year period more
than an astonishing three thousand bottles of Shaker Anodyne, a popular
remedy containing opium and morphine, prescribed by a doctor. It had such
a dire effect on the family, he related, that the "children were obliged to go
without sufficient food and clothing."

These problems coming to light are directly attributable to the
interplay taking place between physician and druggist, as each sought to
stake out the extent of their respective roles. Doctors not only continued

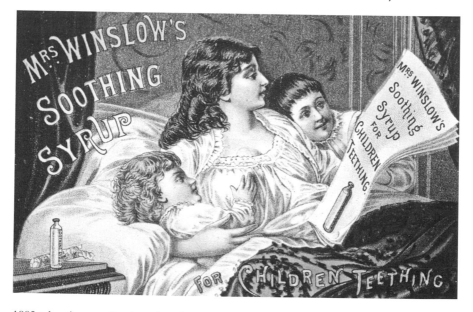

1885 advertisement for the opium-based Mrs. Winslow's Soothing Syrup for Children
Teething. *U.S. National Library of Medicine.*

with their own creations but also sought to exploit the quack medicine and treatment market selling whatever they could lay their hands on, including, as Jackson detailed, "Heart Correctors, Shaker Anodyne, Diphtherine, Iodo Bromide Calcium Compound Elixer, Fellows' and Winchester's Hypophosphites." But what of the one who was supplying the doctor, the druggist whom he said "should be the physician's right hand man in all that is pure and useful"?

In explanation, Jackson then described exactly what was driving their respective actions—once again, money. "What shall we think of him who while he dispenses our prescriptions at the same time carries on a patent cure establishment, and at his counter recommends for every complaint some bogus mixture, with a positive assurance of its value, because forsooth it leaves him a good margin[?]" He then related the financial incentives allowing this to happen, stating, "I am fully aware of the inducements offered by agents for the introduction of some double-distilled-disease-destroyer, or John Smith's unexcelled and inapproachable sneeze producer, forty or one hundred percent profit, and no pay required for ninety days."

The relentless drive toward profits continued, and several years later, one doctor speaking to the state's pharmacists boldly challenged their involvement in pushing questionable medicines.

> *How many of you have washed your hands from the sale of proprietary medicines that are made* only *to fill the pockets of the proprietors—and* you *are made the vendors of them because you can pocket a large share of the profits; you keep these things because you can make money on them.... There is not a druggist in the country who would keep them 24 hours were it not for the profit. This morbid demand of the people degraded the dignity of the profession of scientific pharmacist, and in our State you will find it will never be eradicated until the people become educated to know what they need.*[224]

Indeed, the woeful extent to which many suffered in their ignorance toward drugs was so pervasive that one doctor noted in 1873, "It is difficult to tell which needs the most to be educated—the druggist, the physician—or the public."[225]

Yet additional challenges presented themselves affecting all three interests. After a doctor wrote a prescription, the patient presented it to the druggist to fill, but each possessed radically different perceptions of what the transaction meant. Issues of who "owned" the prescription

arose, with doctors believing it covered a current condition for a finite amount of time and the patient contending otherwise. As one pharmacist related the conflict, the patient believed that "when the Doctor has given him a prescription, and he has paid for it, it is his own to do as he pleases with, either for his benefit or harm…[leaving] it with the Druggist for safekeeping, or greater convenience."[226] In other words, the patient contended that the prescription was virtually open-ended and allowed him as the purchasing owner to unlimited access to drugs whenever and for whatever reason he felt appropriate ("either for his benefit or harm"). However, others argued that the prescription belonged to the druggist himself to do with as he pleased, all of which caused great consternation among the three parties.

In an effort to address some of the problem on the creation of the Vermont Pharmaceutical Association in 1870 it immediately took up the issue of accountability in their dispensing practices. Recognizing the potential for harm that opium and other drugs caused, in 1871 members published their first Code of Ethics, providing great insight into their appreciation for the need to impose obligations on themselves. "We hold," they wrote, "that when there is good reason to believe that the purchaser is habitually using opiates or stimulants to excess, every druggist or apothecary should discourage such practice."[227] Additionally, at the urging of President C.L. Case, who explained his own problems in dispensing these drugs, they further agreed to document their sales not only for their own benefit but for "the people's protection" as well.

Relationships between physicians and druggists also proceeded in a highly questionable manner. Doctors of all rank recognized the financial power they held over pharmacists with their prescriptions, guiding patients toward those they favored and away from those they did not and whom they had blacklisted. As Dartmouth medical student Edward Currier revealed in 1880 in one of the most detailed theses of the times, doctors wrote their orders in code so that patients could get them filled only at pharmacies with which they had a prior relationship. In turn, the doctor received a kickback for the referral in a situation that Currier termed nothing short of highway robbery because it allowed the caregiver to extract a form of booty from their patients.[228]

In other instances, as careful as doctors might be when attending patients living some distance from a drugstore, other mistakes continued, resulting in their unfortunate deaths that then involved questionable relationships between physicians and morticians. As Currier relates further:

A physician measures active medicine, like morphine, with a knife blade; his estimation of quantities in this way can be nothing more than a mere guess, particularly, when called in a hurry or encumbered with winter clothing, and half chilled by a ride in inclement weather. There is no question but that many lives have been jeopardized by this careless and wrong practice. It is not strange that a death certificate becomes necessary....The undertaker comes in and covers up the mistake of the doctor.

Further, on those occasions when doctors remained on the premises after a death and received permission from relatives to conduct an autopsy, their conduct continued in a flippant, irresponsible manner. As the president of the VMS lamented in 1870, after lighting up their cigars and cutting open the corpse, the jokes and stories flew about during their work, after which "the room is soiled and left in general disorder" while the body "is generally left a mutilated and unsightly mass."[229]

Clearly, many loose practices existed between the various professions, only becoming more entrenched as the drug trade expanded. With the number of stores in the state doubling in only a two-year period, the uneducated saw the sale of drugs as a convenient way to make money. Those selling groceries expanded their offerings as they added medicines to their inventories, and illiterate shoe salesmen abandoned their trade and turned to selling drugs. Errors occurred on all levels, including those made intentionally, such as when they sold alcohol (itself heavily adulterated by suppliers) to those not needing it for medical reasons or inadvertently through their failure to fully understand the harmful effects that the substances under their control caused. People died because of them, and they continually threatened to undo the efforts toward professionalism that the educated druggists sought to attain.

At the 1868 annual meeting of the Vermont Medical Society, an important turning point occurred in defining the state's developing drug problem. Among the few issues that members believed warranted in-depth study, narcotics clearly stood out as the most problematic. Dartmouth's Dr. Carlton Pennington Frost received the important assignment to report back at the next meeting "On Uses and Abuses of Opium."[230] Working in Brattleboro at the time, Frost received his medical education from both the Dartmouth and New York medical

colleges, graduating in 1856, and later served as surgeon of the Fifteenth Regiment of Vermont Volunteers, followed by a period in the same capacity to the state's board of enrollment during the Civil War. In 1868, as president of the VMS, he was made an assistant professor at Dartmouth, and by 1872, well-liked and highly regarded, he moved on to serve as dean of the faculty.[231]

By this time, entrepreneurs recognized the new exploitative opportunities that addiction allowed them. In fact, as early as 1861, Vermonters began seeing advertisements blaring out "TO THOSE IN THE HABIT OF TAKING OPIUM, WELCOME NEWS!!" An

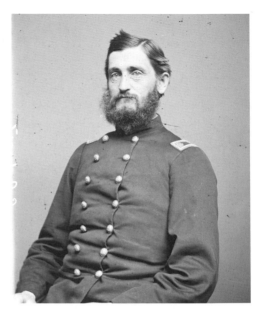

Surgeon C.P. Frost, Fifteenth Vermont Infantry. *Library of Congress.*

unnamed Morrisville individual offered an alternative to "the accursed habit" if the users simply took his so-called Substitute.[232] Similarly, Dr. E.P. Russel, son of Middlebury's William Russel supplying the community with all manner of alcohol and narcotics, took up the same claim with his "Compound Extract of Wheat, the Great Temperance Tonic," touting it as a remedy for numerous ailments, including the "Alcohol, Opium and Tobacco Habits."[233] Others also sought to take advantage of the growing addiction phenomenon, as evidenced by the testimony of Mr. S.G. Gates of East Wallingford. In 1873, he proclaimed the benefits of the so-called Theriaki cure, a reported "opium antidote" of unknown composition concocted by a midwestern doctor. Writing to explain what it had done for him, Gates conveyed in stark terms the hell he experienced before discovering it, writing effusively, "I look back on the last two years as lost; and it all seems like a troubled dream; but, thank God and you, I am *free* again….I hope every opium eater in the land will become acquainted with the fact that there is a *genuine cure*, and a *painless* one, in your hands, thus saving themselves from the *damnable ruin which awaits them.*"[234] However, as with many of such products, they no doubt contained opium in order to provide some form of immediate relief to demonstrate effectiveness and to assure future customers.

Dr. Carleton Pennington Frost (*second from right*) instructing a dissecting class, 1874. *Dartmouth College Library*.

Now, C.P. Frost brought his expertise to bear in order to finally expose to the public just how bad the drug problem was. Of particular importance were his experiences in the recently concluded war, during which a reported 174,200 gunshot wounds to the arms and legs of Union soldiers occurred, resulting in 29,980 amputations requiring the heavy use of morphine, opium and quinine.[235] Whereas morphine had been dusted onto wounds in the past, use of the hypodermic syringe allowed for easy injections just below the skin, providing more rapid results; however, it was not in widespread use, with only 2,093 syringes issued to the Union army throughout the war. Importantly, no less than 10,000,000 opium pills and 2,841,000 ounces of opium-based compounds (laudanum, opium with ipecac and paregoric) were

also used, causing some to conclude that an "army disease" of addiction then ensued. While some soldiers returning home certainly did contribute to the developing problem, others believe that it is an overstated proposition and that they constituted but a portion of the nation's larger addiction phenomenon already under way.[236]

Concerning that number specifically, as Frost studied Vermont's problem, one investigator at the time estimated that there were between 80,000 and 100,000 addicts in the country.[237] However, he noted that those individuals did not come only from the down and out, observing:

> *Neither the business nor the laboring classes of the country contribute very largely to the number. Professional and literary men, persons suffering from protracted nervous disorders, women obliged by their necessities to work beyond their strength, prostitutes, and in brief, all classes whose business or whose vices make special demands on the nervous system, are those who for the most part compose the fraternity of opium-eaters.*

An army drugstore and the hospital steward, 1864. *Library of Congress.*

Married women remaining at home with time on their hands and the ability to engage in drug usage composed a large number of addicts, to include those unmarried women working as domestics, teachers, actresses and in the sex business, together with nurses and doctors' wives, who also had unusually high rates of addiction.[238] Additionally, rural families used addictive drugs to suppress the actions of some of their members, "to control the invalids, sub-normal, and elderly" in order to avoid having to pay for "expensive or shameful institutionalization."[239] The problem had become so prevalent that life insurance companies noting the "enormously" large use of alcohol, opium, chloroform, ether, cannabis and other narcotics taking place refused to provide coverage to suspected addicted applicants.[240]

Additionally, the situation in neighboring Massachusetts provided Frost with knowledge of the increased use of drugs occurring there. Several years earlier, in 1860, dean of the Harvard Medical School Oliver Wendell Holmes spoke before the state's medical society, telling it that the overprescribing of opiates by physicians in one of its western towns "has rendered the habitual use of that drug…very prevalent."[241] People could identify the users, he said, simply because of "the frequency with which the haggard features and drooping shoulders of the opium drunkards are met in the streets." Later, in 1871, the state board of health made further inquiry into the problem. Experiencing less than enthusiastic assistance from physicians in gathering information, the board nonetheless concluded that an opium habit "is more or less prevalent in many parts of the state," finding further that "while it is impossible to estimate it, the number of users must be very considerable."[242]

In tracking down the sources of the drug, one investigator provided a telling assessment that directly implicated Vermont's involvement in Massachusetts's problem:

There are so many channels through which the drug may be brought into the State, that I suppose it would be almost impossible to determine how much foreign opium is used here; but it may easily be shown that the home production increases every year. Opium has been recently made from white poppies cultivated for the purpose, in Vermont, New Hampshire and Connecticut, the annual production being estimated by hundreds of pounds, and this has generally been absorbed in the communities where it is made.

That which is not used where it is produced…together with inferior and damaged parcels of foreign opium received and condemned at [Boston] is sent to Philadelphia, where it is converted into morphia and its salts, and is thus distributed through the country.

Clearly, Vermonters' interest in expanding their involvement with opium beyond merely consuming it was becoming an important factor that now reached well beyond its borders.

Perhaps the most notorious producer of opium in Vermont at the time was Monkton's Welcome C. Wilson, an unabashed entrepreneur appearing boldly at an opportune time before being discredited as a fraud. However, his fall from grace did not occur before optimistic federal officials went so far as to declare his so-called "Vermont," or "American," opium "an important industry" in the state.[243] Their enthusiasm stemmed from Wilson's cultivation of poppies, which began on his farm in 1862. As he explained it, the production process then expanded over the next several years, allowing him to

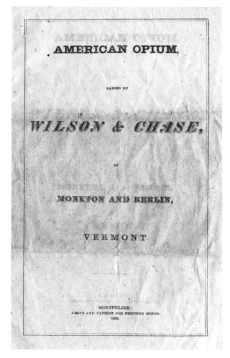

Welcome Wilson's 1869 prospectus for Vermont "American Opium." *American Antiquarian Society.*

reap a "wonderfully profitable" windfall, as he sold his product directly to druggists and physicians. His production increased so much, he said, that he transitioned from obtaining 2.5 pounds of opium per square meter of earth (netting him ten dollars a pound) to 640 pounds coming from six acres (bringing him between eight and ten dollars per pound).[244]

Wilson then put together a prospectus in 1869—"Notice to Farmers in Vermont, and Other States. A New Discovery in the Money System"—in an effort to convince customers to purchase seeds and processing equipment from him, officiously identifying himself as "Prof. W.C. Wilson of Weybridge, Vermont, as the inventor and producer of American Opium."[245] He apparently succeeded in generating sufficient interest that his neighbors readily bought into the scheme, with one newspaper reporting that "quite a few farmers propose to cultivate the plant."[246] Their strong attraction to growing the drug is not surprising because families consuming store-bought patent and commercial opium-based medicines seeking to save money now decided instead to include it in their own homemade remedies, such as

"cough mixtures, tooth washes, lotions, liniments, enemas, poultices, healing tinctures and decoctions."[247]

However, Wilson's charade began to unravel shortly afterward when samples he sent to reputable scientists were exposed as fraudulent, most likely local poppy residue mixed with authentic Turkey opium—yielding a morphine level substantially higher than any purported product that the northern climes could produce.[248] By 1870, a discredited Wilson moved westward, where he continued to pass off his bogus claims of success, only one of many charlatans saturating the medical supply market at the time. What happened to C.M. Robbins of Hancock, who also tried to hawk his samples of opium—initially testing as "pure and of extraordinary strength"—as a Vermont product, is not known, but he appears to have quietly dropped out of sight after similar questions were raised about his "so-called opium."[249]

Opium also found a role in, of all places, the use of horses. Jockeys were well aware of the drug's effects on the animal and the important role it played in the Arab world to induce a temporary state of exuberance allowing it to work beyond normal limitations in that difficult climate. After introducing a large quantity into a horse's feed, the rider had only to wait a short time for the drug to take effect and then run his race. Even broken-down horses ready for retirement could be dosed with opium, allowing unscrupulous sellers to take advantage of unwitting purchasers. As one Dartmouth medical student described in 1877, after tending to the animal's outward appearance by fraudulently coloring its faded hide, the scammer would then give the horse

> a dose of morphia, and, waiting a short time for the drug to act, he then leads forth in triumph his prancing stud which with eye in a fine frenzy rolling, champs his bit, arches his neck as in youth, neighs and impatiently stamps the ground. He is hitched to a buggy and flies around a block or two with eagle rapidity; the price is fixed and paid and the gentleman departs with his prize (!) only to realize in a few days that he himself as well as the horse have been sold.[250]

While certainly not the first formal paper to discuss the increasing evidence of drug addiction in the country, Frost's "Opium: Its Uses and Abuses," presented to the VMS during its June 7, 1870 annual meeting in Burlington, provides an important starting point in understanding its presence in

Vermont.[251] Just one of several doctors making presentations that day, Frost read a succinct, single-spaced, sixteen-page summary of what was occurring and then participated in a "general discussion" afterward with his appreciative audience. His report is devoid of corroborating statistics to back up his findings but nonetheless provides sufficient information to convey the contemporary perceptions held by medical men. A substantial portion of the report is devoted to a review of the importance of opium in treating many afflictions ranging from using it to remove pain, in countering cancer's effects, its use in abortions and in treating dysentery and cholera. He also recounted the various ways that the drug became introduced into the body: by mouth, rectum, abrading the cuticles to apply to exposed blood vessels and by hypodermic injection.

When Frost turned to the abuse of opium, he named two concerns. First, he noted its use in cases where it should not have been employed in the first place or in those where excessive use resulted after the need had passed. Importantly, he related that both instances "may exist with or without the knowledge and sanction of the physician." His second concern related directly toward the public's use of the drug for selfish reasons, specifically "those abuses which result from its use for the gratification of a morbid love for the peculiar intoxicating effects" it could deliver. The danger, Frost recounted, arose once the patient experienced the drug under a doctor's care and took steps to obtain further access to it through the purchase of the heavily laden patent nostrums so widely available. It certainly did not present much of a challenge for the budding addict, he said, simply because the stores were flooded with Mrs. Winslow's Soothing Syrup, as well as a "multitude of cough mixtures, diarrhœa cordials…pain killers, [and] pain extractors" being used "internally, externally, and *eternally* by so many people."

The evidence of physician involvement in beginning the process in the first place had become so obvious that Frost then made the bold assertion that they were the ones responsible for so much of the prevailing "opium habit." Their practice of allowing patients to dictate to them particular dosages and the frequency of their administration had to stop, he said, stating that the physician "is guilty of a grave crime, who by his thoughtlessness of results, induces the formation of a habit of reliance upon opium."

Frost then turned to those consuming the drug not at a doctor's direction but simply for its "intoxicating effects." In such cases, he said, "We can satisfy ourselves by very limited investigation that the amount of opium prescribed by medical practitioners for the cure of disease, large as its use for this

purpose, constitutes but a small proportion of the amount consumed in the communities in our own State." Frost then made reference to the sad fact that opium was consumed largely in secret, stating that it "is generally used without the knowledge of many persons outside the family of the user, unless the amount required becomes pretty large and the effect plainly marked." Cost of the drug did not seem to interfere with the addict's pursuit, as Frost observed further, "We know there are those who will deprive themselves and their families of all but the absolute necessaries of life, and pinch on those, to obtain opium." He also described the prevailing method used by the addicts to consume it: "Most take it in the form of morphine, and by the mouth."

In ending, Frost recounted the words of a noted English physician working with alcoholics and opium addicts describing the differences between the two and who contended that those suffering from too much drink were far better off than the drug user. He related:

> *Opium debases both the mind and the body. The spirit is constantly crying to be relieved from the dead form it is carrying around; that is dragging it down. The opium consumer becomes an irresponsible being. His sufferings are horrible, horrible. He lives in hourly dread, starts at every noise, trembles at every breath of the wind, expects the world to fall upon and crush him. There is no name for what he endures!...Delirium tremens is merciful, compared to it.*

Physicians failing to take charge in prescribing and administering of drugs, their acquiescence in allowing patients to dictate to them the terms of their usage, the subsequent rise of an unquenchable habit and resulting debasement of both victim and family were all matters directly attributable to the actions taken by doctors at the time. Frost's accounts of these budding moments of addiction in the state's history teach us that if even these most basic issues could not be resolved it is hardly surprising that the medical men remained removed from becoming involved in rehabilitating that which they brought about in the first place.

"A CRYING EVIL OF THE DAY"

As Frost lamented Vermonters' current drug usage, authorities' attention continued steadfast in enforcing prohibition. The records of the early 1870s are replete with accounts of their efforts attempting to counter the continued illegal sale of alcohol occurring surreptitiously in hotels and taverns and conducted by complicit druggists and town agents supplying it to those purportedly consuming it for medicinal purposes. Raids by local police and county sheriffs occurred with great frequency, prosecutions were instituted, convictions obtained and monetary sentences imposed, only, in Burlington at least, to have the mayor remit them because of supposed inability to pay. Fed up with the situation, residents petitioned for yet more aggressive action against repeat offenders, resulting in an endless stream of litigation that provided little change. Meanwhile, to the south in Rutland, records of the county jail reveal that many, most often identified as Irish, were locked up for intoxication. At the same time, in October 1874, the VPA met again to hear yet another discourse on society's ills, with Chester's Dr. J.N. Moon presenting on the "Use and Abuse of Opium," described as "a very able paper" with "many instances cited which showed the harm that the abuse of opium" caused.[252]

The adulteration of alcohol by out-of-state suppliers, located mainly in Boston and New York City, providing the state's city and county liquor authorities with their products, also continued to be of concern. Large organized efforts in these locations involving individuals diluting casks of foreign and domestic liquors and wines and then injecting all

manner of stimulants, including opium, into them in order to provide an intoxicating effect took place. In the midst of battling their own opium addiction problem, Massachusetts authorities also sought to counter their actions. However, they found themselves facing a concerted effort working against them, as sophisticated groups aggressively solicited New England outlets to purchase their bogus products from them rather than legitimate suppliers because they "so closely resemble the genuine that they often cannot be distinguished."[253]

The presence of bogus drugs of questionable composition also continued to plague Vermonters. Two years after the creation of the VPA, in 1873, Stowe's Dr. C.E. Gates described the huge problem coming to light caused not by the small nostrums emanating from the state's kitchens and farms but those spewing out from the expanding "manufacturing swindle" then underway.[254] Emphasizing specifically the "uncertainty" and "inferior" quality of these larger producers' products failing to deliver promised relief to a sufferer, he related that they "not only bring distrust and discredit upon the practice of medicine…but also tend to foster and uphold the 'Quackeries' and Nostrums of the day, such nostrums receiving *more* care and attention in manufacture than the products that are now flooding our markets."

Gates's warning could not have been more timely, for a fledgling drug manufacturer had arrived in Burlington the previous year that, over the course of the next two decades, came to play an important role in the presence of drugs in Vermont and around the world. There had never been another business in the state quite like Wells, Richardson & Company, and it quickly grew into a wholesaling behemoth dwarfing the drug-producing efforts of other smaller, local operations, including Henry, Johnson & Lord, R.B. Stearns & Company, B.W. Carpenter & Company, Burritt Brothers and Jones & Riley. In the wake of its success, several pharmacies opened up selling their products, and by 1886, a full range of drugs, accompanied by the ubiquitous soda fountain, had become available as never before.[255]

Owned and operated by intelligent and aggressive men, Wells, Richardson attacked the production, marketing and sale of drugs in a manner the equivalent of, if not exceeding, that of other large manufacturers in the country's metropolitan areas. The company astutely recognized the need to establish close relationships with those selling its products and immediately began to facilitate the process. Only a year after their arrival, the founders sponsored a lavish dinner with entertainment for the state's pharmacists and and their wives attending their annual meeting in Burlington. Escaping prohibition's restrictions against the sale of alcohol, the company picked

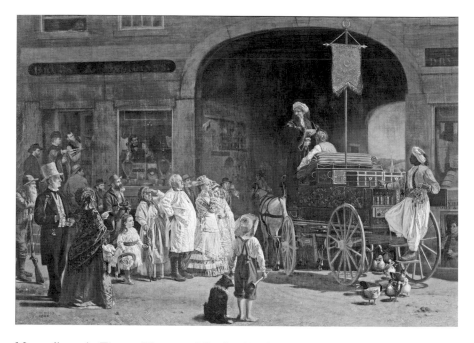

Montpelier artist Thomas Waterman Wood's 1882 *Quack Doctor* using a local backdrop and wagon bearing the name "Dr. I.M. Cheatham," with quacking ducks underneath parked next to a store selling "Drugs & Medicines." *T.W. Wood Gallery, Montpelier, Vermont.*

up the cost for a quick cruise on the steamship *Oakes Ames* across Lake Champlain to Plattsburgh, where the druggists were fêted at a local hotel.

Then, following a memorable dinner, the appreciative party spent half an hour consuming "several toasts" as they acknowledged the largess of their sponsor in putting it all together. Toastmaster and druggist Frederick Dutcher of St. Albans then took special note of the physical appearance of his peers and its relationship to the success they experienced in their trade:

> *It is a great mistake to think that a druggist, and especially one of this Association, must be thin and cadaverous, a poor feeder. I notice quite a number of our friends here…who are striking refutation to this base slander. I have found by experience that there is nothing like a straight-forward legitimate trade, accompanied by a clear conscience, to promote symmetry, beauty and rotundity of form.*[256]

Dutcher's pointed references to their engagement in a "legitimate trade" allowing his friends to maintain a "clear conscience" in their work might

have been accurate to a degree, but the fact is the pharmaceutical trade, from manufacturing wholesaler to the local retailer, remained an unregulated industry for the next three decades. Secrecy abounded among all of the participants, and despite claims of any altruism that might exist, it only facilitated the increasing opium addiction problem.

The permissiveness and lack of oversight that permeated the drug trade became starkly apparent shortly after the VPA returned home to Burlington, and it involved the very steamship that transported them across the lake. The 242-foot-long *Oakes Ames*, built in 1868 for the Rutland Railroad Company to transport railroad cars and valued at $150,000, had recently been sold to the Champlain Transportation Company in 1874 and renamed *Champlain II*. Shortly after 1:00 a.m. on July 16, 1875, on a totally clear evening, it struck a rocky ledge after leaving Westport, New York, with some eighty passengers headed northward. The collision violently threw the occupants out of their berths, and *Champlain II* immediately broke in two. Fortunately, nobody was injured, and all were able to alight from the now destroyed vessel to the shore via makeshift gangplanks set up by the crew.[257]

A subsequent investigation by the company into the uninsured loss ensued, resulting in the surprising revelation that drugs played a significant

Wreck of steamship *Champlain II*, July 16, 1875, Lake Champlain. *Special Collections, University of Vermont.*

contributing role in the event. The experienced sixty-one-year-old pilot John Eldredge explained to investigators he could not account for his having steered so close to shore and was as surprised as anyone at what occurred. When inquired about his physical condition, he could only relate that "I never drink, & had not drank that night. I have never been subject to dizziness & my eyesight is good." And when asked specifically, "Have you been in the habit of taking opium or morphine?" he answered, "No, sir."[258]

However, that was a blatant lie. As related by a crewman describing what he had found out himself after the disaster, "omen or no omen in black cats, morphene [sic] was the black cat that run us on to those rocks."[259] As it turned out, Eldredge had done all he could to obtain the drug, intentionally avoiding visiting any Burlington drugstore that might have raised suspicions because he was well known. Instead, he obtained the assistance of a baggage master who unwittingly purchased five bottles of "white powder" in Whitehall, New York, after Eldredge provided him a piece of paper. The man had not read the paper and simply handed to a druggist for filling. Eldredge admitted to him later when he received the bottles that "this is my winter supply." Additional testimony from several druggists confirmed that he purchased morphine on many occasions and even immediately following the disaster went directly to one and bought three bottles. In the end, his pilot's license was revoked for being "an unsafe person." Captain E.B. Rockwell, whom Eldredge replaced shortly before the collision, explained the investigation's overall findings:

> *The cause of the loss was for the want of morphine. Mr. Eldridge [sic] was suffering greatly from the gout, and to ease the pain had been taking morphine. The drug contracts the optic nerve, and in his case the want of it allowed the optic nerve to expand and throw his vision out of range. That was why the vessel had steamed in so closely to shore as to run upon the rocks.*[260]

While Eldredge disappears from the record following his immediate departure to the West, his travails mark only one of the more notable examples of the effects caused by the ready availability of drugs.

Wells, Richardson's vigorous efforts continued, and the company sent out salesmen throughout New England and beyond, eventually establishing branches in Montreal, London and Sydney and shipping out so many drugs and various kinds of compounds from their Burlington facilities that it amassed revenues of no less than $2 million a year. Occupying some fifty-

eight thousand square feet, or one and one-third acres, of office space, the sophisticated business divided itself up into ten different departments, with varying functions manned by two hundred employees. It also included an advanced advertising operation with a budget of $500,000, utilizing a remarkable twenty-five presses pushing out thirty million pieces of literature and spending $60,000 in postage yearly.[261] Its efforts were so noteworthy that local residents looked on in awe as so many drugs flooded out to local stores. There was so much in evidence that they could be forgiven for thinking, as one wrote, "It is therefore no longer necessary to go to the physician for every illness, but everybody can be his own physician," enabling vigorous self-medicating.[262]

The scale and scope of Wells, Richardson's wholesaling efforts increased so rapidly in its first years that by 1878 it had issued a two-hundred-page catalogue to customers listing virtually every drug, chemical, dye-stuff, proprietary medicine, paint, oil and various sundries they could ever want. Among all the products, company officials proudly noted that "the Drug branch of our business…has steadily increased, till now it forms the largest share of our trade."[263] Their insights into customers' needs was so astute that they even began offering a separate category of "Grocers' Drugs" to those interested only in a smaller number of items than what a larger druggist might need.

They also provided customers with detailed instructions telling them how to display Wells, Richardson products in their windows (boldly promising that "The Advertising Will Sell the Goods"), while teasing them with offers to include calendars, pamphlets, signs and cartons with their orders. In short, the company made it extremely easy for any retailer to order drugs and then get them sold as quickly as possible to a clamoring public. So many druggists took such great pride in creating their window displays that both Wells, Richardson and the St. Albans Remedy Company, proprietors of the popular Smith's Green Mountain Renovator, staged locally judged contests and awarded monetary prizes.

The year 1874 marked the "Centennial of Chemistry," and the nation's chemists proudly recognized their accomplishments over the past decades. That same year, in England, researcher Romley Alder Wright first synthesized heroin from morphine. Meanwhile, the country's "grand manufactural operations" increased significantly, extracting "thousands of pounds of morphine from opium" and placing it into their many preparations.[264] As a result, one Massachusetts investigator looking into the effects of those actions concluded that many "cough mixtures, tooth-

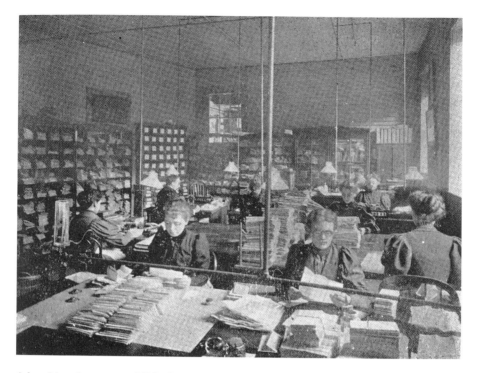

Advertising department, Wells, Richardson Company, circa 1893. *Picturesque Burlington.*

washes, lotions, liniments, and proprietary medicines" contained opium and morphine in unacceptable amounts.[265] In a practice reaching back many years, one of the remedies touted to cure the opium habit was found to be "a clear solution of sulphate of morphia colored pink…and sweetened with sugar," directing the user to take it three times a day. As one of the largest purveyors of such products in the country, Wells, Richardson undoubtedly knowingly participated in similar fashion, also offering in its catalogue unlimited amounts of opium in the form of laudanum and paregoric, available by the pound. Additionally, the company made it easy to purchase a staggering number of patent medicines, described in a separate twenty-three-page section that included the opium-infused Bateman's Drops, Godfrey's Cordial, McMunn's Elixir of Opium and Mrs. Winslow's Pills and Syrup.

The company also participated in one of the greatest, if not quite illegal, highly questionable practices of the times, touting the wildly successful alcohol-based Paine's Celery Compound as a cure for, among other complaints, the opium habit. Beginning in 1856, Colonel Milton

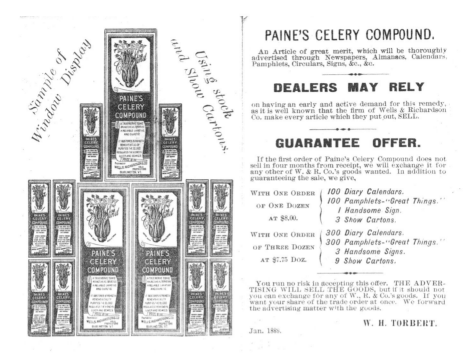

Wells, Richardson advertising instructions, 1888. *Champlain College Special Collections, Burlington, Vermont.*

Kendall Paine operated a successful drugstore in Windsor where he created many perfumes, salves and medicines, gaining wide acceptance within the community and beyond. His recipe book is filled with many descriptions of their contents: Paine's Paregoric, Battley's Sedative, Dr. Oliver Baker's Prescription for Diarrhea, Squibb's Diarrhea & Cholera Mixture, Professor Lamoureaux's "Specific Mixture" and Electric Drops all contained opium; "Sun" Cholera Mixture included laudanum; Chlorodyne, Ayer's Cherry Pectoral, Expectorant Balsam and Dover's Solution incorporated morphine; and Dr. Weston's T.A. Drops were infused with cocaine.[266] While the specific contents of his celery compound, created in 1882, are not described, Paine touted it as "composed entirely of vegetable ingredients." Effusive testimonials began to flood in as customers attested to its effects, including a local resident, the "well-known showman, GEORGE M. CLARK, ESQ., of Clark and White's Minstrels," who had been taking, he said, "great amounts of morphine" to relieve pain. However, it was only on his consuming Paine's compound he could finally attain relief allowing him to "do away with opiates" forever.[267]

Paine's Celery Compound advertising, College Street, Burlington, Vermont, circa 1910.
Champlain College Special Collections, Burlington, Vermont.

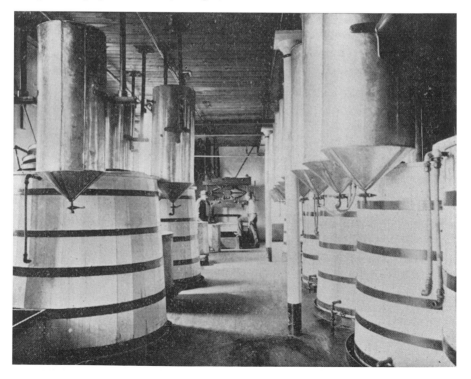

16,740 gallons of Paine's Celery Compound, Wells, Richardson Company, circa 1893.
Picturesque Burlington.

In 1887, Paine sold the compound's rights to Wells, Richardson, which immediately began a vigorous marketing campaign over the next two decades. This included obtaining many testimonials of its own from members of Congress and prominent ministers, bankers and business leaders. Aggressively possessive of the product, should anyone attempt to duplicate it, the company requested the public to let it know, promising, "We will put them where they belong—behind prison bars."[268]

Advertising went up everywhere, as many thousands of gallons were created at any one time in its Burlington facility, bottled up in its putting up room and shipped out to retailers around the world, who then displayed it according to the company's instructions for purchase by a thoroughly duped public. In fact, it was only following imposition of the 1906 Pure Food and Drug Act requiring the disclosure of medicine contents that the public learned of the presence of a staggering 20.0 percent alcohol, with only 1.5 percent vegetable extracts.[269] The finding so surprised the American Medical Association in 1917 it wrote that "Paine's Celery Compound without alcohol seemed almost as much of an anomaly as *Hamlet* with Hamlet left out." Further investigation at the time revealed that the company also acted in a duplicitous manner in marketing the compound in Canada. However, until those revelations took place, the late 1800s were very good indeed for manufacturer, wholesaler, retailer, dispenser and prescriber of patent medicines, each reaping in some fashion their share of the substantial amount of money flowing to them out of their customers' pockets.

❧❦

While many in the production and distribution of drugs simply turned a blind eye toward the harm their conduct caused, one organization stood out and refused to ignore the situation. In 1882, the state's Woman's Christian Temperance Union (founded in 1874) assumed a vanguard position in lobbying for legislation mandating temperance education for youth. Previously, children—already familiar with the stark reality of drugs in their lives because of exposure to them as infants—were instructed as early as 1859 in their *Vermont Speller* how to spell the noun "laudanum" and that it was derived from opium.[270]

Now the WCTU moved to increase the scope of its education and, actually finding a sympathetic ear in the legislature, backed the passage of the nation's first law requiring training in physiology and hygiene with added emphasis on

Lessons on the Human Body, 1885 edition, the nation's first children's school book to include instruction on narcotics as mandated by the Vermont legislature in November 1882. *Castleton University*.

"the effects of stimulants and narcotics on the human system."[271] Then, in school books rushed into production, Vermont children formally learned not only about the hazards of alcohol but also the origin, characteristics and effects of strong narcotics, specifically opium and chloral, then becoming popular as a pre-surgery sedative. The potential for their misuse was described in dire terms, and the children were warned that "*narcotics, one and all*, are, to those who have once fallen under their power, tyrants whose hold can hardly ever be shaken off, and which punish rebellion with torture, while they reward obedience with suffering almost as unendurable."[272] The WCTU's success was noted elsewhere, and by 1886, fourteen additional states had adopted similar legislation.

The WCTU continued in its efforts, creating specialized committees within the state's several chapters devoted specifically to narcotics and engaging in further outreach to the student population. In 1884, Burlington members sponsored a well-received contest for the area grammar and high schools seeking essays on "The evil effects of stimulants and narcotics," awarding fifty-dollar prizes to the winners.[273] The effort also provided additional benefits, as teachers became more familiar with the subject, earning in turn their superintendent's approbation, saying that they "entered into the work with much interest, and availed themselves of all accessible information which could be gained from public and private libraries, and from physicians and other well informed persons."[274]

The thirst for knowledge concerning the effects of drugs was widespread and that same year Enosburg Falls druggist Burney James Kendall exploited that need when he wrote *The Doctor at Home*, describing the many available substances and how to use them for various ailments, to include administering them to horses.[275] Kendall provided a chart to the reader recommending various doses for "an averaged-sized man," to include opium (one half to two grains and one quarter to one drachma for horses), paregoric (one teaspoon)

Dr. Denman calling on patients in Pawlet, Vermont, undated. *Vermont Historical Society*.

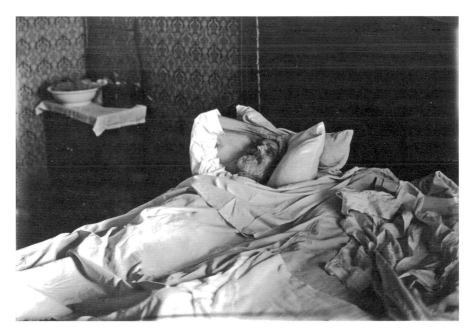

Dying man, photographed by R.C. Bristol, Bellows Falls, Vermont, circa 1900. *Vermont Historical Society.*

and laudanum (ten to twenty-five drops). However, these were only general guidelines, as he cautioned that people had to "study to know how to give the proper remedy, in the proper quantity, at the proper time, with proper hygienic measures." He intended his book to educate the public to such an extent that it could stand in when doctors were not around and, even when present, to act as their assistants.

People needed to know this information, Kendall said, because despite the good intentions of doctors, "there are hundreds of men practicing medicine who do not possess the good judgment which a physician needs above all men." In fact, despite the 1876 law requiring doctors' licensing, the state's medical profession as a whole lagged far behind, as the legislature ignored repeated calls for a centralized system to screen out the incompetents— demonstrating yet another example of laws passed but enforcement ignored. Certainly, overwhelming evidence of wrongdoing became evident with four bogus diploma mills reportedly issuing fraudulent medical credentials in Bennington, Newbury, Newfane and Rutland.[276] When in 1890 the VMS sought the assistance of the state's 562 practicing physicians to get to the bottom of it and verify their training, of the 312 taking the time to respond, 86 were found unlicensed. However, resigned to its inability to get lawmakers' attention on this easily corrected problem, the society simply noted that "politicians attach but trifling weight to medical opinions or wishes."[277] By 1897, Vermont was the only New England state that did not mandate physician competency, and the VMS labeled it a "dumping-ground for the rejected candidates" coming from neighboring states and Canada.[278] Five years later, so many doctors had arrived that Vermont now rated the highest per capita number of them than any other state.

The split within Vermont society concerning the use of alcohol and drugs in the 1890s and the legislature's blind attitude toward the medical profession could not have been more profound. From the perspective of some officials, despite clear evidence to the contrary, its four-decade-long experiment with prohibition was a huge success. As Frank Plumley, the U.S. Attorney for Vermont, proudly related in a sentiment shared by other leaders, "Take the State as a body, every year shows improvement, both in the vigor of enforcement of the law and the decreased intemperance and resulting crime."[279] However, a joint House and Senate legislative committee studying changes to the law at precisely the same moment adopted a wholly opposite view, noting instead the presence of pervasive "official corruption, perjury and fraud."[280]

The problem, the legislators said, existed because of the differences between rural and metropolitan areas in their backing of prohibition, with residents in the smaller towns and countryside feebly attempting to adhere and those in the larger cities living without a care of its dictates, all attended by widespread, blatant refusal to accept any form of enforcement. When officials in Washington inquired in 1891 what efforts Vermont took to deal with the adulteration of food, drugs and liquors, "nothing" was the sad answer. As the state board of health (established 1886) reported to the governor in response to the inquiry, no such investigation had ever been requested in the past. Further, even if one had been, they related that "no appropriation has been made...for this purpose." A bill introduced the prior year allowing for inspections "was killed."[281] As for the 1876 law regulating the practice of medicine, the most that could be said was that it "really amounts to but little."[282]

Numbers alone reveal the pervasive effect that alcohol had on politicians obsessed with its control, to the exclusion of anything having to do with drugs. Licensed retailers of alcohol in the state numbered no less than 498 in 1887 (with 30 bars in Montpelier and over 40 in both Burlington and Bennington), while the more innocuous pharmacy trade amounted to an unthreatening 105 establishments, manned by four hundred licensed pharmacists in 1895.[283] Further, the laws themselves confirm a similar myopic pursuit when, as noted earlier, 1894 statutes addressing prohibition's enforcement numbered 111, described over the course of twenty-two pages, whereas drugs amounted to a mere four sections on less than a single page. As Vermont governor Urban A. Woodbury lamented in his 1896 Farewell Address concerning the undue attention paid to prohibition, "We have law enough now. Our statutes are fairly groaning with the weight of it. Better one page of law that is enforced than a library full that is not and cannot be."[284]

When the complaints of responsible physicians concerning the drug problem are examined, a much more realistic picture is presented. As politicians publicly differed on the effectiveness of prohibition, in 1890, Vergennes doctor Elliot Wardsworth Shipman issued his own urgent call to his peers to exercise caution when using opium. An 1885 honors graduate of the University of Vermont Medical College, the idealistic twenty-eight-year-old was the only physician at the time practicing between Rutland and Burlington caring for diseases of the eye and ear.[285] Shipman seized the opportunity to speak before a large gathering of doctors at the VMS annual meeting on October 9 in the statehouse in Montpelier with an address titled

"The Promiscuous Use of Opium in Vermont."[286] The subject struck at the heart of what many believed a dire public emergency as they listened to other presenters describing deaths attributed to opium use. As one physician noted, following Shipman's presentation, more deaths occurred in the United States because of it than those caused by liquor, with most attributed to the consumption of soothing syrup.[287]

Shipman opened his talk describing his alarm over "the indiscriminate use of opium by the people of Vermont," calculating that they consumed "as much if not more *opium* and *morphine* than the same number of people anywhere in the United States." Then, calling attention to the "loose method in which this drug is handled," he went on to condemn the sad absence of any kind of official regulation concerning its sale and reasonably asked, "Is this right?" In his eyes, it certainly was not, memorably calling the situation "a crying evil of the day."

Describing his personal observations in Vergennes, Shipman related, "I have seen five victims of this habit enter a drug shop…and purchase what opium and morphine they desired, within less than two hours' time and no questions were asked." Calling on the state's doctors for assistance, he told them, "It seems to me that it is our duty as guardians of the public health, and as members of this Society to do all in our power to influence the passage of a law to mitigate this evil." Something had to be done to help the drug addicted because, he stated, while alcoholics were able to reform themselves, those opportunities for opium users were "exceedingly rare."

Shipman then described several sad cases he cared for: a forty-year-old doctor with a ten-year habit, injecting himself hypodermically resulting in his death; a gardener continuing to feed a six-year habit; a twenty-four-year-old girl told by a doctor tired of her complaints to purchase a hypodermic syringe to administer morphine to herself, resulting in her taking huge amounts daily; a man "eating opium for no other reason than its stimulating effects were more lasting than whiskey," carrying around as much as an ounce of opium gum in his pocket "and when he wants a piece to chew he cuts it with a knife as he would tobacco"; and a woman, also taking morphine hypodermically for the past six years, who first developed her habit because "she wanted something to give her rest, and used opium pills," transitioning to the needle and morphine because she "found its effects so pleasing."

Finally, there was the female suffering from menstrual problems who had consulted numerous doctors prescribing large amounts of opium, interspersed with "inhalations of chloroform," to no effect, allowing her to cultivate the insidious habit. Then Shipman revealed in telling fashion through his

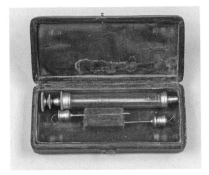

Tiemann & Company (New York) pocket case hypodermic syringe and two needles, patented 1877. *Dana Medical Library.*

subsequent actions the struggles that the medical establishment experienced in identifying and understanding the extent that opium could be used without causing harm. Concluding that the woman had become too accustomed to the drug, he decided to load her system with a huge amount of morphine in an attempt to overcome its resistance but without success. While she survived the experiment, he described it as "the largest quantity of morphine taken by any one person within 24 hours which has come to my knowledge. I have searched extensively through several libraries but can find nothing on record to compare with it." Shipman then ended his talk to his fellow doctors with a call to arms: "As a duty to the public let us endeavor to reduce the enormous sale of this drug in Vermont, and confer a lasting benefit on her people."

Three years later, in 1893, doctors in Chittenden County, including Shipman, formed the Burlington Clinical Society, meeting together periodically to hear presentations on local medical cases and discuss their treatment. Unsurprisingly, opium was of concern, and the following year one member described the extraordinary use of morphine by a woman with uterine cancer.[288] The cause for her condition remained a mystery, but their records disclose both the presence of much syphilis within the community as well as the "very prevalent" occurrence of so many illegal abortions taking place they called it a "habit." VMS minutes also describe doctors' concerns over criminal abortions dating back to at least 1870.

Considering that an eighth of a grain of morphine constituted a dose (one grain for opium), the treating doctor reported that the unwell woman injected herself hypodermically with four grains each hour for sixteen hours a day, followed by an additional four, totaling a large sixty-eight grains each day. Two months later, her consumption increased so much he felt compelled to relate that she was now up to ninety-six grains a day. Her final outcome is not recorded, but notably, as occurred with Shipman's experiment, at no point is there any indication of anyone's concern that the patient had become heavily addicted. Rather, the medical community compartmentalized the problem, viewing it as one of personal responsibility for the patient to deal with and not requiring

their intervention. As records from the Dartmouth Medical College defining the doctor-patient relationship at this time disclose, students received specific instructions in this regard: "Don't treat the opium habit at all. Let the patient go to an asylum."[289]

This seeming lack of empathy exhibited by the medical profession to their patients' drug addictions cannot necessarily be attributed to a lack of understanding of the problem. Students repeatedly heard from their instructors telling them the appropriate dosages of opium, particularly those administered to susceptible infants, children and women. "Women feel the excitant effect more than men, especially hypodermically" they were told, whereas "in young kids opium has a powerful effect.…They go to sleep and don't wake up."

However, for the drug abuser, they deserved, and received, lesser consideration, as students were instructed that the "chief value of opium to the habitués is its power to produce bien-être [wellness] and relieve the opposed languor and general malaise." "Don't allow a patient to have a hypodermic syringe," they were told. "Stick him yourself. The extra charge will do him no harm."[290] If any thought was given toward providing an alternative to the abuser, they were simply instructed to administer cannabis. Notwithstanding either situation, as University of Vermont professor of *materia medica* and therapeutics Dr. Julius Hayden Woodward bemoaned to VMS members in 1895, "One of the greatest difficulties he had in teaching medical students was to impress on them the importance of knowing the physiological allur[e] of drugs" and the looming problem they posed.

As Elliot Shipman noted in his description of several opium-addicted patients in 1890, the medical profession was also represented among them. This decade, and into the early years of the twentieth century, saw innumerable instances of the physician addict, particularly among those practicing in the countryside. While particular statistics are lacking for those in Vermont, other studies elsewhere determined that between 16 and 23 percent of the profession had become addicted to morphine by the early twentieth century.[291]

One of the most noteworthy Vermont examples of the addicted doctor concerned William Seward Webb, the husband of Eliza Osgood Vanderbilt and creator of the innovative, but short-lived, 3,800-acre agricultural expcriment called Shelburne Farms, located on the shores of Lake Champlain. Webb graduated from Columbia College in 1875 as a surgeon and after marrying in 1881 became involved in the Vanderbilt railway business, later acquiring the Vermont land in 1886 using some of Eliza's

University of Vermont medical students displaying various teaching aids; on reverse, "[1897 class] Grinnell." *Special Collections, University of Vermont.*

$10 million inheritance. He began using laudanum in 1879 to treat "worry and neuralgia," only to escalate to powerful morphine by the mid-1890s because of increasing physical complaints relating to rheumatoid arthritis.[292] His ensuing period of addiction, lasting until his death in 1926, was fraught with numerous attempts to wean himself off the highly addictive substance. Calling on the aid of several friends for help, accompanied by periods of self-imposed isolation at his Adirondack retreat and trips to Europe, Florida and Cuba, Webb struggled to regain control of his life. When he consulted a local physician about his frustrating, ongoing desire to use morphine as he rationed out small portions to himself, he was told to take a very large dose in the continuing professional belief it would overcome his cravings—but without success. His problems only worsened, precluding any thought of running for governor in 1905 and forcing him to absent himself on one occasion from meeting President Howard Taft at the time of his visit to the farm in 1909.

As Webb attempted to deal with his addiction by himself, others of lesser means turned to the growing rehabilitation industry offering various cures.

University of Vermont Medical College class of 1890. *Special Collections, University of Vermont.*

University of Vermont medical students, undated. *Special Collections, University of Vermont.*

Dr. William Seward Webb, morphine addict, in his Vermont militia uniform, by L. Alman & Company, New York, circa 1888. *Shelburne Farms Collections, Shelburne, Vermont.*

On June 22, 1892, Montpelier attorney William A. Lord, "considered as one of the best criminal lawyers in the state," became the first patient to walk through the front doors of the Keeley Institute, located in the Vermont Mutual Fire Insurance company building on State Street, to begin a course of treatment for his particular addiction. The creation of Dr. Leslie E.

Right: Leslie E. Keeley, MD, LLD, December 5, 1892. *National Library of Medicine.*

Below: Keeley Institute reunion, Montpelier, Vermont, 1893. *Vermont Historical Society.*

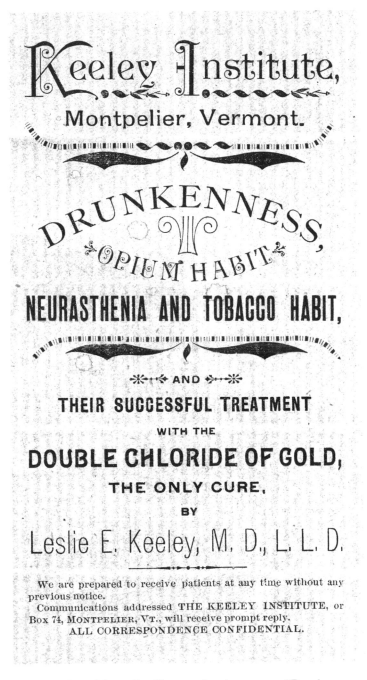

Keeley Institute, Montpelier, Vermont, brochure to cure "Drunkenness, Opium Habit, Neurasthenia and Tobacco Habit," 1892. *Henry Sheldon Museum, Middlebury, Vermont.*

Keeley of Dwight, Illinois, in 1880, his so-called Gold Cure became the rage of the times that saw thousands of substance-abusing addicts turning from ineffective nostrums offering relief and flocking to his various franchises opening up around the country, including Montpelier and Rutland. Keeley promised to provide relief from "Drunkenness, Opium Habit, Neurasthenia [nervousness] and Tobacco Habit" utilizing the "Double Chloride of Gold, the Only Cure." Employing a strict protocol, customers received four daily injections of gold in solution at precise times over the course of three weeks for alcoholics and "four or more weeks for the morphine habit."[293]

While Keeley's controversial experiment folded after a relatively short period in 1895, it did attract large numbers. In its first year alone, the Montpelier branch saw some 367 patients (obtaining a reported 97 percent recovery rate), marking the occasion by a large reunion led off in parade by the Montpelier Military Band.[294] However, even after its demise, Vermonters could still obtain help for their addictions from the Morrell Liquor Cure Company of Massachusetts, as it also offered the chloride of gold formula to correct liquor, opium and tobacco addictions. Its purported success rate is not known, but it, too, went out of business in the following decade.

8

3,300,000 DOSES

The late 1890s reveals a Vermont drug industry practicing questionable ethics and engaging in conduct bordering on the illegal, with many otherwise responsible pharmacists attracted to the easy profits that the sale of alcohol allowed them. Their numbers increased so rapidly in Burlington that it drew the attention of their peers nationally, noting that together with the many additional apothecary shops opening up "the doctors will have all they can do to give all of them business enough to live."[295] Taking advantage of the increased opportunities for sales that the presence of so many druggists presented at their annual meeting in 1895, and which they did so much to facilitate, local manufacturers Wells, Richardson Company and the Burlington Drug Company joined together in hiring the steamship *Reindeer* to take the assemblage for an enjoyable summer day out on the lake.[296]

Druggists plastered signs advertising their medicines virtually everywhere, including all over the town's breakwater (where federal officials immediately stepped in and obliterated the lettering) and to the sides of every structure they could find southward as far as William Seward Webb's hometown in Shelburne. The records are replete with sheriffs conducting numerous raids on their establishments in Burlington (six in one day alone), Winooski, Rutland, Bellows Falls and places in between as they seized their barrels, bottles and jugs of gin, whiskey, brandy and wine. Many druggists' names, some repeat offenders and in one instance the wife of one, appear in arrest and court records for operating without licenses or selling alcohol

Montpelier apothecary store, late 1800s. *Vermont Historical Society.*

for reasons other than medicinal. Accounts of burglaries of drugstores are present, as well as an actual death taking place in one Barre location. On that occasion, two men entered the store, "both under the influence of liquor…and asked for a drink of wintergreen to relieve their feelings. Being told to help themselves they went behind the counter and, mistaking the bottle, took a drink of carbolic acid," resulting in the demise of one of them a shortly thereafter. Surprised that such a thing could happen, a national trade journal reporting the incident reasonably asked, "Why such carelessness in a drug store?"[297]

Depressed and suicidal Vermonters also found drugstores a convenient place to seek out means for their solace and demise. It became so prevalent that in 1899 Dr. J.C.F. With described for the VMS the startling situation:

We have all of us had our experiences with the opium and morphine user. They enter our stores, and under one pretext or another call for the article. Not one of them would we trust with an ounce or a pound....It would seem that honesty is an unknown characteristic to them; have it they must by fair means or foul. I have seen a man get from a druggist an eight-ounce bottle of laudanum, tear the wrapper off and deliberately drink half the contents. I looked on in amazement, thinking surely it was a deliberate attempt at suicide; but it proved not so, for it simply quickly restored the man to a normal condition, whereas he was fearfully nervous and agitated when he entered.[298]

On another occasion reported nationally, "A man who tried to commit suicide in Burlington...by using laudanum, said that his brother killed himself in that way a dozen years ago, and his sister also is a slave to the drug."[299] Confirming the phenomenon, contemporary newspapers also describe many instances of Vermonters dying for a variety of reasons by injecting morphine or drinking laudanum.

Addictions attributed to physician, or iatrogenic, overprescribing of opium and morphine continued. In 1896, Dr. F.W. Comings of Derby made that point yet again in another presentation to the state's doctors, echoing the warnings others made over the past decade in his "Opium. Its Uses and Abuses."[300] In describing the errant, indiscriminate use of the drug, he attributed many instances arising within the female portion of the population because of its administration

for all sorts of aches and pains in chronic pelvic and nervous ailments; in the prescribing of "cough syrups;" in its administration in obstetric practice for the purpose of relieving "after-pains;" in the acute chest and nervous troubles of infancy and childhood and in the too common use of it in so-called "soothing syrups," paregoric and other vile mixtures which are made use of by lazy and ignorant mothers and nurses who care more for their own use and comfort than for the good of their little ones.

The end result, Comings said, rested squarely with the medical profession, telling them, "I speak from experience when I say that out of every ten cases of addiction I believe some doctor was responsible for nine of them." To his mind the situation was intolerable, "I can hardly find words strong enough with which to condemn the careless—nay criminal—prescribing of opium in chronic cases." The harm inflicted on the population required a remedy, and he warned it was time for the medical profession to right its ways and be

more truthful with patients regarding the hazards of opium. It was his hope that "by doing so we shall in some measure atone for the mistakes made by some of the more careless of the profession in too prolonged and injudicious administration of the drug."

While the medical establishment continued to struggle with the conduct of its members and gain credibility with the legislature, in 1894—virtually the last state to do so—Vermont finally created a board of pharmacy to try and corral the wild distribution of drugs.[301] From this point on, those working in the state's drugstores had to obtain a license issued by the board identifying them as either skilled, registered or registered assistants and post it in a conspicuous public place in their business. As a result, hundreds of men already in the trade rushed to file their applications for licenses before a spring deadline required their testing to obtain one. Members of the board were heartened by the response, and in August 1895, President A.W. Higgins expressed the hope before a national convention that through the board's efforts, Vermont could finally take "its place pharmaceutically among other states in the Union."[302]

First Board of Pharmacy of Vermont, 1895. From left to right are (*standing*) Collins Blakely and C.C. Bingham; (*seated*) F. W. Pierce (treasurer), A.W. Higgins (president) and J.G. Bellrose (secretary). *Vermont State Archives.*

Higgins also recognized the pernicious effects of powerful manufacturers when they sold their goods to a minority of druggists unhesitant to greatly undercut the prices of others, forcing financial hardship on them. He then succeeded in gaining an endorsement of actions taken by the Apothecaries' Guild of Boston a week earlier promising to patronize only those manufacturers, which included Wells, Richardson and Burlington Drug Company, refusing to sell to the "price cutters." These actions certainly appear objectively reasonable, but it is important to note the coercive nature attending them. When Massachusetts druggists received their invitations by organizers to join in the effort, they also received a veiled threat telling them that "we count on your assistance. Failing to get such assistance, it would not be strange if the retail druggists of New England should regard you as hostile to their interests and to the public good."[303]

The possibility of repercussions notwithstanding, in aligning their actions with other New England druggists, the Vermonters simply fell into lockstep, demonstrating their overriding concern with preserving their economic interests above all else. However, even in such a seemingly cooperative atmosphere, huge disagreements arose with druggists protective of their rights to sell drugs trying to exclude other kinds of stores from doing the same thing. In 1899, a Burlington tobacco store instituted a line of cut-rate patent medicines, prompting a local drugstore to then offer cigars in retaliation. This resulted in "a lively war" that saw many druggists coming to their brother's aid and offering medicines at largely discounted rates to force the tobacco store to abandon the effort. Fortunately, intervention by wholesale tobacconists and grocers forced the offending store to withdraw his medicines, and peace returned.

In the meantime, retiring governor Woodbury lectured to a joint assembly of the legislature on the continuing violations of prohibition taking place, asking that Higgins's board receive additional authority "to annul the licenses of druggists who are convicted of illegal selling" of liquor.[304] Notably, his reference to the interplay of men in the business of selling drugs and alcohol as medicine constitutes virtually the only expression by the state's chief executive concerning Vermonters' welfare in the context of drugs for many decades as undeniable evidence of widespread addiction exploded onto the scene.

As prohibition gripped the attention of the lawmakers, in late 1899, one of the state's leading physicians sought to change the direction of the conversation—certainly an appropriate measure at this moment in the nation's Progressive Era. Previously, authorities in other parts of the country recognizing their own drug difficulties undertook studies of varying worth to understand the problem, including Michigan (1878), Chicago (1880), Iowa (1885) and Massachusetts (1888). However, in their heavy reliance on anecdotal evidence from physicians and druggists, none delved deeply enough to ascertain the specific amounts of the drugs present in their communities. That situation changed dramatically with

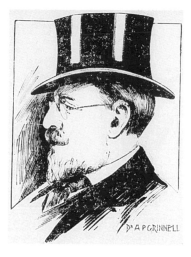

Dr. A.P. Grinnell, 1901. *New York Public Library.*

the important work conducted by Dr. Ashbel Parmelee Grinnell, dean of the faculty at the University of Vermont Medical Department, professor of the theory and practice of medicine and consulting physician to Mary Fletcher and Fanny Allen Hospitals.

Fifty-five years of age at the time, Grinnell was held in high esteem among his colleagues and students who recalled his interest and assistance to them in their early careers. He attracted many to his lectures and drew the avid attention of listeners when delivering talks as an after-dinner speaker. He also attended meetings of the Burlington Clinical Society, and his name appears regularly in their minutes and as a contributor to discussions on various medical issues. It is also clear that Grinnell shared the views of many others at the time, as expressed a decade earlier by fellow member Elliott Shipman, condemning the pervasive presence and abuse of opium in the state.

Grinnell brought a pragmatic, realistic view in studying substance abuse, concentrating his interest on the harm that opium posed rather than simply abiding the public's preoccupation with prohibition. However, he did not dismiss that problem and made it a point to note the pervasiveness of alcohol in the community, unhesitatingly presenting evidence directly at odds with the politicians. While Governor Woodbury expressed the view in 1896 that the conduct of the state's National Guard "in camp [Fort Ethan Allen] this year has never been excelled," Grinnell's investigation revealed

otherwise. In fact, these men attending their annual muster consumed so much alcohol that it caused significant problems for the commanding officer. Confiding in Grinnell, he told him that in all his experiences in military installations in the West, where many saloons existed, he had never seen such drunkenness as he witnessed in Vermont. "I can't understand it," the officer told him, "but it is true."[305]

Propelled by such examples and accumulating evidence coming from throughout the medical profession concerning opiate abuse, in January 1900, Grinnell decided to write to the state's drug suppliers seeking their assistance. He believed that prohibition, despite its enforcement problems, had forced many to simply transition to another form of stimulant. With this information, he could then go to the legislature, intending "to open its eyes to the fact that there is something besides alcohol that can spoil moral development and mental capacity." As it turned out, the results of his inquiry exceeded his wildest expectations, leaving him dumbfounded at what he had uncovered: "I have been so astonished, so amazed at the result of my investigation."[306] Propelled by the enthusiastic, widespread response the report generated both in and outside the state, Grinnell went on to write "Stimulants in Forensic Medicine and a Review of Drug Consumption in Vermont" in 1901 and a third effort in 1905, "A Review of Drug Consumption and Alcohol as Found in Proprietary Medicine."

Obtaining the necessary cooperation and information from the state's physicians (numbering 690), druggists (130), wholesale drugstores (5), general stores (172) and manufacturers (3, but also employing an indeterminate number of roving "pedestrian peddlers") presented a problem from the onset. Enclosing a stamped envelope to return their information, Grinnell explained he was preparing a paper for the state medical society "upon the use of opium and other anodynes," promising that "I have no intention of making use of your name whatever." He then requested that they provide him with an estimate of their monthly sales of opium, morphine, Dover's Powder, paregoric, laudanum, cocaine, chloral, Indian hemp and quinine.

Their responses varied, with some refusing to participate at all and others suspicious and evasive, "intimating they thought there was some investigation going on and did not care to answer the questions." The wholesalers were more direct, simply inferring that Grinnell "was making illegitimate inquiries of them…thinking I was playing some game on them." Accordingly, he decided to simply exclude them from his calculations, resting his findings on those sales reported by 116 retail drugstores and 160 general stores. Responses from physicians were also omitted after learning that no

less than 90 percent of them said they dispensed their own medicines and had not purchased them from druggists, inferring they worked directly with wholesalers. On reviewing the initial responses, he thought them excessive, attributing them to yearly sales, but after writing again learned they were accurate monthly amounts. In the end, Grinnell concluded that his findings could easily be multiplied by a factor of five to establish the actual amount of these drugs sold.

Some of the reports are so startling they merit repeating. One store, located in "a place so small it hardly appears upon the map," sold every month three and and a half pounds of gum opium, six ounces of morphine, five pints of paregoric, five pints of laudanum and three ounces of quinine. In another town with two drugstores (one refused to participate), one reported that it sold three pounds of opium, one gallon of paregoric, three-quarters of a gallon of laudanum, five ounces of quinine and one thousand quinine pills. In a third town, with a population of over ten thousand and eleven drugstores, a single one reported selling five ounces of opium, two ounces of morphine, eight quarts of laudanum and six quarts of paregoric.

When added up, the numbers revealed statewide monthly sales of over forty-seven pounds of opium; nineteen pounds of morphine; 3,300 grains of morphine pills; twenty-five pounds of Dover's pills; thirty-two gallons

M.E. Baxter, Groceries and Drugs, Marlboro, Vermont, 1909, Porter C. Thayer, photographer. *Brooks Memorial Library, Brattleboro, Vermont.*

each of laudanum and paregoric; twenty-seven ounces of cocaine; thirty-two pounds of chloral; thirty-seven ounces of hemp; fifteen pounds of quinine; and 74,200 grains of quinine pills. Importantly, aside from excluding those amounts reported by doctors, none of these figures included drugs hawked by roving peddlers, those contained in the many patent medicines or the fact that residents living on the shores of Lake Champlain frequently made their purchases in New York, where prices were cheaper.

With these numbers, Grinnell made his grim assessment based on a population of 320,000 (actual 1900 census figure is 343,641) and average dose taken by an individual, finding that Vermonters consumed an incredible 3,300,000 doses of opium each and every month. If one of those month's distributions constituted a daily dosing of one and a half grains for every adult man and woman in the state for an entire year as he calculated, then twelve months of the same would result in a similar increase (eighteen grains) each and every day. Compounding the problem, the distribution of the many alcohol-infused "tonics," "blood restoratives" and "alcoholic cures" sold by "public benefactors…the so-called guardians of the human race" composed of the druggists and manufacturers amounted to more than all of that attributed to the legitimate sellers combined. The numbers were simply staggering.

The immediate effects of Grinnell's work drew the attention of physicians in other states, who wrote for further information on the phenomenon. Locally, the only reference to it appears to come from the pharmaceutical trade when one of its members made a passing reference, saying, "He has spent lots of time and money in getting correct information [on drug habits] and in all earnestness I say he is entitled to the credit of the people of the State."[307] For the public, the *Boston Globe* reported that "his results are little less than startling," expressing the hope that now "her men of light and leading will do equally well if they give prompt and candid consideration to remedial measures."[308]

However, in Barre, the news hardly raised attention, with one paper joking:

> *The casual reader or the visitor to Vermont would naturally infer that every resident carried a hypodermic syringe and that every few minutes he pricked his arm and became happy. Or, he might be inclined to look around expecting to see everybody chewing poison as people chew tutti-frutti or hitting the pipe as do our brothers of the Celestial kingdom.*[309]

But in St. Albans, drug usage was no laughing matter, and one writer noted that even some involved with the temperance movement consumed this alternative form of stimulant:

> It is a habit in its very nature so essentially private and so susceptible of secrecy that it may be indulged without fear of detection for years. It is a vice that may be, and that consequently is, practiced by thousands of men and women who maintain before the world every outward manifestation and appearance of high moral character and the most prudent and abstemious virtues. They may even pose as workers in reform movements and carry about them all the air of sincere devotion to the public weal. They may be publicly esteemed as the enemies of alcoholic intemperance, and at the same time secretly indulge themselves in a debauchery of mind and body with which even the liquor habit is not to be compared.[310]

While isolating definitive causes for the rapid increase in opiate abuse remains elusive, one contemporary argument attributed it to rapid changes taking place in society causing people to become unnerved and then seeking solace in various stimulants, a condition that Keeley sought to correct, called "neurasthenia."[311]

Identifying the specific number of addicts is also problematic, as the accumulation of health-related statistics in Vermont, notwithstanding laws requiring their gathering, continued to be of little importance, much to the frustration of policymakers. Inevitably, treatment for those abusing drugs fell to family members able to privately arrange and pay for institutionalization. They did so through an enforceable probate court order requiring the abuser's confinement when deemed unable to care for themselves or when they simply appeared at the Vermont State Asylum for the Insane in Waterbury (founded 1890, later called the Vermont State Hospital), forcing the state to then assume their care.

Entries regarding their admissions provide little insight into the specifics of particular drug usage, but it is clear a pivotal moment arrived in the overall understanding of addiction. In 1883, the superintendent of a private asylum in Brattleboro caring for the insane calculated that of the one hundred residents confined there, 6.4 percent of the overall population (all male) attributed their problem to intemperance, an all-inclusive term failing to distinguish between alcohol and drugs.[312] By 1901, officials had begun recording more descriptive names for these ailments, such as morphinism, cocainism and narcotics rather than those used for other patients that

included heredity, syphilis, epilepsy, masturbation, overwork, domestic infelicity, domestic affliction or disappointment in love.[313]

The numbers of court-ordered drug-related admissions were never large and remained the very last of reasons for some time. In 1901, only 4 individuals are identified with morphine problems, and in 1918, 8 out of an overall population of 737 found themselves detained pursuant to court order.[314] Similarly, in 1922 only 3 drug addicts are listed out of 770 residents.[315] However, at the same time, there were many names listed in the hospital's "Roster of Inebriates and Dipsomaniacs" seeking assistance for morphine addiction and enrolling themselves on a voluntary basis.[316]

In 1918, the special committee of investigation appointed by the secretary of the treasury surveyed physicians around the country, concluding there were 237,655 addicts under their care. Of that number, 1,554 were attributed to Vermont. In neighboring states, the numbers were New York, 37,095; Massachusetts, 13,770; New Hampshire, 3,460; and Maine, 1,084. After obtaining data from additional sources, the committee determined there were more than 1 million addicts in the country.[317] However, in 1921, a distinguished group of medical and education practitioners reviewed these numerous studies, and noting the wide range in estimates of addicts nationally (from between a few thousand to over 2 million), simply concluded it was impossible to obtain an accurate figure.[318]

Over the following decades, various investigators examined the addiction issue even more closely, with one concluding that at the peak of the country's drug abuse at the turn of the century there were an estimated 250,000 addicts residing within a population of 76 million, "a rate so far never equaled or exceeded."[319] Utilizing the findings of another, who calculated an average of 4.59 addicts per 1,000 people, Vermont's population of 343,641 in 1900 results in an estimated 1,577 individuals suffering from addiction.[320]

Grinnell's study is also enlightening when considering the national rate of consumption over the passage of time. In the 1840s, the average annual per capita consumption of crude opium was 12 grains (approximately two aspirins), rising to an estimated 52 grains by the 1890s.[321] Using Grinnell's calculation of 6 grains daily for each Vermonter, or 2,190 over the course of a year, the state's druggists sold amounts far in excess of the rest of the country.[322] In fact, one analyst at the time studying Grinnell's work concluded that Vermonters' consumption of such a large quantity of opium could not possibly be attributed to medicinal use but, rather, to "a large number of habitual users."[323] Certainly the state's population in general was not

staggering about publicly under the wholesale influence of opium at that moment. But it is undeniable that many—doctor, patient and common addict alike—ingested it in a private manner by one of the three ways then in vogue: by mouth, rectum or vagina; via respiratory mucous membrane through smoking or smelling; or by hypodermic syringe.

Questions abound: was it merely a coincidence that prohibition-era Vermont experienced a notorious drug epidemic seemingly out of all proportion to that of other states? How much influence did the lobbying effects of special interests have, such as the pharmaceutical trade, on a legislature that focused so heavily on alcohol issues to the detriment of its inhabitants' becoming addicted to drugs? Why did Grinnell receive noticeably less than enthusiastic

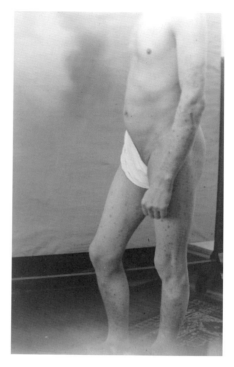

Morphine-cocaine patient, Vermont State Hospital, circa 1900. *Vermont State Archives.*

support for his inquiries unless there was something to hide, such as addicted doctors or persons of repute or to otherwise protect the lucrative, unregulated trade that the medical and pharmaceutical professions relied on? Why were remote Vermont towns, those not even on a map, reporting huge sales of narcotics unless it was for the use of the local population? And why were Vermonters living near Lake Champlain traveling to New York for cheaper drugs unless it was to feed their own addictions?

9

AFTERMATH

As surrounding states began passing laws addressing strong narcotics, Vermont remained steadfastly absent from the effort. To understand why legislators in Montpelier continued in this manner one need look no further than statements made by governors at the beginning and ending of their terms. As the past century so richly demonstrated, Vermonters prided themselves over others for their devotion to minimalist government, exemplified by their town meetings, allowing officialdom to intervene into their lives only when overriding necessity demanded it. The problems that alcohol caused in the century's early years constituted one of those rare moments resulting in prohibition in 1852 but only after a difficult decades-long campaign for change. Meanwhile, the effects of drugs continued to simmer in the background unable to convince officials of the need for similar political action.

In 1902, Governor John McCullough opened his inaugural address by admitting that his duties "are neither many nor arduous" while observing a similar situation in the legislature where its powers "are only called into exercise in the mildest degree."[324] The reason for such hands-off involvement, he said, were attributable to the fact that "the people govern themselves…[because] a state whose citizens have mastered the problem of self-government is best governed when least governed."

While McCullough had much to say about prohibition in this particular election year, the most attention that drugs drew was a passing recommendation that druggists "should be authorized to sell only in small

quantities and only on the written prescription of a physician not interested in the store." It is indeed a curious, myopic comment from the state's chief executive in light of the overwhelming evidence of the use of drugs that Grinnell recently exposed and the fact that it had also become woven into the current campaign. As gubernatorial candidate Percival Clement forcefully stated in arguing for change with the prohibition laws, and no doubt echoing Grinnell's findings, "There is more morphine, chloral, opium and kindred drugs consumed in our state per capita than in any other state in the Union."[325] Nobody could claim otherwise, but the record is starkly devoid of officials ever acknowledging the fact or considering any kind of action.

It took more than another decade, and the outbreak of war in Europe, before Vermont's leaders felt compelled to address the drug problem that so openly presented itself. As Governor Charles Gates described in 1915, "Never before have the voters of the state taken more active notice of the acts of its public servants than at the present time," while noting the radical changes afoot in the business, social and political arenas.[326] This, he said, then imposed on the lawmakers a new burden, as many sought to "place upon the central government many varied powers and responsibilities that heretofore rested with the people themselves. Just how far we, as a state, should go toward parental government, will be the question often to be considered in our deliberations, and our determinations will require our wisest judgment."

However, before meaningful legislation could be enacted, the state witnessed a decade of great resistance to any reforms inhibiting their easy access to drugs because of efforts attributable to, in part, the Vermont State Pharmaceutical Association (the successor to the VPA).

In this era of Roosevelt-led attacks on the nation's large monopolistic conglomerates, the National Association of Retail Druggists that Vermont pharmacists affiliated with found itself labeled as one of society's enemies as "The Drug Trust." This effort threatened to prohibit their agreeing among themselves to set up a pricing system protecting their profitable margins, then under great strain from foreign manufacturers able to undercut them. Druggists in Vermont's counties, reportedly at "swords points" in their vigorous competition against one another, created separate associations and agreed to price drugs similarly and to close their stores on Sundays at noon and not to reopen later in the day. As the minutes of their 1906 annual meeting in Burlington reveal, this was a moment aimed at their economic survival and supporting the national organization in its opposition to threatening legislation rather than addressing the state's

addiction problem.[327] Despite the association's internal disagreements, its loyalty to those wholesalers and retailers spending money on advertising was also clear, as it repeatedly cautioned members to purchase only from them, inferring some form of retribution if they did otherwise: "A word to the wise is sufficient." With only $68.17 in ready cash on the books, there is no way the druggists could afford the elaborate steamship ride over to New York, railroad excursion and lavish dinner provided to the 198 attendees, leaving only the silent testimony of the power that wholesaler Wells, Richardson continued to wield over them and their unceasing need to nurture that relationship.

Additionally, as one newspaper described the paucity of legislative action in fighting the plague of abuse in 1908, it was "the small country merchants, who deal in 'dope' without any knowledge of its dangerous effects, the regular druggists, who don't like to have their business interfered with, and the physicians, who see no advantage, and some possible bother, to themselves" standing in the way.[328] Continuing in that vein, in 1919, the VSPA proudly told its members that it had once again obstructed the passage of "the old narcotic bill" repeatedly introduced by a Burlington representative seeking to prohibit the sale of narcotics without a doctor's prescription, telling them "we killed that in the Senate."[329] Too many interests wanted to maintain the status quo and fought intrusive laws threatening their lucrative pursuits. Meanwhile, the public continued to hear repeated examples of harm related to drugs: "A morphine fiend nearly slugged the life out of a leading Waterbury citizen last week while suffering the cravings of the habit."[330]

The most that Vermont agreed to do at the moment meant following the national lead in requiring medicines to be accurately labeled and naming the ingredients they contained. In 1905, Upton Sinclair wrote *The Jungle*, revealing the horrors of the Chicago meatpacking industry, and *Collier's* magazine exposed the pervasive adulteration of patent medicines and the advertising fraud that accompanied them, raising national concern over the substances Americans ingested. That same year, Congress outlawed the importation of opium except for medicinal purposes, followed in 1906 by the Pure Food and Drug Act curbing trafficking in adulterated or misbranded foods, drugs, medicines and liquors.

Finally, in late 1906, Vermont joined in fighting the drug charade, amending a toothless 1904 law, now requiring that foods and drugs be unadulterated and accurately labeled.[331] Concerning the distribution of strong drugs, including opium, the law only required pharmacists to record the particulars of sales and to open their books to officials making inquiries.

Violations of these new rules, taking effect the following July, amounted only to fines of between $50 and $100, with no potential for incarceration.

It did not take long to expose and prosecute the most blatant scammers. Under a headline "BORAX FOR BEANS. Vermont Authorities Find Glaring Violations of Pure Food Law," a national trade journal announced in 1907 the egregious extent that some went to.[332] Calling them "startling revelations," the article described the state health laboratory's identifying a medicine labeled "Mexican beans" as nothing more than borax. In other cases, a Vermont-made preparation labeled as containing 9 percent alcohol actually had 60 percent, and another supposedly made up of 20 percent alcohol had 9 percent. "Altogether about 25 samples have been examined," the journal related, "a considerable portion of them being found to bear misleading labels."

Perhaps the most notorious violation involved the arrival of highly addictive heroin marketed by the popular Montpelier-based Lester H. Greene company in the form of "Greene's Warranted Syrup of Tar," a purported remedy for coughs and colds. Advertised heavily in the state's pharmaceutical minutes for several years, Greene promised druggists an 80 percent profit on sales, coaxing them to stock the product with a cajoling "Can you afford not to push it?" Many of the state's responsible pharmacists attested to its positive effects. In 1901, one speaker before the VSPA related several of their names, including past president of the board of pharmacy A.W. Higgins, while describing instances of stores selling it ten times more frequently than any other similar concoction.[333] He also offered a bit of poetry on its behalf:

> *There is a young man in New York*
> *Who has such a cold he can't tork* [talk]*;*
> *A friend from afar sent Syrup of Tar*
> *He'll be well when he smells of the cork.*

What Greene did not tell anyone concerned the concoction's presence of heroin, which, together with other ingredients, allowed for such positive results for ailments.

The tide began to turn for companies such as Greene's, and following passage of the 1906 law, investigators made inroads on their operations. In 1908, Governor George Prouty proudly noted at his inaugural that "it is impossible to state the great benefit" obtained because of their enforcement activities, recommending that the pursuit of adulterated substances "should

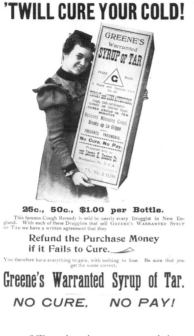

'TWILL CURE YOUR COLD!

25c., 50c., $1.00 per Bottle.

This famous Cough Remedy is sold by nearly every Druggist in New England. With each of these Druggists that sell Greene's Warranted Syrup of Tar we have a written agreement that they

**Refund the Purchase Money
if it Fails to Cure.**

You therefore have everything to gain, with nothing to lose. Be sure that you get the name correct,

Greene's Warranted Syrup of Tar.

NO CURE, NO PAY!

Syrup of Tar advertisement, containing alcohol, heroin and chloroform, manufactured by Lester H. Greene Company, Montpelier, Vermont, 1898. *Vermont Historical Society.*

have constant supervision."[334] A year later, the Burlington state's attorney, lacking a trustworthy police force, continued in that vein and hired the services of the Boston-based Wood-Morgan Detective Agency to make a number of inquiries locally. Unnamed, the mysterious "Operative No. 2" then went to eleven different drugstores on July 9 and made several purchases of suspect substances, including Greene's Syrup of Tar.[335] The results of that particular investigation are not disclosed, but in March 1916, the company found itself prosecuted for misbranding and entered a guilty plea in the U.S. District Court, paying a $50 fine.[336] Similarly, in 1915 Vergennes drug manufacturer Dr. H.A. Ingham & Company, producing "Ingham's Vegetable Expectorant Nervine Pain Extractor" to treat all manner of ailment, including "suspended animation," paid a $100 fine for two counts of misbranding. The most egregious of the counts concerned its representation that "for teething and restless children, it is not only safe and harmless, but positively beneficial," when, in fact, it contained not only 86 percent alcohol but also morphine and other opium alkaloids.[337]

The Wood-Morgan operatives, including off-duty Boston inspectors, continued in their secret work, repeatedly called in by several other state's attorneys and the attorney general himself, as they fanned out over the state. Their efforts included surveilling many drugstores for continuing illegal alcohol sales and penetrating the means they used to avoid detection. Careful to avoid unwanted attention, druggists in towns where courts sat in rotation made certain to suspend their illegal activities while in session, with one promising thirsty customers he planned to "sell full blast" once it recessed. Corrupt cops throwing dice and working billiard tables, prostitutes Minnie Corbin and Mrs. Clara James servicing their clients ("dirtiest spoken women

I ever met" Operative No. 24 wrote), men surreptitiously supplying "rum sick" loggers in far off lumber camps and the suspicious actions of suspected pharmacists were identified and reported to authorities. The investigators learned the coded ways used by customers inquiring if a druggist had alcohol available, crossing fingers laid on a counter and giving a number indicating the amount of Speckled Trout Pure Rye Whiskey, Los Angeles, Red Eye and Jamaica Ginger they wanted, concoctions of questionable composition. However, some became so concerned for their own well-being working in an environment dripping with suspicion by closely watching locals that they suspended operations and left.

In Rutland, corruption ruled on several levels, as out-of-state breweries seeking to avoid the law invested in local bars and obtained licenses they could not otherwise have obtained. Local liquor commissioners beholden to assistant judges for their appointments allowed it to occur, resulting in tax-avoidance schemes that led Percival Clement to report to the attorney general in 1912 that he was "thoroughly disgusted" with the scandalous actions of the judges.[338]

Other forms of drug abuse continued, including the use of opium to kill unwanted children. In Shelburne Falls, Mrs. Samuel Myers fell under suspicion in 1910 following the death of her infant child, the fourth in the family to do so in the past eight years.[339] In certainly not the only case of its kind, an investigation by a local doctor and the sheriff discovered evidence of heavy drug usage when twenty-three empty paregoric bottles were found hidden in her barn and received reports from neighbors of her saying "she did not want any children, as they were too poor." When confronted, the mother admitted her involvement, explaining that she fed a full bottle of the substance to her baby the prior evening "to make her sleep."

In 1912, a Rutland pharmacist and member of the board of pharmacy reported witnessing the continued sale of huge amounts of drugs in his city. As he calculated it, the community of twelve to thirteen thousand individuals purchased a staggering 400,000 morphine tablets every year, with less than 10 percent of that attributable to filling doctors' prescriptions. Additionally, as the paper reporting the astounding news related, the "Rutland drug fiends" purchased one hundred ounces of morphine in powder form, as well as 30,000 heroin tablets.[340] The particular drug she used is not described, but in 1916, twenty-two-year-old Mary Austin put up a "hard fight" when three police officers attempted to arrest her for breach of the peace. "She fought like a crazy woman," the paper said, "and it is thought that she was doped."[341]

Why Rutland specifically experienced such heavy usage at the time is not identified, but a 1919 report describing a Pennsylvania farming community does relate a similar circumstance.[342] There, drug addiction among active farmers, who routinely used laudanum to treat their aches and pains, did not pose a problem. However, for retired farmers and their wives, the rural aged and those living among them, the invalids, tenants and domestics, there was indeed much addiction attributable not to patent medicines but to those obtained directly from physicians or drugstores based on their prescriptions. In turn, the residents in the neighboring towns and villages adjacent to those farms demonstrated a significantly higher per capita rate of consumption ("very far in excess") of that seen in large cities.

In Vermont, the questionable conduct taking place between physician and druggist continued that same year with the VSPA's code of ethics admonishing that "we discountenance all secret formulas" between the two professions.[343] Paregoric for children and laudanum for the adults, Vermont's papers repeatedly tell the story of a population constantly resorting to readily available opium-based products to silence crying babies, to quell their own uneasiness, to send the depressed and the burdensome elderly into the next world or—in several cases raising authorities' suspicions—to commit murder.

On April 30, 1910, Vermont congressman and chairman of the House Foreign Affairs Committee David J. Foster introduced the nation's first anti-narcotics bill. His effort focused on the practical requirement that dealers be registered and that they record all narcotics sales, an effort predictably opposed by, among others, the American Pharmaceutical Association. The measure never received a vote, but the House Committee on Ways and Means continued pursuing the matter with hearings and in 1911 received testimony describing Grinnell's findings in Vermont.[344] Foster's bill was later resurrected following his untimely death in 1912 and enacted into law in 1914 as the Harrison Narcotics Tax Act, named after New York representative Francis Burton Harrison. The law now required—in addition to some watered-down versions of Foster's provisions—that possessors of narcotics purchase tax stamps from the Treasury Department's Bureau of Internal Revenue. With the imposition of penalties for noncompliance, the radical transformation of

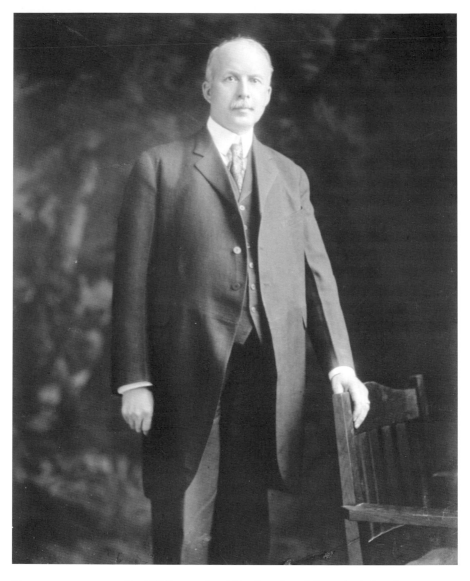

Vermont congressman David J. Foster, circa 1905, introduced the nation's first drug legislation in 1910. *Library of Congress.*

drug abuser from a pitiable, pathetic soul into a convicted criminal had now begun.[345]

As these events unfolded, Vermont became engaged in the growing eugenics movement aimed at improving mankind by promoting the reproduction of desired, or positive, individual traits and inhibiting the

negative ones. In 1912, departing governor John Mead took up the cause and recommended that the legislature consider an innovative approach dealing with "the insane, the epileptics, the imbeciles, the idiots, the sexual perverts, together with many of the confirmed inebriates, prostitutes, tramps and criminals."[346] As he described them, "This class is prolific, knowing no law of self-restraint, and consequently defectives are increasing in numbers and are of a more pronounced type." Asking rhetorically what could be done to protect society from these unfortunates and they from themselves, Mead suggested the imposition of "restrictive legislation in regard to marriages... segregation of defectives [and] a surgical operation known as vasectomy." The legislature actually instituted a sterilization program but rescinded it the following year. Medically, while Mead's "confirmed inebriates" might include the drug addicted, specific references to them remained absent from the discussion. But as one physician wrote at the time, "inebriates are of the defective class," with the alcoholics posing the largest harm. He recommended that some portion of them "should be segregated and prevented from having children."[347]

Notwithstanding, the state's doctors certainly knew of the problems that continued ready access to drugs allowed. As their professional journal reminded them,

> "Soothing syrups," medicated "soft drinks," and habit forming "treatments" galore still spell prosperity for their exploiters, and that almost daily are seen such reports as "cocaine used by sons of prominent families," "boys use heroin," "heroin cough-tablets bought daily at confectionery store by school-girls of 11 and 13;" or yet again, "physicians sell cocaine to drug-fiends," "doctor sells cocaine to boys."[348]

Additionally, as one newspaper related, the state had attained a reputation for permissiveness and as a mecca allowing easy access to drugs by those seeking to avoid the consequences of their illegal pursuit in nearby New York and Massachusetts. "The enforcement of these laws in neighboring States has driven a great many 'dope fiends' to this State," one paper decried, "and every Vermont druggist can attest to a large demand upon the part of non-residents for these deadly drugs."[349] Meanwhile, in Maine, a similar complaint arose when one investigator reported to Congress in 1911 that "the largest amount of morphine and cocaine...is used in the summer months; and there is no doubt that that has a great deal to do with the transient population that goes there perhaps to recover from too much

of the use of the drug in winter."[350] He also described seeing evidence of the voracious demand for drugs with "six stage coaches drawn up in front [of a large wholesale drugstore], each coming there to get its supply of morphine. That was then distributed out along stage routes radiating from Portland."

Finally, in the far southwestern town of Bennington near the New York border, its representative—tiring of the sight of these "drug fiends of the Empire state who come over to Vermont to lay in a stock"—introduced the state's first drug law in January 1915.[351] By no means comprehensive, "An Act to Regulate the Sale of Opium, Morphine and other Narcotic Drugs" provided for at least some degree of oversight.[352] Now it became a crime, punishable by a fine of between $50 and $1,000 and imprisonment of not more than a year, for distributing these substances exceeding certain amounts without a physician's prescription. Additionally, as with the Harrison Act, it required that pharmacists maintain records of their sales and make them available for inspection by authorities. The battle joined, the following decades saw an emphasis in Vermont, as elsewhere, on punitive enforcement of its drug laws, leaving rehabilitation for the addict to resolve by him or herself.

With the nation's sudden imposition of laws limiting the free availability of drugs, Vermonters received dire warnings from Washington that "a wave of crime and insanity is feared as the result of this sudden shutting off" as addicts braced themselves to deal with "the panic."[353] However, concerns that asylums might then fill up with them were dismissed locally, as one paper related the alternative, with the sufferer placing himself under the care of a physician to assist in weaning him off drugs' effects. That relationship existed from the very start of the problem and should continue it said: "Morphine has always been the drug most used by unfortunates hereabouts. Many addicted to it have acquired the habit honestly, because it was given them first by a physician for a proper purpose…and from this they learned its power and later sought its soothing effects without medical sanction."[354]

Placing themselves under a doctor's care may have worked for some, but for others, the lucrative proceeds invited criminal conduct. Vermont now experienced the next phase of problems that drugs provided.

<p style="text-align:center">⤲❦⤳</p>

Smuggling across the state's border with Canada constituted a time-honored exercise for those seeking to avoid detection of their criminal

conduct. Goods of all manner transitioned both north and southward for well over a century in many different ways; indeed, cattle herded by traitorous Vermonters were sent through their thick forests to supply the British army during the War of 1812. With heavy enforcement efforts directed toward the main ports in Boston and New York, smugglers simply moved out to remote areas away from prying eyes.

The Maine coast with its many inlets, the waterways of the Great Lakes and the forests of northern Vermont then became the focus of their efforts. Now, rather than using those difficult methods of the past, such as the strong backs of smugglers themselves, their horses, wagons and boats, they turned to trains, automobiles and airplanes. Combatting their efforts, customs officials worked vigorously along the border and with law enforcement officials throughout New England, sharing information and watching suspects traveling from Boston, Springfield, Troy and New York City to Montreal to make their purchases and then attempt to return undetected. Their work was exceedingly difficult, as organized rings working north of the border staged a relentless war against them that involved drugs, illegal immigrants and bootleg liquor.

The news accounts for the opening decades of the twentieth century describing smuggling efforts in Vermont reveal the heavy demand for drugs in the metropolitan areas. In 1924, "the largest 'dope' haul" ever made to that date occurred in Alburg, with the arrest of two men on a southbound train from Canada giving fictitious Boston and New York City addresses. A search of their baggage revealed the presence of an impressive 644 cans of morphine and 6 more of cocaine valued at $6,000 but with a street value of $60,000 "when broken up into smaller lots for the use of the addict who relies on bootleg channels for his or her supply."[355]

Accounts also relate that on at least one occasion, a railroad employee became involved, with porter Robert Williams charged in 1916 with concealing over twelve pounds of heroin in his locker. Over in Utica, New York, former Burlington physician John Merrow found himself under arrest following a raid by federal officials of his National Clinic Incorporated business, where they uncovered an illegal quantity of a staggering fifty thousand heroin tablets. Unfortunately, he died shortly afterward, thereby putting an end to the case. The following year, "William Davis and his wife, Rose Davis, both colored," were intercepted on a southbound train from Canada, with Rose found carrying "heroin, morphine, and opium cleverly concealed in her petticoat which had been turned up around the bottom and the drug[s] placed in the pocket thus formed."[356]

In 1919, the actions of Maxwell Aubach and Albertus Schpitzer, headed for Springfield, Massachusetts, from Montreal, aroused such suspicion that a search of their luggage revealed 148 bottles of cocaine and heroin and 77 cans of smoking opium, valued at between $20,000 and $30,000. Each received a one-year sentence in the Atlanta Penitentiary.[357] For one Vermonter assisting in an another out-of-state smuggling operation, his and another individual's vehicles were seized for transporting "many thousands of dollars' worth of narcotics" from Vermont to New York and Boston.[358] Edwin Warren became involved with three other men in transporting $1,000 of "dope" from Montreal by train.[359] He received a nine-month sentence after his attorney asked that he be incarcerated long enough so that he might withdraw "from the slavery of dope." His accomplice, Joseph Guertin of Montreal, received a one-year sentence, choosing to serve it in the Montpelier jail rather than in Atlanta when offered the choice by the judge, while the other two men received fines of $50 and $100.

By 1926, smugglers employed more elaborate methods, such as one that officials discovered on their arrest of a thirty-eight-year-old St. Albans housekeeper, Celia Murray.[360] Suspicious of her previous conduct in traveling to Montreal several times and then returning immediately, agents finally intervened, finding an ingenious "harness strapped about her body." When disassembled, they discovered it held "two large packages of morphine cubes and a similar package of heroin," valued at several hundred dollars. According to Murray, she intended to use them for herself.

In 1925, the public read a highly unusual story captioned "Police Dog Big Opium Smuggler," describing "one of the biggest opium smugglers" working the Vermont border.[361] Its name is not provided, but officials credited a particularly intrepid German shepherd with making several trips from Canada carrying heroin concealed in its collar. Information provided to authorities by a knowledgeable reformed smuggler explained that the animal was taken across the Vermont border in a vehicle by its owner and handed off to an accomplice. He then loaded up the collar with the drug and set the dog loose in the woods. It then found its way back home, avoiding detection by authorities. Once back with its owner, the collar was opened and its contents, valued at between $2,000 and $3,000, unloaded and taken to the large cities "where it is diluted with sugar and milk and sells for a small fortune."

A particularly unusual situation presented itself with the so-called drifting labor, or floating labor camps, made up of transitory men working in various capacities on difficult projects in removed locations.[362] Separated from the developed towns because of the nature of their work, loggers

and lumbermen in Maine consumed large amounts of "alcohol tablets" containing cocaine, which, when dissolved in water, reportedly provided them with "a highly stimulating effect." While reports of similar conduct in Vermont's forests appear absent, the use of heroin is not.

In this moment, when drug usage transitioned from using syringes and needles to inject morphine to the easily transported and consumed powdered heroin that snorting allowed, it is not surprising to see reports of its presence among laborers working in the rural parts of the state. In 1923, a reported 175 black workers toiled in the southern mountains between Readsboro and Whitingham on a railroad tunneling project while living in ramshackle camp conditions. Moments of violence and serious rioting accompanied their biweekly paydays, and the engineering company overseeing the effort attributed it to their heavy use of alcohol and "the peddling of heroin," which was "practically a regular feature" in the camp.[363] The drugs arrived in the difficult to access location via the men's girlfriends coming to visit from Troy, New York, after they walked a strenuous two miles along the railroad bed to reach them. A raid conducted by authorities at the request of the company, which included Boston narcotics officers, resulted in several women being detained and only "a box of pills of various colors" seized. They were then warned to move on.

Additional examples of drug dealing also occurred when authorities began looking into the actions of the doctors themselves. In 1924, Proctorsville physician G.D. Buxton ran afoul of the Harrison Act for failing to keep accurate records and reportedly furnishing drugs to addicts.[364] After pleading guilty to the offenses, the investigating officer from Boston requested that a "drastic sentence" be imposed but was rebuffed by the judge, who asked simply, "Has it got to where a doctor cannot give medicine as he thinks best?" After ordering a modest ten-dollar fine, he expressed further disdain for having to entertain the prosecution, commenting, "If that seems too much I will reduce it." Two years later, Derby Line's Dr. George Waldron was arrested, again by Boston officers, for selling them a quantity of morphine for fifty dollars.[365] As the paper describing the incident related, the agents "could have purchased any amount of the drug that they had money for. The apprehending of Doctor Waldron is one more link in the chain of narcotic smugglers known to [be] operating along the border."

Meanwhile, poor Edward Gilman of St. Albans, struggling to overcome a heroin addiction he thought he put behind him following a period of treatment at the state hospital, was arrested. Returning to his old ways after a physician started him on morphine again to treat an

injury, Gilman knew he needed help and appealed to authorities to send him back for more treatment. However, even with the backing of a judge and the mayor advocating for his assistance, bureaucracy intervened, and Gilman simply went to Burlington, where the police arrested him for vagrancy. With no system in place to assist him further, the court simply sentenced him to a one-dollar fine and incarceration of not less than four or more than six months.[366]

Attempts to break the rising addiction rate continued without success, with one Vermont paper lamenting in 1924 those futile efforts and turning to the citizenry itself for a solution: "Is it a far cry to say that public opinion aroused and directed would abolish all drug evils? Public officials have failed. Altruistic organizations have failed; it is submitted that only the arousing of national conscious [sic] by education will prevail."[367] However well-intended, education efforts did little, as the thirst for drugs remained unabated, taking a varied course over the next decades.

Addiction attributed to loose physician practices began to wane after 1910, as users looked elsewhere for their sources of heroin. Easily consumed through sniffing, it replaced smoking opium and cocaine, finding a huge and ready market in the nation's large urban centers. In fact, in 1920, it is estimated that nine out of ten addicts in the country lived within 180 miles of Manhattan.[368] Then, during the following decade, the phenomenon reached into rural areas, becoming increasingly entrenched with its use. By 1932, the Bureau of Narcotics officially declared that "heroin has supplanted morphine to a considerable degree as the drug of addiction in every part of the United States except on the Pacific Coast."[369]

In the next few years, sniffing yielded to so much subcutaneous injection that by 1940 "the heroin mainliner had emerged as the dominant underworld addict type."[370] This class of user, identified more frequently as male than female, unable to justify their use of the drug for medical reasons, then became a social pariah, viewed as possessing a "twisted personality" requiring institutionalization. While the war years saw a period of declining usage, it returned with such a vengeance afterward that by the 1950s authorities sought to revive an abandoned 1930s effort to create a nonaddictive substitute. In one of only a few institutions assisting in the effort, several graduate students working out of the Middlebury College chemistry building basement

between 1949 and 1953 then took up the challenge.[371] Their earnest work, with some so consumed they found themselves working upward of fourteen hours a day, involved attempts to rearrange morphine's molecular structure through a complicated twelve-step process. While certainly noteworthy, their actual contributions to science remain obscure.

At the same time, efforts turned toward instituting heavy criminal punishments to curb usage. However, by 1962, reformers opposed to such measures succeeded in convincing the Kennedy administration to examine the problem in a more comprehensive and compassionate manner. Then, over course of the next several years, substantial legislative changes took place, most notably marked by President Richard Nixon's involvement in passing the Comprehensive Drug Abuse Prevention and Control Act in 1970, replacing the preexisting ramshackle body of laws in effect since 1909.[372]

The hazards incurred because of heroin and other dangerous substances in Vermont during the early 1960s appears relatively benign when compared with the havoc they continued to bring in the more highly populated cities. However, by 1967, things began to change in the Green Mountains, as residents found themselves very much a part of the national problem. Marijuana constituted the drug of choice for students, and for the first time, Castleton State College found it necessary to put into effect a policy directed at their use of illegal drugs. From that time on, disciplinary action awaited anyone found in possession, using or experimenting with nonprescription narcotics, a situation precipitated by the arrests of three students and a French instructor by state police for possessing marijuana.[373] All of this took place at the same time that law enforcement policymakers sought to increase their effectiveness because of alarming reports of increased instances of crime occurring in the rural areas, attributable to "habitual or professional criminals" and the presence of the recently constructed interstate road system making access to the state easier.[374]

Of increasing concern were the more harmful substances coming to the forefront when authorities noticed a marked spike of usage over the course of a single year. According to one state police commander seeking funds to hire additional investigators, police received "relatively few drug complaints" in 1966, only to witness that number balloon to over 180 the following year.[375] In describing this recent phenomenon, he related:

> *The majority of the cases which have caused the greatest concern is the wide spread and increasing use of the hallucinogenic, stimulant and depressant type drugs. Information that high school students and*

teenagers have been using these harmful drugs has been traced to the fact that Vermont now supports a large number of the ski bum type individual and out-of-state students who bring the use of these harmful drugs with them into the State of Vermont. Once in Vermont they have found that they may continue their drug activities and can also encourage local and so-called town teenagers to join them in their drug activities. These shiftless ski bums, part-time college students and drop-out students now roam throughout Vermont all year long. Their attitude seems to be one of dropping out of the square society, a role of non-contribution and many of them are characterized by their unshaven faces, filthy clothes and generally unkempt nature. Their philosophy is to encourage other youths to drop out of society and experience their new found values through the use of drugs.

While arrests for drug offenses in 1968 amounted to a mere 56 (with 22 convictions), by 1970, that number had increased tenfold to 535 (resulting in 183 convictions). One study attributed the rising numbers to both the growing drug problem and to "increased police investigations due to public pressure."[376] Such outside pressure only grew in the coming years, becoming so dire that by 1984 a massive mailing by "outraged" residents sent to Governor Richard Snelling called on him to lead the effort "for tough sentences for drug dealers" because "drug abuse is out of control across our nation, and even in our state."[377]

In 1970, state police investigators estimated the number of heroin addicts in Vermont at between 300 and 500 individuals, while the "serious drug abusers" numbered over 5,000. However, a panel examining those figures later determined they may have actually underreported the true extent of the problem, finding "the total drug addict and heavy abuser population… much higher."[378] This, in fact, appears an accurate assessment, as the country then fell into its second-highest period of drug addiction in its history as a result of the baby boomers coming of age, succeeded only by the "morphine disaster of the late nineteenth century," when addiction occurred in 4.59 per 1,000 of the population and now estimated at 3.09 per 1,000.[379] Assuming a Vermont population of 444,742 in 1970, the number reported by police could instead approximate 1,374 individuals abusing drugs, as opposed to the estimated 1,577 in 1900.

As officials scrambled to put together programs directed toward the problem, the Vermont State Hospital continued to serve as an initial treatment location for addicts. Between 1968 and 1970, admissions increased from 35

Dear Governor: APR 1 1 1983 418.

 I live in your state, and I'm outraged at how drug abuse is out of control across our nation, and even in our state.

 You can be a leader in our fight to stop drug abuse. I urge you to push now for tough sentences for drug dealers and drug-related crime.

 I look to you to lead the fight for tough jail sentences to lock up drug dealers, and protect our homes, schools, and neighborhoods from drug abuse.

Signed _Rene J. Meunier_

From a 1983 drug enforcement mail-in campaign to Governor Richard Snelling. *Vermont State Archives.*

to 89—attributed to the use of hallucinogens (40 percent), amphetamines (40 percent) and opiates (20 percent)—and then to 130 by 1971. So many young people availed themselves of their services that a special unit was created for their particular care. Meanwhile, the Department of Corrections reported that some 119 prisoners were identified as experiencing drug-related issues, and those numbers only increased. An analysis of abusers revealed that many were young males from all levels of the socioeconomic scale, with the poor easily identified by their admissions to the hospital and as prisoners, while the well-off remained obscure because of their ability to obtain aid from private treatment facilities.

 State archives describe the herculean efforts undertaken by members of the healthcare profession working directly with the addicted as they struggled to understand how so many fell under the influence of drugs. The state hospital's director of research, Dr. Robert W. Hyde, related in 1970 that the state's youth sought to remove themselves from the "real world" because of "the horror of the atom bomb and the Presidential [Kennedy] assassination."[380] His well-intended remedy, he wrote, lay in coaxing them to follow the ways of Henry Thoreau "with meditation, relaxation, mountain-top experiences, [and the] depth of human relationships."

Demonstrating the struggles that he and his associates experienced with their new responsibilities, the same day of his remarks, Hyde, together with another doctor and two others, came under blistering attack by their superior, Commissioner of Mental Health Dr. Jonathan Leopold, for their handling of an important drug-related meeting. "I am damned burned up," he wrote, "at the completely inadequate planning and arrangements which went into today's meeting and will not tolerate a recurrence." Their offenses included, among others: the arrangement of tables and chairs ("was appalling"), a loud coffee machine (that would "buzz, gurgle, slurp and belch") and the use of psychiatric technicians to prepare the gathering's lunch (one of whom "began clinking pennies in a tin box for no apparent purpose"). Warning them against any future repetition, Leopold called their failures "a disgrace to our staff capability...that such a poorly planned and executed meeting could have actually taken place."

In fact, the state hospital was beset with many other problems besides petty complaints relating to poorly planned meetings. Caregivers attended rushed training sessions, with many traveling out of state to conferences only to return and find obstacles as they sought to transfer their newfound knowledge to others. When a vaunted substance-abuse program fell apart, a postmortem evaluation identified several deficiencies, including administrative mismanagement, misunderstanding among personnel concerning their roles, staff resistance to change, confusion in applying for federal grants and a belief that their work was all for naught since, they contended, it belonged to the state's communities to deal with the drug problem through local treatment facilities.

Policy changed, and assuring that resolution of the problem remained a local issue became the overriding focus, as state officials viewed themselves strictly in an oversight role. On May 21, 1970, Attorney General James Jeffords convened the first meeting of the Governor's Drug Council, made up of representatives from various government and private organizations, to begin the effort.[381] Discussions addressed the challenges they faced among themselves as they sought to identify their appropriate roles in the fight, with education constituting a foremost concern. However, it did not come without opposition. Dr. Leopold advised the group that educators thought "that drugs are not their business and in some way attitude change needs to take place."

In fact, the state department of education simply refused to provide any assistance, telling Jeffords in no uncertain terms "that until there is a direct demand either from the people or probably [the governor] that they did

not intend to initiate any formal program."[382] Additionally, administrators at the department of health (derisively identified by one official as "farmers or insurance people") also chose not to become involved, stating that they had no interest whatsoever and that responsibility for resolving the problem rested with the department of public safety, itself experiencing significant challenges as it sought to reorganize and obtain additional drug investigator positions. As Jeffords wrote forlornly to Governor Deane Davis at the lack of direction, "[T]he ball has now been passed to the Governor's Committee on Youth."

Strong resistance to becoming involved in the fight extended elsewhere as well. Many from the medical, pharmaceutical and veterinary professions registered vigorous complaints against proposed legislation requiring their completing any more paperwork than what they already experienced. Testimony provided to legislators revealed that hallucinogens constituted the largest problem at the time, and accordingly, some contended that any effort to address other kinds of drugs was unwarranted. Notwithstanding, there are indications that within the pharmaceutical profession some believed it necessary to address the distribution of heroin in its various forms, requiring that it only be done on a physician's prescription. From within the medical profession, the issue could not be any clearer, condemning any effort whatsoever interfering with their patient relationships. In sum, as one spokesman for the doctors wrote in opposition to a particular piece of legislation, while demonstrating at the same time the fierce defensive resentment shared by many, "the bill attacks the profession[s] of pharmacy, dentistry and medicine by implying the drug abuse problem is caused by the three professions."[383]

Interestingly, while their efforts indicate a united front against legislation impeding their collective work, records reveal a level of distrust and resentment actually existed between them. In 1967, Herbert J. Feinberg, a member of the Vermont Board of Pharmacy, wrote:

Pharmacy is well controlled compared with the medical profession in this state. I can show you letters I have written to physicians informing them of the law of this state, as well as the law of the land. One physician authorizes refills "for duration of illness," and this can lead to severe abuse, another physician lets his secretary sign his name to RX's, another physician tries regularly to find ways to circumvent the fed narcotic law. He even wrote one RX to dispense Class A Narcotics in lots of fifty until his patient had exhausted the 200 quantity he has authorized....Physicians in this state need education as to the laws of the land and state.[384]

Accordingly, in light of the doctors' requiring so much training as opposed to the unblemished state of the pharmaceutical trade, Feinberg emphatically wrote that "our powers are being taken away from us and I for one will not stand by and see this done." In sum, from the perspective of the educators, physicians and pharmacists, resolving the problem lay with anyone other than themselves.

Still, Feinberg's pointed observations regarding the medical profession appear well founded, as addiction attributed to their prescribing methods, just as in decades earlier, remained a well-entrenched practice. As one state police case revealed in 1967, a single unethical doctor's prescribing methods resulted in a staggering forty-one pharmacies having their records examined by investigators. Many patients obtaining narcotics from the physician were interviewed, with several found to be clearly addicted and not wanting to betray their relationship with him. In the case of one individual, police uncovered an additional forty felony violations and the identities of a previously unknown five addicts, including their use of the postal service to distribute drugs.[385]

In 1975, two staff members of the Vermont Alcohol and Drug Abuse Division prepared a report based on a comprehensive survey of seven Vermont general hospitals, including nearby Hanover, New Hampshire's Mary Hitchcock Hospital, to determine the extent of alcohol- and drug-related cases arriving in their emergency rooms. Their effort, "Emergency Room Survey," provides important information describing the numbers of Vermonters, and their reasons, for resorting to medical care in their moments of crisis. It also identified a turning point in the types of substances being consumed.[386] Notably, they also reported on instances involving the ongoing problem with physician-assisted addiction:

> [T]wo hospitals stated that they have a handful of patients who are maintained indefinitely on narcotics by their doctors. The diagnosis is hidden, such as chronic migraine headaches or pancreatitis, but in fact the patient has a good old-fashioned narcotic habit. It should be pointed out that all these patients are socially respectable citizens with medically induced addictions—not professional junkies. Nevertheless, the practice of maintaining a patient as a narcotic addict without ongoing attempts to detoxify him raises some legal and ethical issues.

Concerning the reasons for patients' seeking assistance, the survey examined the 1974 experiences of these hospitals, finding that of the 691

instances involving substance abuse, 386 (56 percent) identified alcohol as the leading cause. "There are more inebriates," they wrote, "turning up on hospital ERs than all other types of drug abuser put together....ER staff members...have been assaulted by belligerent drunks, and a consensus is that the unruly drunk is by far the most difficult type of drug-affected individual to deal with."

They further reported that there were 127 cases (18 percent) attributed to the use of barbiturates, tranquilizers and other central nervous system (CNS) depressants, while 94 individuals (14 percent) identified over-the-counter drugs causing their problems. In further examining the types of drugs used, the researchers determined that

> *of the "hippie" drugs, "speed," "acid," "grass," and "downers," (the use of which by middle-class youth led to widespread media coverage of what was pictured as an "epidemic of drug abuse" in the late 1960s, with resultant public and governmental concern) only the "downer" group is currently resulting in a significant number of emergency medical situations in Vermont.*

That finding was further qualified by the fact that these substances, largely alcohol and CNS depressants, were legally obtained and resulted in 90 percent of all drug-related emergency room admissions. Of those abusing the various substances, 62 percent were men over the age of thirty using alcohol, while women between the ages of eighteen and twenty-five consumed largely licit sedatives at a rate of 75 percent to males making up the remaining 25 percent of users. Only 10 percent of cases involved opiates, stimulants or hallucinogens, indicating a distinct change in the kinds of substances being consumed at the time.

However, such numbers could be deceiving when compared to the perceptions that a community might have regarding the presence of drugs in its midst. In St. Albans, suspicions ran wild of rampant drug use among members of the despised counterculture arriving in the past few years. Accordingly, in 1973, officials decided to hire a drug investigator, one with a seemingly unblemished reputation as a prior Vermont state trooper and Vergennes chief of police, twenty-nine-year-old "Super Cop" Paul David Lawrence, in order to deal with it. Then, over the course of eleven months between August 1973 and July 1974, Lawrence racked up an astounding 106 drug charges against individuals for dealing in a range of substances, from ubiquitous trivial amounts of marijuana to highly pure heroin and

the only instance in Vermont undercover work history involving a .62-gram chunk of opium.[387]

Unfortunately, Lawrence was a rogue cop able to fool his co-workers on many levels, including fellow policemen and county prosecutors, as he singlehandedly and without corroborating evidence built bogus cases against many innocent individuals. During a later investigation into his actions, evidence revealed that the drugs he contended were purchased actually came from the New York State Police laboratory, provided by an unwitting friend believing he was using them for training purposes. In the end, some seventy individuals received pardons, and Lawrence was sentenced to a three- to eight-year sentence for perjury, marking one of the darkest moments in the state's law enforcement history.

When Dr. J.C.F. With made his presentation to the Vermont Medical Society in 1899 lamenting the state's huge consumption of drugs, he reasonably asked why people living in the country required so much morphine when a druggist working in New York or Boston dispensed but a mere five ounces of it for an entire year. "One would think the human mind more equally balanced," he said, "where God's free nature, green and fresh, surrounds us, and where life is not rushed out of the body and the candle burned at both ends, as in our city life. Country villages and farmhouses seem to furnish the greater number of users, and why this is so let anyone tell."[388]

With's prescient questioning remains, and in 2014, Governor Peter Shumlin shocked Vermonters and the rest of the nation in his state of the state address, admitting the continuing dire threat that drugs posed:

> *In every corner of our state, heroin and opiate drug addiction threatens us. It threatens the safety that has always blessed our state. It is a crisis bubbling just beneath the surface that may be invisible to many, but is already highly visible to law enforcement, medical personnel, social service and addiction treatment providers, and too many Vermont families. It requires all of us to take action before the quality of life that we cherish so much is compromised.*[389]

Shumlin then listed the cold, hard facts facing the state: since 2000, more than a 770 percent increase in treatment for all opiates; an over 250 percent

increase for those seeking heroin treatment since 2000, with 40 percent in the past year alone; double the number of deaths from heroin overdoses from the prior year; and an estimated $2 million of heroin trafficked into Vermont each and every week. By 2016, one investigator estimated that virtually 3 to 4 percent of the population, approximately twenty thousand people, were then in the throes of addiction.[390]

The news only worsened with the revelation that Vermont, along with Maine, led the country in the number of newborn babies exposed to opiates during pregnancy, resulting in an unprecedented number of them taken into custody by the Department for Children and Families. Vermonters also assumed an additional unenviable role as the nation's leader in the number of DUIs on the road at fifty per one thousand.[391]

Nationally, the U.S. Drug Enforcement Administration reports that as of 2015, heroin constituted the country's "number one drug threat," identifying the heaviest demand coming from the Northeast.[392] Synthetic opioids, such as fentanyl, are becoming readily available, resulting in significant increases in the number of user deaths, while improved heroin purity, low cost and ease of use through sniffing continue to make it a desirable commodity. Why Vermont finds itself in this unattractive leading position largely confounds officials in the same way it did nineteenth-century doctors when they first recognized the problem. Some argue that it is the cold climate; for others it is the easy access that interstate highways allow, as traffickers travel south from Canada or north from the large metropolitan areas, or the great profits that they can obtain by taking a low-priced commodity in the city, cutting it and then demanding higher prices in the rural north. For others, it is simply a matter of calculated risk, consciously engaged in by users believing in their invincibility in the moments before addiction moves in and takes over their lives.

Regardless, there is one easily recognized avenue crying for change,

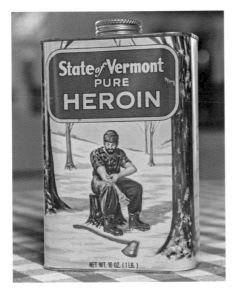

The New Face of Heroin. Art director, Mark Maltais; illustration, David M. Brinley; photography, Fredrik Broden; lettering, Jon Valk. Rolling Stone *magazine, April 10, 2014.*

and it rests within the medical profession itself, a factor that has existed in one form or another for the past two hundred years of the state's history. As commissioner of the Vermont Department of Health, Dr. Harry Chen, related in 2016:

> *Overprescribing opioid painkillers is a root cause of the deadly crisis of addiction we are now facing, not only here in Vermont but across the country. To reverse this trend, we must understand the cultural context that led well-meaning prescribers to this point. Aggressive and misleading marketing by drug manufacturers, and pressure by those bodies that accredit, oversee and reimburse health care organizations and providers to treat pain as the "fifth vital sign" made for a system that encourages unwarranted prescribing.*[393]

Chen's assessment that physicians share the blame in overprescribing is certainly correct, but in singling out the pharmaceutical industry for fault he fails to acknowledge the clear evidence of the profession's centuries-long practice of refusing to address addiction, viewing it essentially as a necessary evil attending their more important role in alleviating pain. Essentially, the responsibility for gaining some semblance of rehabilitation following addiction has consistently rested with the patient, a battle that is infrequently won and only through the application of sheer determination.

It began with frontier doctors naively telling patients to take their powdered medicines, dissolve them in alcohol and then consume them at various times of the day. As Dartmouth's Nathan Smith admitted in 1811, the resulting harm coming from the increased consumption of alcohol was directly attributable to these very directions. At the same time, people appreciated the unobtrusive relaxation that chewing gum opium and imbibing in its derivatives allowed them and found reason to continue with it for virtually the entire century, until legislation banned its general availability in the early twentieth century. Prohibitionists refused to acknowledge the evidence of increasing addiction because of opium and morphine, remaining steadfastly focused on keeping alcohol, the cause of so much public discord, out of the hands of the population. So, for the lawfully minded, not trusting the endlessly squabbling medical profession and the suspect relationships existing between them and the druggists, they turned instead to the easily obtained, ubiquitous and unregulated, patent, or quack, medicines flooding the market. Outrageous claims of their efficacy attracted many, including those seeking to heal their addictive

ways and who ended up taking concoctions containing the very substances they sought to escape, whether it was opium, morphine or alcohol.

For three decades, between 1870 and 1900, responsible physicians sounded the alarm that many Vermonters treaded a dangerous course in their drug usage, culminating with Grinnell's astounding finding that they consumed over three million doses each and every month. Technological advances made much of it possible, allowed through the easy administration of morphine by using hypodermic syringes and needles, while those tinkering with its molecular structure discovered and then marketed highly addictive heroin after 1898.

Within the medical profession itself, professors lamented their inability to teach students to appreciate the dire effects that drugs caused. When faced with someone suffering from a drug habit, they were taught to simply send the victim to an asylum. Many of those selfsame doctors then shared the travails of their patients as they, too, fell victim to addiction because of drugs' daily presence in their lives, only to find that they also had to grapple in their own way toward healing.

Addiction, or habit, was recognized for many decades but never dealt with until regulations came into effect to prohibit the adulteration of food and drugs and proscribing the readily available opium-based products in the early twentieth century. With the new laws, violations of those provisions created a criminal element intent on exploiting the demands of users, and many engaged in creative smuggling and trafficking efforts to satisfy them. Notwithstanding, yet another opiate epidemic blossomed by 1970, catching authorities unawares, only to return with a vengeance by the next century's second decade. It continues to confound the best efforts of officials to stem the tide.

For our main story, Vermont's travails with opium in the nineteenth century were both the same as and yet so dissimilar from other states' experiences. Many in those other locations also fell victim, allowing addiction to grow because politicians and policymakers chose not to become involved in policing healthcare issues, leaving it to the population and medical profession to sort out. Some states did take more aggressive action earlier than Vermont did, steadfastly believing itself removed from the others as it refused to take action until either the people demanded it or danger forced its hand.

In its frontier location, the challenges for those in the Green Mountains were uniquely different. There, while doctors and pharmacists grappled with modernizing their professions, the state legislature took a hands-off approach to oversight, remaining resolutely focused on alcohol prohibition.

It did so for an extraordinary length of time. Intervention might have come much earlier if the lawmakers had been as concerned about drug usage as they were with alcohol. Because of their inattention, the responsible among the medical profession found themselves unable to take effective action to address the continued presence of ill-educated and unlicensed doctors, diploma mills and the widespread availability of death-dealing drugs in their midst.

As a slice of Vermont's nineteenth-century experience, the difficult and complex challenges posed by identifying, acknowledging and then ameliorating drug abuse and addiction are worthy of notice today. These examples serve an important purpose in instructing later generations of the commonality we all share in dealing with many of the same issues that continue to plague society in general and Vermont specifically.

NOTES

DC—Rauner Special Collections Library, Dartmouth College, Hanover, New Hampshire

HSM—Collection of Henry Sheldon Museum of Vermont History, Middlebury, Vermont

UVM—Special Collections, University of Vermont Library, Burlington, Vermont

VHS—Vermont Historical Society, Barre, Vermont

VSARA—Vermont State Archives and Records Administration, Middlesex, Vermont

Chapter 1

1. Thomas Henderson, *Hints on the Medical Examination of Recruits for the Army* (Philadelphia, PA: Haswell, Barrington, and Haswell, 1840), 11.
2. William W. Grout, *Oration before the Re-Union Society of Vermont Officers* (Rutland, VT: Tuttle & Company, 1869), passim.
3. John Todd, *Centennial Celebration of the Settlement of Rutland, VT* (Rutland, VT: Tuttle & Company, 1870), 4–5.
4. C.P. Frost, "Opium: Its Uses and Abuses," *Transactions of the Vermont Medical Society for the Years 1869 and 1870* (Burlington, VT: R.S. Styles, 1870), 145.
5. E.W. Shipman, "The Promiscuous Use of Opium in Vermont," *Transactions of the Vermont Medical Society for the Year 1890* (Burlington, VT: R.S. Styles, 1890), 73.

6. *Vermont Statutes, 1894* (Rutland, VT: Tuttle Company, 1895), 797–820; 905.

7. A.P. Grinnell, "Stimulants in Forensic Medicine: A Review of Drug Consumption in Vermont," *Medico-Legal Journal* 19, no. 1 (1901): 422.

8. Record book, Cumberland County, vol. 1, 1772–1773, container WMCC-00010, VSARA; E.B. O'Callaghan, ed., *Documentary History of the State of New York* (Albany, NY: Weed, Parsons & Company, 1849), 708.

9. Ethan Allen to Governor Jonathan Trumbull, undated, Stevens Papers, A006-00001, VSARA.

10. Benedict Arnold report, May 11, 1775, *Spirit of Seventy-Six*, ed. Henry Steele Commager (New York: HarperCollins, 2002), 105.

11. Manuscript Vermont State Papers, 1777–1946 (hereafter VSP), SE-118-00008 and 00009, passim, VSARA.

12. William Slade Jr., *Vermont State Papers* (Middlebury, VT: J.W. Copeland, 1823), 230.

13. Ibid., 416.

14. Ibid., 477.

15. *Wine Account for the General Assembly of 1787*, VHS.

16. *Farmer's Library* (Rutland, VT), January 6, 1794.

17. Samuel Williams, *Natural and Civil History of Vermont*, vol. 2 (Walpole, NH: Isaiah Thomas and David Carlisle, 1794), 388.

18. *Rutland (VT) Herald*, November 16, 1795.

19. VSP, SE118-00083, VSARA.

20. "For a Lottery to Publish a Medical Compendium," *General Petitions 1797–1799, State Papers of Vermont*, ed. Allen Soule (Lunenburg, VT: Stinehour Press, 1962), 321.

21. Ibid., 325.

22. *Rutland Herald*, March 9, 1805; October 10, 1807.

23. Abby Maria Hemenway, *Vermont Historical Gazetteer*, vol. 1 (Burlington, VT: A.M. Hemenway, 1867), 181.

24. Slade, *Vermont State Papers*, 514.

25. Joseph A. Gallup, *Sketches of Epidemic Diseases in the State of Vermont: From Its First Settlement to the Year 1815. With a Consideration of Their Causes, Phenomena, and Treatment. To Which Is Added Remarks on Pulmonary Consumption* (Boston: T.B. Wait & Sons, 1815), passim.

26. Medical case notes 1802–14, John Norton Pomeroy Papers, UVM.

27. Oliver P. Hubbard, *Early History of the New Hampshire Medical Institution* (Washington, D.C.: Globe Printing and Publishing House, 1880), 28.

28. Gallup, *Sketches*, 408.

Chapter 2

29. Peter Lee, *Opium Culture: The Art & Ritual of the Chinese Tradition* (Rochester, VT: Park Street Press, 2006), passim.

30. Vermont Medical College, Woodstock, VT, Student Notebook, 1841–42, UVM.

31. Nathan Allen, *Essay on the Opium Trade: Including a Sketch of Its History, Extent, Effects, Etc. as Carried on in India and China* (Boston: John P. Jewett & Company, 1850), 4; William G. Smith, "An Inaugural Dissertation on Opium, Embracing Its History, Chemical Analysis, and Use and Abuse as a Medicine," University of the State of New York, April 2, 1832, 10–11, 16.

32. VSP, SE118-00007, VSARA.

33. *Vermont Gazette*, September 29, 1788.

34. "Eben Judd's *Journal of Survey to the Upper Coos, 1786*," *Vermont History* 81, no. 2 (Summer/Fall 2013): 202.

35. *Middlebury Mercury*, December 14, 1808.

36. John Lindsey, *Discourse, Delivered before the Honorable Legislature of Vermont, October 10, 1822* (Montpelier, VT: E.P. Walton, 1822), 13.

37. Dr. Reuben Mussey lectures, DA-3, 21177, DC.

38. William P.C. Barton, *Outlines of Lectures on Materia Medica and Botany* (Philadelphia, PA: Joseph G. Auner, 1827), 222.

39. James Thatcher, *New American Dispensatory* (Boston: T.B. Wait and Company, 1813), 647.

40. *Burlington Gazette*, October 6, 1815.

41. *Reporter* (Brattleboro, VT), April 29, 1817.

42. Ibid., November 7, 1803.

43. *Washingtonian* (Windsor, VT), April 8, 1811.

44. Selah Gridley, *Dissertation on the Importance and Associability of the Human Stomach, Both in Health and Disease; Delivered Before the Vermont Medical Society, at Their Annual Meeting in Montpelier, Oct. 17, 1816* (Montpelier, VT: Walton and Goss, 1816), 4.

45. Vermont Medical Society, minutes of meetings, vol. 2, 1814–1851, UVM.

46. Gallup, *Sketches*, 248–49.

47. *Woodstock (VT) Observer*, February 19, 1822.

48. Dr. Reuben Mussey lectures, DA-3, 21177

49. Valentine Seaman, *Inaugural Dissertation on Opium* (Philadelphia, PA: Johnson and Justice, 1792), 20–21.

50. *Weekly Wanderer* (Randolph, VT), June 26, 1802.

51. Jonathan A. Allen, "Address Delivered before the Addison County Temperance Society at Newhaven, VT, Oct. 20, 1829," Allen Family of Middlebury and Rutland, Vermont Papers, 1804–1910, MSC 187, VHS.

52. William Sweetser, *Dissertation on Intemperance* (Boston: Hilliard, Gray and Company, 1829), 91.

53. Allen Notebook, 1811, MSC 187:6, VHS.

54. Rachel Hope Cleves, *Charity & Sylvia: A Same-Sex Marriage in Early America* (Oxford, UK: Oxford University Press, 2014), passim.

55. Thomas Cooper, *Tracts on Medical Jurisprudence* (Philadelphia, PA: James Webster, 1819), 419.

56. Thomas De Quincey, *Confessions of an English Opium-Eater: And Suspiria de Profundis* (Boston: Ticknor, Reed and Fields, 1850), viii.

57. *Rutland (VT) Herald*, April 3, 1797.

58. *Vermont Gazette*, August 9, 1836; July 10, 1838; *St. Albans (VT) Messenger*, March 10, 1847; *Bennington (VT) Banner*, November 10, 1864; *Caledonia* (St. Johnsbury, VT), January 10, 1868; *Burlington (VT) Free Press*, July 15, 1887.

59. *Vermont State Paper* (St. Albans), February 23, 1836.

60. *Vermont Gazette*, November 14, 1785.

61. Ibid., July 2, 1787.

62. George B. Griffenhagen and Mary Bogard, *History of Drug Containers and Their Labels* (Madison, WI: American Institute of the History of Pharmacy, 1999), 75.

63. David F. Musto, *American Disease: Origins of Narcotic Control* (New Haven, CT: Yale University Press, 1973), 2.

64. *Rutland Herald*, August 15, 1807.

65. *Middlebury (VT) Mercury*, March 2, 1803; August 12, 1807.

66. *Green Mountain (VT) Patriot*, June 15, 1803.

67. *Reporter* (Brattleboro, VT), November 11, 1809.

68. Dawn D. Hance, *History of Rutland, Vermont, 1761–1861* (Rutland, VT: Rutland Historical Society, 1991), 598; Ernest L. Bogart, *Peacham: The Story of a Vermont Hill Town* (Washington, D.C.: University Press of America, 1948), 233.

69. Sherman, *Freedom and Unity*, 133.

70. Rowland Robinson, *Vermont: A Study of Independence* (Boston: Houghton Mifflin Company, 1892), 297.

71. Williams, *Natural and Civil History of Vermont*, 320.

72. Tench Coxe, *View of the United States of America* (Philadelphia, PA: 1794), 106; Timothy Pitkin, *Statistical View of the Commerce of the United States of*

America (Hartford, CT: Charles Hosmer, 1816), 101; W.J. Rorabaugh, *Alcoholic Republic: An American Tradition* (Oxford, UK: Oxford University Press, 1979), 73.

73. John Hodgkinson, *Letters on Emigration: By a Gentleman, Lately Returned from America* (London: C. and G. Kearsley, 1794), 17.

74. Innkeepers' licenses, A123-00001, VSARA.

75. Lewis D. Stilwell, "Migration from Vermont," *Proceedings of the Vermont Historical Society* 5, no. 2 (1937): 109; *Vermont Sentinel*, February 28, 1811.

76. Abby Maria Hemenway, *History of Washington County* (Montpelier: Vermont Watchman and State Journal Press, 1882), 833, 914; *Middlebury (VT) Mercury*, December 14, 1803; March 5, 1804; Gary G. Shattuck, *Insurrection, Corruption and Murder in Early Vermont: Life on the Wild Northern Frontier* (Charleston, SC: The History Press, 2014), 21.

77. "To the Honorable the General Assembly," SE005-00006, VSARA.

78. *Day Book No. 2, May 16, 1809, Oliver Cromwell Rood, Waterbury, Vermont*, author's collection.

79. Bogart, *Peacham*, 208; *Weekly Wanderer* (Randolph, VT), September 4, 1802.

80. Ian R. Tyrell, *Sobering Up: From Temperance to Prohibition in Antebellum America, 1800–1860* (Westport, CT: Greenwood Press, 1979), 25.

81. Rorabaugh, *Alcoholic Republic*, 11.

82. Arthur F. Stone, *Vermont of Today* (New York: Lewis Historical Publishing, 1929), 99.

83. *Rutland Herald*, July 15, 1799.

84. Speech of Governor Tichenor, October 1803, in E.P. Walton, ed., *Records of the Governor and Council of the State of Vermont* (Montpelier, VT: J.M. Poland, 1876), 523.

85. John Woodcock, "Dissertation on Delirium Tremens," DA-3, 10925, DC.

86. Rorabaugh, *Alcoholic Republic*, 171.

87. Allen Notebook, MSC 187:6, VHS.

88. Rhoda Scott to Mary Scott, February 3, 1823, A1141, Bennington Museum, Bennington, Vermont.

89. *Vermont Asylum for the Insane* (Brattleboro, VT: Hildreth & Fales, 1887), 7.

90. Robert Shalhope, *Tale of New England: The Diaries of Hiram Harwood, Vermont Farmer, 1810–1837* (Baltimore, MD: Johns Hopkins University Press, 2003), 235–39.

91. Calvin B. Pratt, "Delirium Tremens," 1833, DA-3, DC.

92. Cyrus B. Hamilton, "On Ebriety," DA-3, 10925, DC.

93. John P. Batchelder, *On the Causes Which Degrade the Profession of Physick; An Oration Delivered before the Western District of the N.H. Medical Society* (Bellows Falls, VT: Bill Blake & Company, 1818), passim.

94. Stone, *Vermont of Today*, 305; Hance, *History of Rutland*, 602–4.

95. Henry Ingersoll, "Lectures on the Theory and Practice of Physic & Surgery 1811 by Nathan Smith, M.D.," ms. 811602.3, DC.

96. Daniel O. Morton, *Discourse Delivered at Montpelier, October 16, 1828 on the Formation of the Vermont Temperance Society* (Montpelier, VT: E.P. Walton, 1828), 7.

97. Stone, *Vermont*, 98.

98. *Centennial Celebration of the Settlement of Rutland, VT*, 78.

99. *Journals of the General Assembly of the State of Vermont...1806* (Bennington, VT: Anthony Haswell, 1806), 193; Morrissey, *Vermont*, 113.

100. *Rutland Herald*, September 5, 1810.

101. David T. Courtwright, *Dark Paradise: A History of Opiate Addiction in America* (Cambridge, MA: Harvard University Press, 2001), 41.

Chapter 3

102. Reverend Daniel Haskel, *Sermon, Delivered in Randolph at the Annual Meeting of the Vermont Juvenile Missionary Society, October 13, 1819* (Middlebury, VT: Francis Burnap, 1819), passim.

103. Joshua Bates, *Discourse Delivered in Castleton, at the Organization of the Vermont Juvenile Missionary Society, September 16, 1818* (Middlebury, VT: Francis Burnap, 1818), 17.

104. Levi Parsons, *Memoir of Rev. Levi Parsons: First Missionary to Palestine from the United States* (Burlington, VT: Chauncey Goodrich, 1830), 138.

105. *Christian (VT) Messenger*, July 29, 1818.

106. Henry Davis, *Sermon, Delivered on the Day of General Election at Montpelier, October 12, 1815* (Montpelier, VT: Walton and Goss, 1815), passim.

107. *National (VT) Standard*, January 11, 1820.

108. Hemenway, *History of Washington County*, 90.

109. Samuel Sheldon Fitch, *Six Lectures on the Functions of the Lungs* (New York: S.S. Fitch & Company, 1856), 83.

110. R.D. Mussey, *Health: Its Friends and Its Foes* (Boston: Gould and Lincoln, 1862), 41.

111. Richard Harrison Shryock, *Medicine and Society in America: 1660–1860* (Ithaca, NY: Cornell University Press, 1960), 91–92.

112. *Vermont Chronicle*, June 4, 1830; *Book of Health: A Compendium of Domestic Medicine* (Boston: Richardson, Lord and Holbrook, 1830), 170.

113. William R. Preston, *Medicine Chests for Ships and Families, with New and Approved Directions* (Portsmouth, NH: C.W. Brewster, 1839), passim.

114. *Vermont Gazette*, March 13, 1827.

115. *Watchman* (Montpelier, VT), January 15, 1828.

116. Mussey, *Health*, 309–10.

117. Albion Edwin Cobb, "The Right Use of Medicines," DA-3, 10955, DC.

118. Hunting Sherrill, *On the Pathology of Epidemic Cholera* (New York: Samuel Wood and Sons, 1835), 147.

119. Allen Family Papers, MSC 187, VHS.

120. Papers of Albert Smith, DA-3, 2176, DC.

121. Joanna Smith Weinstock, "Samuel Thomson's Botanic System: Alternative Medicine in Early Nineteenth Century Vermont," *Vermont History* 56, no. 1 (Winter 1988): 5–22.

122. Samuel Thomson, *Narrative of the Life and Medical Discoveries of Samuel Thomson* (Columbus, OH: Pike, Platt & Company, 1832), 68.

123. *Transactions of the Vermont Medical Society for the Year 1880* (Montpelier, VT: Argus and Patriot, 1881), 24.

124. Vermont Medical Society, minutes of meetings, vol. 1, 1814, UVM.

125. *Vermont Intelligencer*, February 23, 1818.

126. *Farmer's (NH) Cabinet*, May 16, 1818.

127. *American (VT) Yeoman*, September 16, 1817.

128. Thankful Wilcox to Carlos Wilcox, February 1, 1816, Noah Landon Papers, ms. 142, VHS.

129. VMS, minutes of meetings, vol. 2, 1814–1851, UVM.

130. "An Act, Regulating the Practice of Physic and Surgery within this State," *Acts and Resolves Passed by the General Assembly of Vermont, 1817–1820* (Middlebury, VT: Frederick Allen, 1820), 27.

131. Arthur F. Stone, *Vermont of Today with Its Historic Background, Attractions and People*, vol. 1 (New York: Lewis Historical Publishing Company, 1929), 313.

132. Frederick Clayton Waite, *First Medical College in Vermont: Castleton 1818–1862* (Brattleboro: Vermont Printing Company, 1949), 118–21.

133. Oliver Wendell Holmes, *Complete Poetical Works of Oliver Wendell Holmes* (New York: Grosset & Dunlap, 1850), 219–20.

134. *Proceedings of the Vermont Pharmaceutical Association, October 11, 1871* (Rutland, VT: Tuttle & Company, 1871), 8–9.

135. Papers of Albert Smith.

136. Edward Kendall, *Travels through the Northern Parts of the United States in the Years 1807 and 1808*, vol. 3 (New York: I. Riley, 1809), 265–66.

137. Papers of Albert Smith.

138. Bogart, *Peacham*, 230–33.

139. Ibid.

140. Papers of Albert Smith.

Chapter 4

141. M. Therese Southgate, "Castleton Medical College 1818–1862," *Journal of the American Medical Association* 204, no. 8 (May 1968): 700–1.

142. *Watchman*, December 28, 1830.

143. Letter, June 27, 1896, Dartmouth Medical School administration correspondence, container 2151, DC.

144. Samuel Rezneck, "The Study of Medicine at the Vermont Academy of Medicine (1827–1829) as Revealed in the Journal of Asa Fitch," *Journal of the History of Medicine* 24 (October 1969): 416–29.

145. Southgate, "Castleton Medical College," 699.

146. J.V.C. Smith, ed., *The Boston Medical and Surgical Journal*, vol. 23 (Boston: D. Clapp, 1841): 182.

147. "PLEDGE," September 9, 1835, "Constitution and Records of the Temperance Society of the N.H. Medical Institution, Organized October the 19th, 1832," DC.

148. Edward Hitchcock, *Reminiscences of Amherst College* (Northampton, MA: Bridgman & Childs, 1863), 152.

149. "To the Honorable the General Assembly of the State of Vermont," undated, Petitions, SE118-00063, VSARA.

150. Ibid., "Petition of Stebbins Walbridge & Others, August 15, 1834."

151. "Lecture Book, Vermont Academy of Medicine, Augt. 1836," Special Collections, Castleton University, Castleton, VT.

152. Stephen G. Hubbard, "A Thesis Upon the Use and Abuse of Arsenic," DA-3, 10934, DC.

153. *Watchman*, July 12, 1836.

154. Ibid., August 9, 1836.

155. Ibid., April 27, 1835; April 5, 1836.

156. *Vermont Sentinel*, June 10, 1836.

157. Ezra Edson, "Constitution, Thomsonian Convention, Peru, Vermont, January 24, 1838," pamphlet, VHS.

158. Silas Wilcox, *Book of Health* (Bennington, VT: J.I.C. Cook, 1843).

159. Leonard Worcester, *A Memorial of What God Hath Wrought…Peacham (Vermont), March 31, 1839* (Montpelier, VT: E.P. Walton, 1839), 6.

160. Report, *Journal of the House of Representatives of the State of Vermont*, October 13, 1836 (Middlebury, VT: American Office, 1836), 223.

161. *Nineteenth Annual Report of the Vermont Domestic Missionary Society…Sept. 14, 1837* (Windsor, VT: Chronicle Press, 1837), 10.

162. Rutland Petition, October 20, 1837, Petitions, SE118-00065, VSARA.

163. Leonard Marsh, *Physiology of Intemperance…University of Vermont, June 29, 1841* (Burlington, VT: Chauncey Goodrich, 1841), 15.

164. Papers of Albert Smith.

165. William Henry Thayer, *Address to the Graduates of the Vermont Medical College of the Class of 1856* (Keene, NH: 1856), 9.

166. *Vermont Patriot and State Gazette*, November 6, 1837.

167. Ibid., October 30, 1837.

168. "An Act to Regulate the Practice of Medicine and Surgery in the State of Vermont," eff. November 28, 1876, *Acts and Resolves* (Rutland, VT: Tuttle & Company, 1876), 194.

169. *Revised Statutes of the State of Vermont, 1839* (Burlington, VT: Chauncey Goodrich, 1840), 428, 445.

170. Ashbel P. Grinnell, "History of Medical and Surgical Practice in Vermont," *New England States*, vol. 3 (Boston: Hurd & Company, 1897), 1,469.

171. Thayer, *Address*, 8.

172. Joseph A. Gallup to Jonathan A. Allen, June 16, 1845, Allen Family Papers.

Chapter 5

173. *Semi-Weekly Eagle* (Brattleboro, VT), June 19, 1851.

174. Courtwright, *Dark Paradise*, 28.

175. *Proceedings of the Vermont Pharmaceutical Association, October 11, 1871* (Rutland, VT: Tuttle & Company, 1871), 7–8.

176. Joseph W. England, ed., *First Century of the Philadelphia College of Pharmacy, 1821–1921* (Philadelphia, PA: Philadelphia College of Pharmacy and Science, 1922), 150.

177. *Proceedings…October 11, 1871*, 9.

178. *Proceedings…1873*, 27.

179. Edward Hervey Currier, "Relations Existing between Physician and Apothecary," DA-3, 10955, DC.

180. *Proceedings...October 11, 1871*, 8.

181. Lewis C. Beck, *Adulterations of Various Substances Used in Medicine and the Arts, with the Means of Detecting Them* (New York: Samuel S. and William Wood, 1846), 157.

182. Curtis A. Wood, "Opium," DA 3, no. 10954, DC.

183. *Proceedings of the American Pharmaceutical Association* (Philadelphia, PA: Merrihew and Thompson, 1853), 11.

184. *Vermont Watchman and State Journal*, October 15, 1846.

185. *Proceedings of the Vermont Pharmaceutical Association, October 11, 1871* (Rutland, VT: Tuttle & Company, 1871), 7.

186. "Patent Medicines," February 6, 1849, Report No. 52 (to accompany H.R. No. 755), House of Representatives, Thirtieth Congress, Second Session, passim.

187. Dr. Carter's Compound Pulmonary Balsam (1845), Newbury, VT, Pamphlets, VHS.

188. Smith, ed., *Boston Medical and Surgical Journal* 40 (1848): 207.

189. Truman Powell to Dr. J. Wright, January 16, 1837, in A. Curtis, ed., *Thomsonian Recorder*, vol. 5 (Columbus, OH: Jonathan Phillips, 1837), 191.

190. Minutes, February 5, 1846, Records of the Addison County Medical Society, HSM; *Northern Galaxy* (Middlebury, VT), April 14, 1846.

191. J.F. Skinner, "Domestic Medicines," *Boston Medical and Surgical Journal* 40:309.

192. Temperance Records, February 26, 1833, Original Church Records, First Congregational Church in Jericho, VT, VCC & VDMS, Box 3, UVM.

193. Rutland Petition, October 20, 1837, VSARA.

194. Allen Family Papers, MSC 187:16, VHS.

195. Samuel Swift, *History of the Town of Middlebury...Vermont* (Middlebury, VT: A.H. Copeland, 1859), 362.

196. H.P. Smith, *History of Addison County, Vermont* (Syracuse, NY: D. Mason & Company, 1886), 176.

197. C.B. Currier to Meader, December 2, 1867, no. 867656.3, Papers of William P. Russel, 1833–1894, HSM.

198. Undated, post office business, Russel Papers, HSM.

199. *Journal of the Senate and House of Representatives of the State of Vermont...1857* (Montpelier, VT: E.P. Walton, 1857), 175.

200. *Proceedings at the Annual Meeting of the Vermont State Temperance Society... January 16, and 17, 1850* (Windsor, VT: Chronicle Press, 1850), 4.

201. Russel License Report, Box 1, Vol. 1, HSM.

202. Russel Papers, Large ledger vol. 1, 1833–1851, HSM.

203. Julia Thomson account book, Weybridge Collection, Box 206, VHS.

204. Minutes, January 23, 1856, Records of the Addison County Medical Society, vol. 1, 1835–1920, HSM.

205. McDonald Newkirk, *Sleeping Lucy* (Chicago: self-published, 1973), passim.

206. Calkins, *Opium and the Opium-Appetite*, 36–38; Thomas M. Santella, *Opium* (New York: Infobase Publishing, 2007), 14.

207. *Proceedings of the Fifth Annual Meeting of the Vermont State Pharmaceutical Association, October 25 and 26, 1898* (St. Albans, VT, 1898), 54.

208. Basil M. Woolley, *Opium Habit and Its Cure* (Atlanta, GA: Atlanta Constitution Print, 1879), 45–46; Statement of Dr. Christopher Koch, "Importation and Use of Opium," *Hearings before the Committee on Ways and Means of the House of Representatives*, Sixty-First Congress, December 14, 1910, and January 11, 1911 (Washington, D.C.: Government Printing Office, 1911), 70.

209. *Third Report to the Legislature of Vermont Relating to the Registry and Returns of Births, Marriages, and Deaths…Ending December 31, 1859* (Middlebury, VT: Register and Job Book Office, 1860), 85; *Nineteenth Report…Ending December 31, 1875* (Rutland, VT: Tuttle & Company, 1877), 100; *Proceedings of the Vermont Pharmaceutical Association, September 24–25, 1873* (Rutland, VT: Globe Paper, 1874), 27.

Chapter 6

210. William Sweetser, *Address Delivered before the Chittenden County Temperance Society, August 26, 1830*, 12, VHS.

211. Thayer, *Address*, 10.

212. Newkirk, *Sleeping Lucy*.

213. Currier, "Relations Existing between Physician and Apothecary."

214. William H. Grant, "Duties of Medical Men," DA-3, 10953, DC.

215. *Transactions of the Vermont Medical Society for the Years 1871, 1872 and 1873* (Montpelier, VT: Argus and Patriot, 1874), 311.

216. *Vermont Phoenix* (Brattleboro), July 16, 1859.

217. *Third Report*, 89–90.

218. *Second Annual Report…of the State Board of Health of the State of Vermont for the Year…1888* (Rutland, VT: Tuttle Company, 1888), 12.

219. England, *First Century*, 134.

220. *Transactions of the Vermont Medical Society for the Year 1866* (Burlington, VT: R.S. Styles, 1866), 31.

221. Smith, "An Inaugural Dissertation on Opium," 21.

222. *Transactions...1871, 1872 and 1873*, 305.

223. *Transactions...1866*, 27.

224. *Proceedings of the Vermont Pharmaceutical Association, 1873* (Rutland, VT: Globe Paper Company, 1874), 48.

225. Ibid., 49.

226. Ibid., 43.

227. *Proceedings of the Vermont Pharmaceutical Association, October 11, 1871*, 17, 31.

228. Currier, "Relations Existing between Physician and Apothecary," DA-3, 10955, DC.

229. *Transactions 1870*, 111.

230. *Vermont Daily Transcript* (St. Albans), October 20, 1868.

231. William B. Biddle Atkinson, ed., *Physicians and Surgeons of the United States* (Philadelphia, PA: Charles Robson, 1878), 197.

232. *Lamoille News Dealer* (Hyde Park, VT), April 5, 1861.

233. "Dr. Russel's Compound Extract of Wheat," advertisement, HSM.

234. Francis Browne, *Lakeside Monthly* (Chicago: Browne & Company, 1873), 440.

235. Richard A. Gabriel, *Between Flesh and Steel: A History of Military Medicine from the Middle Ages to the War in Afghanistan* (Lincoln: University of Nebraska Press, 2013), 165–67.

236. David T. Courtwright, "Opiate Addiction as a Consequence of the Civil War," in Larry M. Logue, ed., *Civil War Veteran: A Historical Reader* (New York: New York University Press, 2007), 110.

237. Horace B. Day, *Opium Habit* (New York: Harper & Brothers, 1868), 7.

238. Courtwright, *Dark Paradise*, 40–41.

239. H. Wayne Morgan, *Yesterday's Addicts: American Society and Drug Abuse, 1865–1920* (Norman: University of Oklahoma Press, 1974), 11.

240. J. Adams Allen, *Medical Examinations for Life Insurance* (New York: J.H. and C.M. Goodsell, 1870), 21–22.

241. George Donohoe, "Medical Profession Not Responsible for Certain Drug Habits," *State of Iowa, Bulletin of Iowa State Institutions* vol. 17, no. 1 (January 1915): 83.

242. F.E. Oliver, "Use and Abuse of Opium," *Annual Report of the State Board of Health of Massachusetts* (Boston: State Board of Health, 1872), 165–66.

243. *Twentieth Annual Report of the Vermont Agricultural Experiment Station* (Burlington, VT: Free Press Printing, 1908), 378; Report of the

Commissioner of Agriculture for the Year 1870, *Executive Documents Printed by Order of the House of Representatives 1870–71* (Washington, D.C.: Government Printing Office, 1871), 210.

244. *Burlington Free Press*, May 14, 1869.

245. Prospectus, *American Opium Raised by Wilson & Chase at Monkton and Berlin, Vermont* (Montpelier, VT: Argus and Patriot Job Printing House, 1869), 7.

246. *Vermont Watchman and State Journal*, July 14, 1869.

247. Oliver, "Use and Abuse," 167.

248. William Proctor Jr., "Notes on American Opium from Vermont," *Buffalo Medical and Surgical Journal* 8 (1869): 151; "Additional Note on American Opium from Vermont," *American Journal of Pharmacy* 41 (1869): 23.

249. William Proctor Jr., "Assay of Pure American Opium from Poppies grown at Hancock, Vermont, by Mr. C. M. Robbins," *American Journal of Pharmacy* 42 (1870): 127.

250. Wood, "Opium," DC.

251. *St. Albans Messenger*, June 10, 1870; Frost, "Opium: Its Uses and Abuses," 131.

Chapter 7

252. *Rutland Daily Globe*, October 23, 1874.

253. *Fourth Annual Report of the State Board of Health of Massachusetts* (Boston: Wright & Potter, 1873), 167.

254. *Proceedings…1873*, 41.

255. W.S. Rann, ed., *History of Chittenden County, Vermont* (Syracuse, NY: D. Mason & Company, 1886), 485–86.

256. *Rutland Daily Globe*, September 27, 1873.

257. *St. Albans Daily Messenger*, July 17, 1875.

258. Champlain Transportation Company Records, UVM.

259. Ibid., Abijah North statement, July 25, 1875.

260. *Nautical Gazette* 99, no. 1 (July 3, 1920): 84.

261. Joseph Auld, *Picturesque Burlington* (Burlington, VT: Free Press Association, 1893), 159–62.

262. Ibid., 160.

263. *Catalogue and Hand-Book of Wells, Richardson & Co.*, 1878, pamphlets, VHS.

264. Charles Chandler, ed., *American Chemist* 5, nos. 2, 3 (August 1874): 70.

265. *Pharmaceutical Journal and Transactions*, vol. 5 (London: J.&A. Churchill, 1875), 272.

266. M.K. Paine apothecary recipe book, MSA 748:5, VHS.

267. Clark testimonial, May 8, 1883, Paine's Celery Compound advertisement, VHS.

268. Wells, Richardson Paine's Celery Compound retailer instructions, VHS.

269. *Journal of the American Medical Association* 69, no. 14 (October 1917): 1,638–39.

270. Robert McKinley Ormsby, *Vermont Speller; or, Progressive Lessons* (Bradford, VT: A. Low & Company, 1859), 95.

271. *Acts and Resolves Passed by the General Assembly of the State of Vermont, 1882* (Rutland, VT: Tuttle & Company, 1883), 36; Mary Hunt, *History of the First Decade of the Department of Scientific Temperance Instruction in Schools and Colleges of the Woman's Christian Temperance Union* (Boston: Washington Press, 1892), 10.

272. Orestes M. Brands, *Lessons on the Human Body* (Boston: Leach, Shewell & Sanborn, 1885), 165.

273. *Green Mountain (VT) Freeman*, March 5, 1884.

274. *Nineteenth Annual Report of the City of Burlington, Vermont* (Burlington, VT: Free Press Association, 1884), 102.

275. B.J. Kendall, *Doctor at Home* (Enosburgh, VT: B.J. Kendall, 1884), passim.

276. John M. Currier, "Medical Colleges of Vermont—Bogus and Genuine," *Medical and Surgical Reporter*, vol. 64 (1891): 237.

277. *Transactions of the Vermont Medical Society for the Year 1890* (Burlington, VT: R.S. Styles, 1890), 46–47.

278. *Transactions…1897*, 186.

279. *Cyclopædia of Temperance and Prohibition* (New York: Funk & Wagnalls, 1891), 523.

280. House of Representatives, November 17, 1890, *Journal of the House of Representatives…1890* (Burlington, VT: Free Press Association, 1890), 508–12.

281. J.H. Hamilton to Governor C.S. Page, March 28, 1891, *Fifth Annual Report…of the State Board of Health* (Rutland, VT: Tuttle Company, 1891), 56.

282. *Annual Report of the Secretary of the State Board of Health…1889* (Rutland, VT: Tuttle Company, 1889), 20.

283. *Cyclopædia of Temperance*, 522; *Journal of the House of Representatives…1886* (Montpelier: Vermont Watchman, 1886), 395; *Western Druggist*, vol. 17 (Chicago: Engelhard & Company, 1895), 396–97.

284. Farewell address of Urban A. Woodbury, accessed July 22, 2016, https://www.sec.state.vt.us/media/49117/Woodbury1896.pdf.

285. Jacob Ullery, *Men of Vermont* (Brattleboro, VT: Transcript Publishing Company, 1894), 360.

286. Shipman, "Promiscuous Use," 72.

287. Ibid., 38.

288. Records of the Burlington Clinical Society, VHS, passim.

289. Frost Family Papers, September 1888, MS-1034, DC.

290. Ibid.

291. Courtwright, *Dark Paradise*, 41.

292. Erica Huyler Donnis, *History of Shelburne Farms: A Changing Landscape, an Evolving Vision* (Barre: Vermont Historical Society, 2010), 128–32.

293. Leslie E. Keeley, *Keeley Institute, Montpelier, Vermont*, pamphlet, HSM.

294. *Argus and Patriot* (Montpelier, VT), June 28, 1893.

Chapter 8

295. *Pharmaceutical Era*, vol. 19 (1898), 485.

296. *Vermont Watchman*, August 28, 1895.

297. *Pharmaceutical Era*, vol. 17 (1897), 462.

298. *Proceedings of the Sixth Annual Meeting of the Vermont State Pharmaceutical Association, October 25 and 26, 1899* (St. Albans, VT: 1898), 54–55.

299. *Pharmaceutical Era*, vol. 17 (1897), 346.

300. F.W. Comings, "Opium, Its Uses and Abuses," *Transactions of the Vermont Medical Society for 1895 and 1896* (Burlington, VT: Free Press Association, 1897), 359.

301. *Vermont Statutes, 1894*, 895.

302. *Western Druggist*, 396–97.

303. *Merck's Market Report*, vol. 4 (1895), 318.

304. Vermont Secretary of State, "Inaugurals & Farewells," accessed July 10, 2016, https://www.sec.state.vt.us/media/49117/Woodbury1896.pdf.

305. A.P. Grinnell, *Stimulants in Forensic Medicine: A Review of Drug Consumption in Vermont* (Burlington, VT: 1901), 15, VHS.

306. Ibid., "Use and Abuse of Drugs in Vermont," *Transactions of the Vermont State Medical Society, 1900* (Burlington, VT: Free Press Association, 1901), 67–68.

307. *Proceedings of the…Vermont State Pharmaceutical Association…1901* (St. Albans, VT: Messenger Company, 1901), 101.

308. *St. Albans Daily Messenger*, May 11, 1901.

309. *Barre (VT) Evening Telegram*, May 7, 1901.

310. *St. Albans Messenger*, May 11, 1901.

311. Timothy Hickman, "'Mania Americana': Narcotic Addiction and Modernity in the United States, 1870–1920," *Journal of American History* 90, no. 4 (March 2004): 1,281.

312. G. Thomann, *Real and Imaginary Effects of Intemperance* (New York: U.S. Brewers' Association, 1884), 26, 134.

313. *Vermont State Officers' Reports for 1901–1902* (Albany, NY: J.B. Lyon Company, 1902), 33–41.

314. *Biennial Report of the Supervisors of the Insane…1918* (Rutland, VT: Tuttle Company, 1918), 9.

315. *Vermont Public Documents…1922* (Rutland, VT: Tuttle Company, 1922), 19.

316. Patient records, 1891–1969, VSH-00109, VSARA.

317. Charles E. Terry and Mildred Pellens, *Opium Problem* (Camden, NJ: Haddon Craftsmen, 1928), 9–32.

318. Ibid., 1.

319. Musto, *American Disease*, 5; David F. Musto, MD, "History of Legislative Control Over Opium, Cocaine, and Their Derivatives," http://www.druglibrary.org/schaffer/History/ophs.htm.

320. Courtwright, *Dark Paradise*, 28.

321. Musto, *American Disease*, 5; Musto, "History of Legislative Control over Opium."

322. Grinnell, "Use and Abuse," 66.

323. Smith E. Jelliffe, "Some Notes on the Opium Habit and Its Treatment," *American Journal of the Medical Sciences*, 125 (1903): 789.

Chapter 9

324. "Inaugurals & Farewells," accessed July 29, 2016, https://www.sec.state.vt.us/media/48806/McCullough1902.pdf.

325. Mason A. Green, *Nineteen-Two in Vermont* (Rutland, VT: Marble City Press, 1912), 12.

326. "Inaugurals & Farewells," https://www.sec.state.vt.us/media/48704/Gates1915.pdf.

327. *Proceedings of the Thirteenth Annual Meeting of the Vermont State Pharmaceutical Association, 1906* (Bradford, VT: Opinion Press, 1906), passim.

328. *Orleans County (VT) Monitor*, December 9, 1908.

329. *Proceedings of the…Vermont State Pharmaceutical Association…1919* (Burlington, VT: Free Press Printing, 1919), 17.

330. *Orleans County (VT) Monitor*, December 9, 1908.

331. *Acts and Resolves…1906* (Published by Authority: Free Press Printing, 1906), 186.

332. *Pharmaceutical Era* 38, no. 17 (November 21, 1907): 495.

333. *Proceedings…1901*, 109.

334. "Inaugurals and Farewells," https://www.sec.state.vt.us/media/48887/Prouty1908.pdf.

335. Vermont Office of the Attorney General, cases and investigations, 1907–1913, PRA-00421, VSARA.

336. "Service and Regulatory Announcements," U.S. Department of Agriculture, Bureau of Chemistry, February 8, 1917, 34–35.

337. *Journal of the Missouri State Medical Association* 12, no. 1 (November 1915): 508.

338. Vermont Office of the Attorney General, PRA-00421, VSARA.

339. *St. Albans Messenger*, April 7, 1910.

340. Ibid., February 22, 1912.

341. Ibid., August 31, 1916.

342. Morgan, *Yesterday's Addicts*, 76.

343. *Proceedings…1919*, 97.

344. Statement of Dr. Alexander Lambert, *Hearings*, 144.

345. James L. Nolan Jr., *Reinventing Justice: The American Drug Court Movement* (Princeton, NJ: Princeton University Press, 2001), 28.

346. "Inaugurals and Farewells," https://www.sec.state.vt.us/media/48815/Mead1912.pdf.

347. *Vermont Medical Monthly* 19, no. 8 (August 15, 1913): 189–90.

348. Ibid., 181.

349. *Middlebury Register*, January 22, 1915.

350. Statement of Dr. Hamilton Wright, *Hearings*, 93.

351. *St. Albans Messenger*, January 21, 1915.

352. *Acts and Resolves Passed by the General Assembly of the State of Vermont…1915* (Hanover, NH: J. Padock & A. Spooner, 1915), 336.

353. *St. Albans Messenger*, March 4, 1915; Morgan, *Yesterday's Addicts*, 173.

354. *St. Albans Messenger*, June 3, 1915.

355. Ibid., March 1, 1924.

356. Ibid., August 3, 1916; October 10, 1917.

357. *Caledonian (VT) Record*, March 4, 1919.

358. *St. Albans Messenger*, August 8, 1918.

359. *Caledonian Record*, June 12, 1919.

360. Ibid., March 1, 1926.

361. Ibid., July 30, 1925.

362. Morgan, *Yesterday's Addicts*, 72–74.

363. *St. Albans Messenger*, May 15, 1923.

364. Ibid., March 20, 1924.

365. Ibid., June 18, 1926.

366. Ibid., January 22, 1925.

367. Ibid., August 7, 1924.

368. Courtwright, *Dark Paradise*, 87.

369. Ibid., 105.

370. Ibid., 109.

371. *Middlebury College News Letter*, April 1, 1949; *Middlebury Campus*, November 19, 1953.

372. Courtwright, *Dark Paradise*, 162–63.

373. *St. Albans Messenger*, May 9, 1967.

374. "A Report on Vermont's Crime Enforcement Needs," August 1, 1968, Drug Council Records, 1969–1972, PRA-00834, VSARA.

375. Lieutenant Robert Iverson to Colonel E.A. Alexander, November 13, 1967, Drug Council Records.

376. "Scope and Nature of Drug Abuse in Vermont," Clinical Studies, 1940–1990, VSH-00120, VSARA, passim.

377. Governor Richard A. Snelling records, 1977–1985, A184-00107, VSARA.

378. "Scope and Nature."

379. Courtwright, *Dark Paradise*, 169–70.

380. Robert W. Hyde, MD, "Perspectives of Drug Use," February 11, 1970, VSH-00112, VSARA.

381. Drug Council records, VSARA.

382. Ibid., James M. Jeffords to Deane C. Davis, July 25, 1969.

383. Ibid., Edward Croumey to Dr. David Gray, December 20, 1967.

384. Ibid., Herbert Feinberg to Mr. Brownell, December 13, 1967.

385. Ibid., Iverson to Alexander.

386. "Emergency Room Survey, 1975, Jody Norton and Gwen Goldberg," Clinical studies, 1940–1990, passim.

387. Hamilton E. Davis, *Mocking Justice: America's Biggest Drug Scandal* (New York: Crown Publishers Inc., 1978), 177–80.

388. *Proceedings of the Fifth Annual Meeting of the Vermont State Pharmaceutical Association, October 25 and 26, 1898* (St. Albans, VT, 1898), 54–55.

389. Governor Shumlin's 2014 State of the State Address, January 8, 2014, accessed September 5, 2016, http://governor.vermont.gov/press-release/gov-shumlins-2014-state-state-address.

390. "Researcher Aims to Give State New Tools to Fight Opiate Crisis," September 5, 2016, accessed September 6, 2016, http://vtdigger. org/2016/09/05/researcher-aims-give-state-new-tools-fight-opiate-crisis.

391. "Vermont-Maine Have Highest Rates of Drug-Exposed Babies," August 13, 2016, accessed September 5, 2016, https://www.boston.com/news/health/2016/08/13/vermont-maine-have-highest-rates-of-drug-exposed-babies; "States with the Worst Drivers," August 10, 2016, Smart Asset, accessed September 5, 2016, https://smartasset.com/auto/states-with-the-worst-drivers.

392. "National Heroin Threat-Assessment Summary," DEA Intelligence Report, June 2016, accessed September 5, 2016, https://www.dea.gov/divisions/hq/2016/hq062716_attach.pdf.

393. Vermont Department of Health press release, April 13, 2016, accessed September 5, 2016, http://healthvermont.gov/news/2016/041316_pain_management_petition.aspx.

INDEX